No Regrets

Caught in the Crossfire
of an African Civil War

This is an account of the events leading up to and including the conflict that trans-pired on and around the campus of International Christian Academy in 2002 and 2004. The author has done her utter best to ensure the accuracy of the account, however, over time memories fade and change. Any differences in the author's account and what others may remember were not intentional or intended to harm others. The author, publishers and all those associated with this book, directly or indirectly, disclaim any liability, damage, loss or injury resulting from this account. If you wish to communicate with Julia Vaughan and do not know her personally, please contact her through Morten Moore Publishing.

All passages quoted from the Bible are in the New International Version, unless otherwise noted.

In chapter 4, Julia discusses Third Culture Kids. Much of her information, beyond personal observation, is taken from the work of Dave C. Pollack and Ruth E. Van Reken. If you wish to read more on the subject, please check out their books, *Third Culture Kids: Growing Up Among Worlds* and by Ruth Van Reken, *Letters Never Sent: a global nomad's journey from hurt to healing*.

No Regrets: Caught in the Crossfire of an African Civil War
by Julia Anna Vaughan with Ken Vaughan
First Edition 2017
© Julia Anna Vaughan
All rights reserved to Julia & Ken Vaughan

Published by Morten Moore Publishing LLC
PO Box 881
Flagstaff, AZ 86002

ISBN: 978-0-9991108-0-5

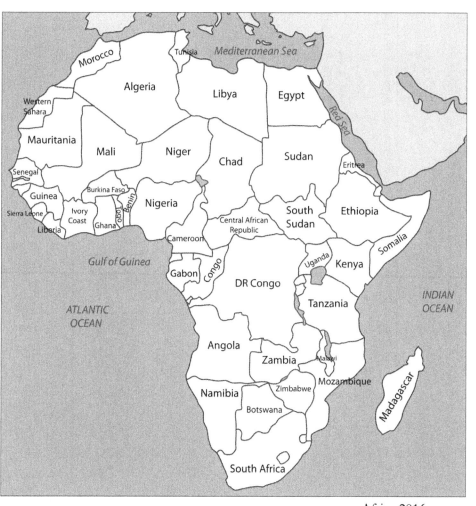

Africa 2016

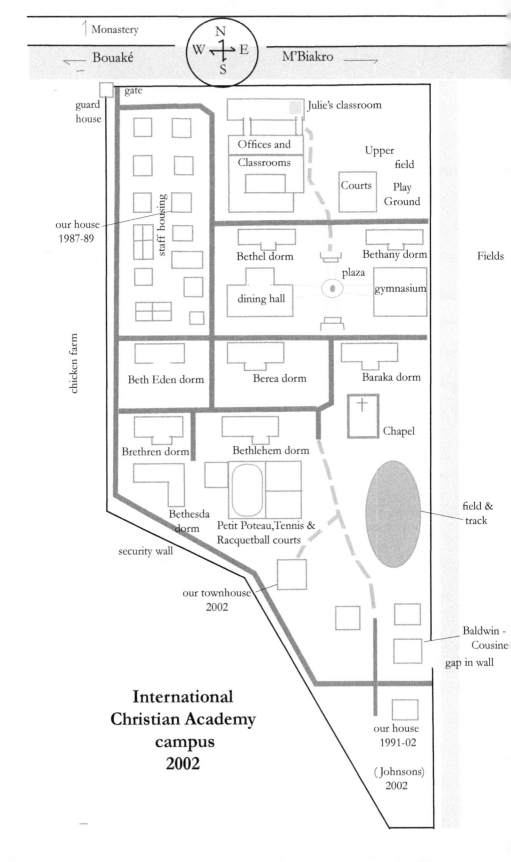

International
Christian Academy
campus
2002

Contents

To the author
of the greatest book ever written,
Jesus Christ,
to Him be the glory,
and thanks for this great adventure.

Prologue

The staccato burst of machine gun fire shattered the quiet African evening. The sound reverberated and ricocheted off the cement school buildings, multiplying its effect and masking its point of origin.

Stunned, we dove for the smooth cement floor of the dining hall. Surrounded by windows on all four sides, hiding was impossible. So, we pulled over two long tables, one to shelter beneath and the other to serve as a shield in front of us.

Before we could finish, the battle erupted on both sides of us. Tracer bullets were visible through the window while the two armies shot their artillery over our heads. The sound was deafening. Curled in a fetal position beside me was a fresh first-year teacher. Shivering in fright he kept murmuring, "We're going to die, we're going to die."

What could I say? "Oh God," I stammered under my breath, "Only You can help us!" I began gently patting the young man's back, trying to comfort him while the bullets continued to fly. "It's going to be all right."

Oh Lord, you have laid your hand upon me.
Such knowledge is too wonderful for me!
If I rise on the wings of the dawn,
if I settle on the far side of the sea,
even there your hand will guide me;
your right hand will hold me fast...
All the days ordained for me were written in your book
before one of them came to be."

Psalm 139 selected verses

Chapter 1

Long before I settled on the far side of the sea in Africa, God's hand
was indeed upon me, holding me fast and guiding me. Undoubtedly
God had an uphill job as he looked down upon that little freckle-faced,
pig-tailed feisty girl who perpetually wore band aids on her skinned
knees and had a definite mind of her own. Strong-willed. Stubborn.
Not surprisingly I was frequently in trouble, alone or with one or more
siblings of which I had four, two older sisters and a younger sister and
brother. Yep, I was a very typical middle child.

After having two girls I guess it was logical for my parents to ex-
pect their third baby to be a boy. My older sisters even called me 'baby
brother' for a while. So, I think I was predisposed to become a tomboy.
Actually, I reveled in my self-assumed role and loved climbing the big-
gest oak trees, target shooting with rocks, competing with the boys, and
exploring the wilds around our home in Northern California, loving
every minute of it. I never imagined at the time that God was preparing
me for the wilds of Africa and that he would use my stubbornness in a

positive way.

Because my parents, Lee and Doris Alloway, were from difficult, fractured homes they wanted to build a strong, loving family. So, when Sue and Sandi, my older sisters, were preschoolers my hope-filled parents began looking for a church. They realized that a strong, loving family needed a spiritual base; they just didn't have a clue how to go about creating that base.

My paternal grandmother was a member of the Christian Science Church, and raised her children to follow those beliefs. But as adults, many of those eight children began to question those same beliefs, including my father and his brother, Jim.

Full of enthusiasm but not yet articulate enough to share deeply about his spiritual journey, Jim had come for a visit in order to share his newborn faith. His advice, between puffs of his cigarette, was to find a church which preached that Jesus was God and that the Bible was the true and only Word of God. His words resounded with the truths my great-great grandma had shared with my mother when she was little. Uncle Jim said the preacher could explain it all better than he could.

Already prepared by the Spirit's leading, my parents set out on a quest to find Truth. They visited nearly every kind of church but sadly came away disappointed each Sunday. That is, until they stumbled upon a small Baptist church out in the prune orchards in Los Gatos, California, now called Calvary Church. They soaked up every song, every word of the sermon. Not wanting to influence my dad, my mom did not even look at him at the end of the service, but slipped out and quietly walked to the front of the church where the pastor was waiting. When she opened her eyes after praying, there was my dad next to her, both of them with their eyes streaming tears of joy. They had found Truth!

Thrilled with their new-found faith, they pored over the church bulletin to find out when they could next come and learn more. Hey, look! There's something called a Deacons' meeting Tuesday night! Wow! So, with my sisters safely ensconced with a sitter and their best clothes donned (mom in pillbox hat and white gloves with heels and hose with seams), they arrived early for this sure-to-be-wonderful Deacons' meeting, whatever it was! The men began arriving for their leadership meeting but no business was conducted that evening. Those godly men graciously received these baby believers like family, answered

4

their questions, accepted them without reservation and made them feel loved. What a great beginning to their spiritual growth!

Calvary Church's annual Missions Conference began the following week. My parents were thrilled to become a part of such a world-wide effort to share God's love. While they eagerly attended each meeting workshop, they were troubled by something they heard: an offering would be taken at the close of the conference to help support the missionary workers and fund their ministries. That an offering was to be taken was not the issue; the fact that they had nothing to contribute was their concern. Generous people, my parents desperately wanted to give something, but my mom was already counting out the pennies for groceries. Then she remembered: there was a 6-pack of beer sitting untouched in the refrigerator that they could return to the store. Greatly relieved to find a solution, my parents joyfully cast their *beer money* into the offering plate. Their priorities had been forever changed.

Soon after my parents' spiritual birth they found out they would experience another physical birth, mine. As they quickly began absorbing and applying biblical principles, my mom was moved to initiate reconciliation with my grandmother, Julia Strawn Paulson. Thus, when it came time to bestow a name upon me I was given the commemorative name of Julia, after my grandmother and great-grandmother. Proverbs tells us that "A good name is more desirable than great riches" so I have much to live up to.

God did get hold of this scallywag character named Julia, who on rare occasions would boast to her daddy as soon as his work boots touched the front porch, "I didn't get a spanking today!"

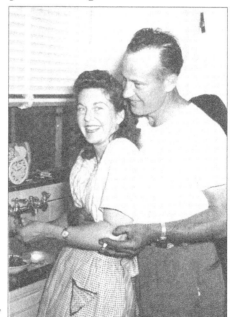

Lee & Doris Alloway

5

Strong-will, stubbornness, and plain old mischievousness are not a recipe for good behavior. But at the ripe old age of five I remember lying on my top bunk after our regular Saturday night baths, as our pretty pastel organza dresses my mom had sewn hung on the closet door, and I started thinking instead of sleeping. I knew that tomorrow, at the end of the sermon the pastor would ask if anyone wanted to accept Jesus as their Lord and Savior; he would pray with them if they came to the front of the church. I knew in my heart of hearts that I needed Jesus and that I couldn't wait until the next morning. So I hollered out to my parents that I needed them. They patiently explained the plan of salvation and listened to my childish but sincere prayer of repentance.

I wish I could say I was a perfect person after that but I was (and still am) a work in progress. But, do you want to know something encouraging? Every time I have failed and asked God for forgiveness He has given it to me. Amazing! And I have had to do it a lot!

Along about this time God was doing a parallel work in the life of the little boy

Julie, 1st grade

*Sisters
left to right: Julie,
Sandi, Bettie, Sue*

who was to become my husband, Ken Vaughan. As my parents eagerly attended Calvary Church they met many other young parents including Lloyd and Dale Vaughan whose first two children were the ages of my sisters. A natural friendship developed between the moms as their young ones shared piano teachers, Sunday school picnics, and birthday parties. So, our moms were already close before I was born. Kenny Vaughan, along with sisters Ginny and Shirley, became part of our lives.

However, long before anything romantic developed, our family moved fifty miles south to Watsonville, California, still on the California coast but in a fertile farming area. I was in second grade and easily fell in love with the country life, complete with cows and chickens (though I do not claim to have enjoyed cleaning out the chicken coop). A year after our move, we joyously celebrated the birth of our only brother, David. We were now a family of seven. Sort of.

Throughout my childhood we had various and assorted people living with us for a while. Around the time of my birth a high school senior named Will lost his parents in a car accident so my parents

Ken, 1st grade

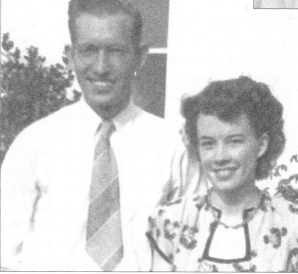

Lloyd & Dale Vaughan

welcomed him into our family. He called our place home until he married and began his own family. I think it was because my parents had such unhappy childhoods that they opened their hearts and home to whomever needed that extra love for a season of their life. I took this for granted while I was growing up but of course it was still impacting me. This 'open heart—open home' principle was later to be put into practice by Ken and me on another continent far away, but its roots were deep in my humble home in California.

The summer before my tenth grade year my parents sold the ranch and moved us all back to Los Gatos. Just before the move I got to go to Hume Lake for summer camp. It was a marvelous time, full of fun, good teaching, and of course many silly pranks. I made many new friends, including several girls who attended Calvary Church in Los Gatos. In fact, one of the girls was Ginny Vaughan. Making these friends really helped my transition back to the city life of Los Gatos from rural Watsonville.

These were the days of mini-skirts, Beach Boys, Beatles, Viet Nam, and the hippie movement. Among other activities, my next older sister, Sandi, and I joined the youth choir which was composed of high school and college students, including new friend Ginny Vaughan, her sister Shirley, and their brother, Ken. Ken had graduated from high school the previous June and was attending a local college. I did note this cutie with the horn-rimmed glasses, fashionably long blond surfer

Four doting sisters with little brother

8

hair and fuzzy sideburns. What a hunk!

Tom McKee, our youth pastor, was a visionary who began a program for us called Summer Service Corps. Now, this was long before anyone was doing short-term missions trips with high schoolers. But Tom's vision encompassed more than just going out in ministry in the summer. During the school year he taught a preparatory course—almost a junior seminary—which we were required to complete in order to participate in the summer program.

Tom made church history come alive, taught us how to dig deeply and use Bible study tools and do Greek and Hebrew word studies. We learned how to effectively share our spiritual journey with others and how to discern for ourselves the foundational doctrines of the faith. We all attended secular schools so these were precious times of discovery and growth.

The first summer I got to be on a team that worked with children and youth from rugged logging camps near Ft. Bragg, California; Ken's team worked with children on a reservation in New Mexico. Looking back I can count twenty-five kids from our youth group who later answered the call to full-time Christian service. I never dreamed at the time that I would ever be one of these.

I can see God smiling down on us when during Calvary's mission conference Ken asked me out on a date. I only knew at the time that I was 15 and would have to ask my parents' permission to go out with this 'older man' of nearly 18. Only because they knew Ken's parents did my parents give their okay. Thus began a relationship that would become increasingly serious.

When Ken left to attend college in Oregon the next year we wrote each other every single day, and saw each other only during holidays. Writing helped us develop our relationship in a way being face-to-face never could. And, we got lots of practice since we were apart for the next two years. Still, the distance was agonizing.

Over the summer between my junior and senior year I worked at Camp Hammer in the Santa Cruz Mountains. Helping in the kitchen and giving swimming lessons to the campers gave me not only a fun summer but it also gave me a taste of freedom. Perhaps that's why I listened to my friend, Debi's advice.

What was her *profound* wisdom? To date other guys besides Ken.

After all, he'd been my only really serious boyfriend and she assumed there was no way I would go out with other guys at Biola, where I was planning on going. Then, she figured we'd sure as shootin' get married since Ken and I had already talked seriously about eventually getting married. All fine and good. But, what if, years down the road after a couple of babies, I shake my head in wonderment, look around, and ask myself why I didn't shop around more before I settled down with Ken? So, dating during my senior year was my last chance! Her logic seemed reasonable to me.

While I did love Ken, I didn't have much to compare it with. Was it the kind of love that would last?

So, when Ken drove up to Los Gatos for his Thanksgiving Break I hit him with it. Like a two by four in the face. It went something like this.

"So, Ken, you know how much I love you…."

"Yes, I do!" Kiss kiss.

"Wait a minute! I have something to talk about!"

"Sure, go ahead," he said, still smiling.

"Well, I've been thinking that with this being my senior year and our last year apart, we need to make sure that what we have between us is really God's will for our lives."

"Ok, I'm listening," he replied. But his smile had quickly faded.

"Well, I think it would be a good idea if when you go back to Biola you take out other girls, and I go out with other guys here in Los Gatos. Then when you're home on breaks we just go out with each other. By next summer we should know for sure if we're really in love for forever. If we're meant for each other no matter how many people we date will change that. What do you think?"

His face was troubled. "I don't think it's a good idea. I just couldn't share you with any other guy. It's got to be all or nothing for me."

Uh oh.

I don't do well with ultimatums. They seem to bring out my stubborn streak and make me want to dig in my heels. So, yep, you can guess what my response was.

"Ok," I said, tight-lipped. "Then it's going to be nothing."

Ken's jaw dropped, dumbfounded, as I jumped out of the car slamming the door behind me with tears streaming down my face. My parents' surprised faces greeted me as I blurted out, "Ken and I have broken up---for good!" before fleeing to my bedroom and flinging myself on my bed, inconsolable.

The next few days were a blur. I cried. My mom cried. Ken cried. His mom cried. All our friends cried. It was awful!

While I cried I also prayed, "Dear God, is this what You want? If it is, it sure doesn't feel right! I'm not asking for happiness but I do need a sense of peace in this decision! Please, God!"

Finally, I was able to condense my swirling thoughts into one pivotal question: do I need to date other guys to know that Ken is The One you have for me, or do I already love him enough (at the *mature* age of 17) to say that I will commit to loving him faithfully for the rest of my life, beginning right now? It was a weighty question, with my entire future depending on the answer.

After even more prayer and soul searching I realized that I did indeed, really and truly, love Ken with all my heart. With God as our partner in our relationship I felt that our love would last for a lifetime. Now I needed to find out if Ken felt the same way.

He had been going through his own agony, wondering if he'd ruined "the best thing that had ever happened" to him. To this day, neither of us remembers who called first but one of us did, opening the door to a sweet reconciliation. It had been a miserable three days but I was glad we'd plumbed the depths of our relationship. Now we truly knew where we stood with each other. Now we were committed. We were committed—to each other and to seeking God's will in making vital life decisions. It was a good precedent to make.

At long last I graduated on the beautiful front lawn of Los Gatos High School and was accepted to Biola University, where Ken was attending. I absolutely adored my classes. Up to that moment most of my teachers had been atheists or existentialists or simply without faith of any kind, so to be able to speak of spiritual things openly in the classroom was wonderful. It was thrilling to have professors who prayed before beginning class! Plus, Biola elevated missions to the forefront. Becoming a missionary or, being missions-minded was an expected

outcome for all students. Whether living out our faith in our own neighborhood or across the ocean, God called us to obedience. Indeed, I was ready and willing to take up the challenge, but I never really thought God would take me up on my offer. I never envisioned He would ask me to actually go. Me?

Ken and I worked part-time in the school cafeteria as well as attending classes. There we met many international students—a first for me--and I loved giggling and scraping plates and talking with kids from India and Nigeria and Korea and Japan and other far-flung countries. It was a glorious cross-cultural experience which was to serve me well in the future. Our God had a plan.

Christmas break of my freshman year saw Ken and me driving back to northern California to see our families. While Ken and I had dreamed about getting married one day we had not talked about a timeline. Besides, there was no way as a poor college student he could afford an engagement ring, which he insisted be given when he proposed.

Christmas and all its activities came and went. At the church's New Year's Eve service Ken suggested leaving early. I eagerly agreed, thinking he just wanted to spend more time alone with me. He'd given up going to see the Rose Parade in Pasadena with his family just to stay with me. How sweet! However, he had an ulterior motive.

No sooner had we pulled into my parents' driveway than Ken put his arms around me and asked me if I would marry him. Scooting away, I blurted out, "You can't ask me that!" knowing he still couldn't afford a ring.

"Yes, I can," he insisted.

"No, you can't!"

"Yes, I can!"

"No, you can't!"

Finally, Ken dramatically drew from his pocket a little velvet covered box with a beautiful engagement ring. He explained that his mother had given him the stones from her mother's wedding ring so he could have them re-set for my ring. What other objections could I offer? It was a done deal—I said yes and have never regretted my decision. God was to use Ken repeatedly in the many years to come to reveal to me His timing and His leading.

In his heart a man plans his course,
but the Lord determines his steps.

Proverbs 16:9

Chapter 2

Silent Night, Jingle Bells, Good King Wenceslaus, Away in a
Manger......I love all Christmas songs and Christmas decorations, and
all things truly celebrating Christmas. So, sometime during the Spring
semester, we chose December 17th to begin our lives together during
the semester break from Biola. I was all of nineteen and Ken just
twenty-two.

Our parents were thrilled about our alliance and did all they could
to help us with the wedding. My mom sewed the long velvet gowns for
my bridesmaids; Ken's mom and friends arranged all the flowers. The
service was lovely; family and friends from near and far joined us as we
took our vows to each other before God. Our honeymoon snowed in
at a little cabin at Lake Tahoe was blissful.

Once ensconced in our little apartment in Southern California we
set about building our marriage. After four years of dating and engage-
ment I thought I knew everything about Ken and he thought he knew
everything about me. We would live in perfect harmony happily ever
after. I thought it was normal to expect him to be able to read my mind
and detect every nuance of my mood or wishes and respond perfectly.
Although I was used to a more confrontational approach complete with
yelling, slamming doors, and tears, when communication went awry,
Ken was patient and even-tempered, though surely bewildered at times.
With much practice and love we continued to hone our communication
skills. Maintaining good communication between a husband and wife is
a life-long process, although it didn't take long for us to develop an easy
rhythm of living and loving together.

Now wed, Mr. & Mrs. Ken Vaughan

We attended a church in Fullerton that had a powerful, practical pastor, new to town, by the name of Chuck Swindoll. We were well-fed under his teaching as millions of people would be in the years to come.

While going to school full-time, Ken worked two part-time jobs, Sears and Biola's cafeteria. I worked thirty hours a week at Cerritos High School and went to school part-time at Fullerton. With only one car I don't know how we did it.

We started out with no living room furniture except brick and board bookcases and a large beanbag chair Ken's mom made. So, when we weren't working or going to night classes, we spent evenings after studying lounging together in the beanbag, reading through the collection of vintage Charles Dickens or Agatha Christie books we'd been given. If we had free time on the weekend we'd pop over to the beach or play board games with the other young couples in our apartment complex. The guys played Risk while we gals swapped stories and traded homemaking tips, finding much in common including ways to

stretch our meager budgets.

Being frugal was part of my background and now we honed it to an art. I discovered day-old bread, counting out the slices so we'd have exactly enough to last the week. No snacking! But we were young and in love and the future was before us, ready for us to conquer it.

God would prove many times over to be Jehovah-Jirah, as He provided for our needs. We did not own any credit cards, so what we had was either cash or held in our joint checking account—our liquid assets were very meager. When our checking account dipped down to fifty cents on more than one occasion we did the only thing we could. We prayed that God would provide. We'd been reading about George Mueller's faith experience where he decided not to share his needs with anyone but God and God came through for him every time.

On one occasion, when our account was especially low my paycheck wasn't enough to cover our normal expenses, including next month's rent. I think God arranged the situation so He could show us His strength in our weakness. Just days before the rent was due I went to the mailbox to get the post. Among the other letters was a lovely card. Unsigned. With a $50 bill enclosed! We weren't going to be evicted! We could even eat until the next paycheck! Thank you, God, for taking care of us and for teaching us another lesson in trusting You.

Spring break during Ken's semester of student teaching saw us trundling up to Oregon, full of hope, to the interviews he'd set up with public school administrators. Our dream was to move up to the scenic Pacific Northwest and be light and salt in the secular arena. We'd have gloriously happy ruddy-cheeked children and raise them out in the country, where they'd learn to appreciate God's marvelous creation.

It was a good goal, a good dream. But I'll let Ken tell you this part of our story.

Ken

"Ah-haaaa, I see that you're from California," the interviewer observed, followed by the sound of the guillotine falling:

"I'm sorry to tell you this, but we don't hire Californians. We hire our own." I had heard that sentence so many times during the week, I had it memorized.

I was finishing my student teaching through Biola University,

17

and had lined up a series of interviews across the state of Oregon during the Spring Break. Julie and I had decided that Oregon would be a great place to get a teaching job. It was a beautiful area – 'God's country'-- as the Oregonians called it. That was our plan, but the plan wasn't unfolding as we had envisioned. In fact, I wouldn't say that the doors were being closed – it was more like the doors were being slammed, key locked, bolted, and padlocked! Oregon was definitely not the direction that God was leading us. Every single interview that I had lined up went the same way. "We don't hire Californians."

No interview lasted more than five minutes, and we were discouraged as we headed back on a fourteen-hour trip from Portland to Los Angeles – no job, and out of money except just enough for a soft drink for each of us at the half way point in California's Central Valley. We were only able to pay for the gas because my father had loaned us his Shell credit card. It seemed like such a wasted trip. So where was God leading us? We were discouraged.

A week earlier, on our way up to Oregon, we had stopped at my parent's home in the San Jose area where Julie and I were born and raised. My mother suggested that I apply for a teaching position at Valley Christian School. I had worked as an after-school janitor at Valley Christian during my senior year. That was my only exposure to Christian schools since I had gone through the public school system all the way through high school. Even Biola, at that time, didn't provide me with a philosophy of Christian education. The Christian school movement was still in its infancy.

I knew virtually nothing about what it meant to teach from a Christian perspective. So when my mother suggested I apply at Valley Christian, I agreed pretty much just to please her. An interview was quickly arranged with the chairman of the school board, Bud Callisch. The interview seemed to go well, and Mr. Callisch ended the interview with, "At least if it turns out you're not cut out for teaching, we know you'll keep your classroom clean!" I laughed, knowing I wasn't really planning on working there anyway.

God's ways aren't our ways. I was taught that growing up, and we were learning this to be so true. The very day after we

returned from our discouraging trip, I received a call from Mr. Callisch. He offered me a fifth grade teaching position at their Los Altos campus. Since God had clearly shown us that Oregon was not in His plans, I accepted the job with Valley Christian. This decision would impact our lives in many ways. One major change would be that I would fall in love with Christian education. This decision would also re-enforce our trust in God's provision for direction, protection, and financial needs.

Julie

Ken's sister Ginny and husband Steve helped us move our belongings up to San Jose that summer. We arrived in time to celebrate my sister Bettie's wedding to Dave Peterson. Then, while my parents flew to Germany to visit my sister Sue and her husband in the Air Force, we took care of my 12-year-old brother, David. Our moving to San Jose seemed to be working out well for everyone.

Although we had no idea at the time, God had yet another reason for our moving back to our old stomping grounds; Ken's mom, Dale Vaughan, had only five more months to live. Breast cancer survivor rates were much lower in 1973. Dale had undergone a radical mastectomy, radiation, and a hysterectomy in an effort to thwart the insidious and aggressive disease. Lloyd had taken her to Mexico for experimental treatments. She had sought healing at Pentecostal meetings. But her illness raged on, with precious few intervals of relief.

Ken's parents celebrated their twenty-fifth wedding anniversary by flying to Hawaii in September, but their trip was cut short when Dale became too ill to continue. She spent the remainder of her time on earth in various hospitals, where Ken and I were able to visit her daily. She retained her sense of humor and good spirits, except for those especially difficult days which became increasingly frequent. One evening she sent us all home earlier than usual---all except her husband, Lloyd.

The shrill ring of the telephone pierced through my sleep. Ken's mom had just died. I had never been around a dying person and so was unprepared to hear the shattering news. How could this happen? I had been praying nearly every waking moment for her healing! I had scoured the Scriptures for stories displaying the power of prayer. I read

how Elijah called down fire from heaven—and it happened! Hannah prayed for a son and she conceived! Was my faith too small? How could God allow such a wonderful, godly woman die? She was only forty-seven—that was too young! We cried out to God in our pain and incredulity.

It took months for Ken and me to work through our initial grief. I continued to search the Scriptures and sought godly counsel. It was a hard time, a time of testing. Those months were a time of reluctant growth for me, as God continued to reveal Himself as a loving God as well as a Sovereign God. Resting in what God chooses to do, or not do, is not an easy thing. This was the biggest challenge of my life so far: trusting God, even when I didn't understand, when I hurt so badly. Learning to trust God when I could not fathom His purpose was a challenge I would face repeatedly in the years to come. God has always proved Himself to be worthy of our trust. No matter how bad the circumstances, God is still good. He still loves us.

Our lives went on as we continued to heal. And, God had more challenges in store for us.

Ken

Trusting in God's provision in meeting our financial needs became obvious very quickly. Even though Valley Christian was a showcase for the Christian school movement, and still is today, my salary was considered to be below the poverty line in the state of California. God would have plenty of opportunities to teach us to trust Him with the provision of our needs.

Now that I had a steady job during the school year, Julie and I decided to begin our family. Ken's dad had remarried and moved into his new wife's condominium. When he asked us if we'd like to move into the house Ken grew up in, we saw his offer as part of God's provision for us and our yet-to-be-born baby. During the lean summer months when I painted for the school district, we qualified for Medicaid assistance. It would pay for all the costs of having our July baby. The problem we faced was that Julie already had an obstetrician that she was comfortable with, but he didn't accept Medicaid patients. We would have to pay for his services out of our own pocket – a whopping $700! This was a month's

gross salary!

Initially we were able to save some money toward that end. We had scrimped up $349 but had reached the point at which we could no longer save money; we were spending every cent of our monthly income. Julie had been laid off her job. Where would the remaining $351 come from?

One Thursday evening I was playing volleyball in our church gym. Toward the end of the evening as I jumped up to block a shot from the opposing team, I came down on the foot of my team-mate next to me. He was unhurt but I fell to the ground in agony. My ankle was either broken or seriously sprained so, I went to the emergency room at the nearby hospital. It turned out that my ankle was severely sprained and not broken for which I was thankful. But now we had the expense from the emergency room hanging over our heads when we were trying to save money.

Fortunately, the church had accident insurance so I filled out the proper claim forms and waited for the reimbursement. Weeks passed and I began to get notices for payment from the hospital. I worried that the insurance company would not pay up, so I filled out a claim form for my employee health insurance at Valley Christian School. In one week's time, I received a check that covered the hospital expense. The same day, I received the check from the church's insurance company. Each check covered our expenses 100%!

Now I wondered what to do! Was God using this as a way to meet the expense of the obstetrician? God surely knew that we needed that extra money! I had been paid twice for one injury. Was it right to keep the second payment? We prayed about it that night, asking God for guidance. In the morning I knew the obvious answer – I burned one of the checks in the fireplace before heading off to work. Was I nuts? In burning the second check, had I destroyed God's provision? I felt clearly that wasn't God's intention—it was not ethically right.

My lunch break came, and I went to the teacher's lounge to eat, picking up the papers in my teacher's box along the way. Among the announcements and bulletins was an envelope. Inside the envelope was a check for $352! An anonymous donor had

given the school a large sum of money to be divided evenly among all the teachers. Each teacher's gift amounted to $352! God had provided! We were learning that God's way is not only different from our ways, but His way was much better! God knows the big picture!

Even my fifth grade students could figure out that $349 plus $352 equals $701. What was the extra dollar for? Was there a purpose for that extra dollar or was it just a coincidence? Not long after our daughter Laura's birth, she began to have a series of ear infections due to fluid problems in her ears and needed surgery to place drainage tubes into her ears to open up the channels. Medicaid paid for all the expenses of the operation except for one dollar! God knows the big picture and He does indeed provide! His provision was also a confirmation that we were right where He wanted us.

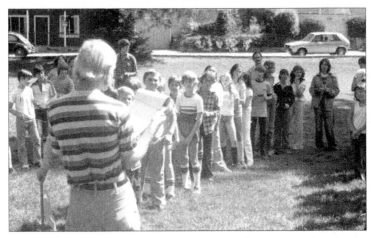

Ken teaching at San Jose in 1977

After working eight fantastic years at Valley Christian and having two more children, Andy and Aimee, it began to be obvious that we could no longer afford to live in the San Jose area. The South Bay was metamorphosing into Silicon Valley. The price of homes was skyrocketing as was the standard of living. Many of my students came from families with luxurious homes, designer clothes, and multiple luxury cars. These were Godly, kind, generous, and involved people - home of the dearest people you could

ever want to work for or with. But, not only was it becoming impossible to live in San Jose on a Christian school teacher's salary, but we did not want our children to grow up thinking this high standard of living was the norm. God put the desire in our hearts for our children to have a more realistic view of how the rest of the world lived – or at least how the rest of California lived. Once again, we began yearning to live in the country. We had no clue that this was to be our first step in God's transplanting us into third world Africa.

God once again provided us with direction, though not according to our plan. I began requesting applications from other Christian schools in Northern California. I had received several of them but had not acted on any of them, when I received a note in my classroom notifying me that someone had called long-distance to speak to me.

During my lunch break, I discovered that the caller was a pastor from a church in Yuba City, California. They had a small Christian school that was in need of a principal to begin the following school year. I had never heard of this pastor nor the church and school. I had heard of Yuba City and I had no interest in relocating there.

Yuba City brought three things to my mind: Juan Corona – a mass murderer of migrant workers; a tragic school bus accident taking the lives of many high school students; and finally, the only time I had been through Yuba City I was rear ended by a high school student without insurance. No, I had no desire to move to Yuba City! But God had different plans!

Julie and I agreed to visit the church and school. We were pleasantly surprised at the friendliness of the people and the school board. We found out that the pastor had received my name through someone he knew in Alaska who had previously worked at Valley Christian. What a small world!

I accepted the job, and we moved to Yuba City in late June, only to learn the true condition of the school. There were only ten students enrolled for the fall! The school was in a nose-dive to extinction. The first thing to do was to triage the situation. I found that the most important thing to address was to revamp the

curriculum, which to that point had mostly depended on cast-off textbooks from the local public school system. The school board gave me a carte blanche to update the curriculum. I gladly used all the money they had given us for moving expenses, knowing new curriculum was a solid investment. That was followed up by calling the many parents who either formerly had their students at the school or had not made up their mind yet if they were going to enroll their students in the fall. They were waiting to see what changes would be made. I introduced myself and invited them to come and look at the changes.

We began the school year with 38 students, our daughter, Laura, in first grade. The increase was a confirmation to me that I was where God wanted me once again, though I must admit to doubting that when I first arrived. Grace Christian Academy began to grow quite rapidly and after a few years it was obvious that we needed more classroom space. Grace Baptist Church issued bonds to raise money to build a new building with eight new classrooms, a kitchen, and a gymnasium!

It is one thing to build a building, and yet another thing to furnish it with all the things a school needs: desks, chairs, cabinets, chalkboards, bulletin boards. We began to pray for God to provide those items for the school since the bonds only covered the construction of the building and not furnishing it. God was faithful once again to provide for our needs. Out of the blue, I received a call from George Smith, a teacher friend with whom I had taught at Valley Christian. He had heard of a school in the San Jose area that was closing. The school district was in dire need of money so they had sold the property and all the buildings on it to a housing developer.

I quickly contacted both the school district and the developer. The school district did not want to spend all the money and effort it would take to dismantle the school – besides they did not have any facilities to store all the furnishings and equipment. The developer had no use for it and was just going to bulldoze it all. With both the school district and the developer in agreement, we were able to take whatever we wanted from the school, except for the kitchen, for the grand sum of $50!

Church member Brian Warner was a professional truck driver and had a forty-foot flatbed trailer. With a crew of volunteer help and several pickup trucks, for two consecutive weekends we took all the cabinets, desks, chairs, sinks, chalkboards, and bulletin boards we needed. To top it off we were able to take a good portion of the playground equipment and even the flagpole! God provides in amazing and unimaginable ways!

There was no question that God had provided, once again confirming our move to Yuba City. After six years, the enrollment at the school was over two hundred students! The school was in the black financially and all things were looking great. Julie and I decided to put our house in the city on the market and look for land in the country on which to build our dream country house with lots of space for our children to grow and play. That's when we discovered that once again, God had bigger plans than that for us, and He would provide us with a new direction.

Julie

Although I hadn't wanted to return to the full-time work force until after all our children were in school, finances and circumstances dictated differently. By working as the Office Manager/Bookkeeper/Nurse/Substitute/Whatever at Grace Christian Academy I helped add to our nest egg and keep us out of debt. My parents, who had also moved to Yuba City, helped out by taking care of our youngest daughter, Aimee, first during pre-school then later, after her half-day kindergarten. They formed strong lasting bonds during those precious years. Laura and Andy were growing into sweet-natured, active children. Life was going well.

Since architectural design is one of my hobbies I found pure joy in drawing up floor plans then making a wooden model of my dream house: a two story farm house with a wrap-around porch. The home would be big enough to give the kids room to play and grow and have friends over and host family holidays and visits from all our grand-children-to-be. My dad was a builder and I loved woodworking too. It would be a father-daughter project! We'd be making memories while creating a home to pass down to future generations. Doesn't that sound wonderful? Cruising through the peach and walnut orchards in quest of

acreage for sale became a frequent past-time.

Right about this time Ken lobbed the bomb: "I think this is a good time to go work in Africa!"

"What?! But! But!" I sputtered, "What about the plans for our dream house?"

Ken reminded me that we'd spoken of going to teach in Africa SOMEDAY and perhaps that someday was now. I struggled with the very idea of it for a week or more, although I did recall back in the fuzzy recesses of my mind that we had decided long ago that when the school got on its feet and was thriving that we would investigate overseas service. So, I started praying.

I also wrote my friend, Barb Baldwin, who was working with her husband and children at a school for missionary kids in the Ivory Coast, telling her the direction of our thinking. She and I had been friends since high school; Ken and Dave's friendship began in middle school. We'd been at Biola together and Dave taught with Ken at Valley Christian before we helped them pack their crates for Africa. Barb's letters challenged my faith, changing my question from "why should we go to Africa?" to "why shouldn't we go to Africa?"

We talked it over with our family. My mom gave the situation a new spin when she rather humorously said, "Julie, remember when you were in San Jose and prayed that God would move you out to the country?"

"Sure, Mom, I remember."

"Well, maybe God interpreted your prayer a bit differently and instead of hearing that you wanted to move out TO the country, He heard you wanted to move out OF the country!"

I just smiled.

Still, I struggled. Maybe we wouldn't be needed! Maybe we wouldn't be accepted by the mission agency! Maybe our kids would rebel at the change! Maybe we wouldn't be able to raise the finances! So many unknowns!

Ken and I had several friends who were in overseas service so we had some concept of what would be involved should we decide to 'answer the call.' I did know that becoming a missionary overseas was a process. Many, many obstacles had to be conquered before we could ever set foot on African soil, 8,000 miles away as the crow flies. What

a daunting prospect! I knew that if this was indeed God's will for our family that He would take care of each step. Still not knowing if it was God's will, we started filling out applications and a zillion forms, taking tests, submitting to evaluations and interviews. And we kept praying.

The director at the school for missionary children in West Africa responded. "Yes! We most certainly could use you! Please come!" With each completed step, we felt affirmed that this was the path God had for us.

Laura was now eleven, Andy nine, and Aimee six years old when we discussed going to Africa FOR REAL. After much discussion, looking at photographs of West Africa, and answering as many of their questions as we could, we separated the kids to ask them the BIG question. We didn't want their responses to influence each other so we asked them one at a time, "What do you think about going to Africa?"

Andy, Aimee & Laura ready for a new adventure in Africa.

Laura furrowed her brow and gave the question serious thought before she said, a bit timidly but gamely, "Well, I don't know. Maybe it would be all right. I'd try it." Andy loved sports, especially soccer, so if he could still play *over there*, he also said he'd give it a try. Little Aimee eagerly chirped, "I'll go get my sleeping bag now!"

Whew! We couldn't ask for more than that. It looked like God had prepared us all to give it our best shot. Another hurdle had been cleared. Thank you, Jesus.

Amazingly, men, women, children, and families began giving money to meet our expenses! Kool-Aid! Shampoo! Money! Clothes and shoes for a family of five for two years were donated! We were really going to cross the USA and the Atlantic Ocean, across the Gulf of Guinea to minister in the Ivory Coast, la Côte d'Ivoire!

In the Spring of 1987 we wrapped up work at Grace Christian

Academy in Yuba City and began packing for International Christian Academy in Bouaké, Côte d'Ivoire. My dad built our crates, making sure they were watertight. Our house had sold as well as most of our possessions. We drove to Sacramento to get our necessary inoculations: yellow fever, hepatitis, meningitis, tetanus, plus boosters for all the normal shots. Yet, there are still many third-world illnesses that don't have inoculations: malaria, dengue fever, cholera, tuberculosis, ebola, amoebic and bacterial dysentery, parasites, AIDS, plus a world of other scary sicknesses. Our guardian angels were going to be busy!

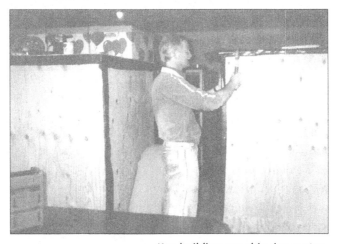

Ken building our shipping crates.

However intimidating these illnesses sounded or however strange the cross-cultural environment would surely be, those were not to be my most difficult adjustments. By far, the hardest thing to do was saying goodbye to our friends and especially our families. As I tearfully said my painful goodbyes to my sister, Bettie, I explained how we were convinced that going to Africa was God's will for us. And, since it was His will how could I not go? How could I say, "Jesus, I know you want me to leave my home and go to Africa but I love my sister and family so much that I just can't leave them"?

Then I imagined Him gently speaking, "Julie, I left my home and my Father because I love you—and the people of Africa!" So, what can I say to such a compelling Christ? Yes! To go was the only answer I could give.

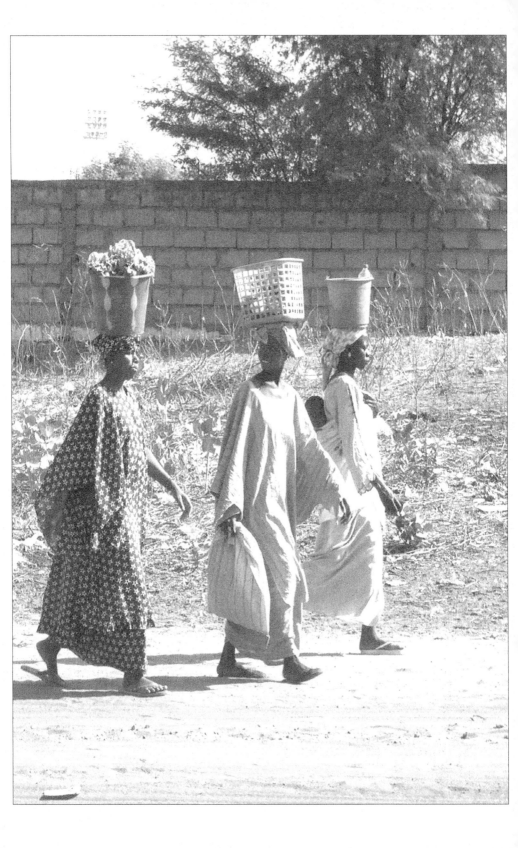

A nyone who loves his father or mother more than me
Is not worthy of me;
Anyone who loves his son or daughter more than me
Is not worthy of me;
And anyone who does not take his cross and follow me
Is not worthy of me.
Whoever finds his life will lose it,
And whoever loses his life for my sake
Will find it.
Matthew 10:37-39

"There are far, far better things ahead
than any we leave behind."
C.S. Lewis

Chapter 3

Venomous snakes, malaria, war, typhoid fever, broken bones, mysterious illnesses, rashes, death, cancer, evacuations, robberies—a strange list to compose following Lewis's quotation. And yet, and yet. Can we not say that whatever God places in our paths He will use to His good?

Had I known all the challenges we were to face in the years to follow, this blue-eyed California girl may not have made the choices I did. And yet. And yet. I have no regret for making those choices. Our African years have been full and rich and wonderful and very, very memorable. We came to love Africa and her people. God did indeed have far, far better things ahead.

Skidding to a bumpy halt, the Air Afrique plane opened its doors to a whole new world for us beginning in Abidjan, Côte d'Ivoire, the capital. Drowsy and cotton-headed from our thirty-hour trip, the five of us

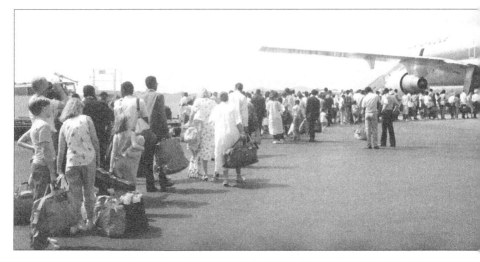

End of the line, waiting to board the plane.

along with our friends, the Baldwins, stumbled down the rolling stairway and started trekking across the tarmac toward the airport, far, far away. Enveloped by the steamy tropical rain forest air, I felt like I was in a dream. Mix together diesel fumes, decaying vegetation, extreme heat and extreme humidity and you can get an idea of the pungent atmosphere into which we'd landed. It was exotic and horrible and wonderful to our noses! We were in Africa!

The pungent scents were soon accompanied by wondrous sounds and sights. Babies crying, a cacophony of languages being spoken, birds squawking, engines roaring, taxis tooting; our senses were on overload. Our eyes drank in the beautifully patterned and loudly colored fabrics of the traditional African clothes. Men wore elegant three piece 'suits' but here the three pieces were drawstring pants, a long-sleeved and embroidered long shirt, with another voluminous elaborately embroidered piece to top it off. Here it is called a grand bou-bou. The ladies were similarly arrayed with intricately sewn and embroidered fitted tops and wrap-around-tuck-in skirts called pagnes. It seemed like every woman carried a baby on her back but surely that is an exaggeration. Wrapped securely in yet another pagne which tucked around the mama's middle, the baby's feet peeked out on either side of mama's waist. I would never tire of seeing the sweet feet of African babies.

As we crowded into an already crowded arrival area we saw to our chagrin that everyone was putting their passports through a blind

opening in the wall. There was no information booth; no one to answer our questions or explain. We hung back, not knowing if this is what we were to do as well. People began to motion to us that yes, we were to abandon our precious passports into this black hole as well. Gulping and saying a prayer, we released into the unknown the only documents which confirmed our identities and allowed us to travel.

Jet-lagged and feeling lost, we stood around (nary a chair or seat in sight), not knowing what to expect next. Twenty or thirty minutes later a tall man in a neatly pressed army khaki uniform pushed his way to the center of the crowd and began calling out something we could not hear or understand. We stood on tiptoe to see what was happening. People were moving, bumping against each other. As abruptly as the man appeared, he turned and disappeared. Time passed. He reappeared and began yelling again. As we edged forward we now realized that he was calling out people's names and returning their passports to them. Seasoned travelers, Dave and Barb Baldwin, assured us that this was normal. We'd be through soon, right?

We'd gotten our passports in San Francisco and diligently made sure we'd dotted all our I's and crossed all our T's with our documents, so we were taken aback when the somber-faced official told us we'd have to follow him because there was a problem. Great! My heart

thumping, I tried to follow what he was saying in French.

"Pardon, monsieur, mais je ne te comprends pas," I tried to explain in my high school French. I breathed a prayer of thanks for my old teacher, Mr. Keplinger, when the chief honcho seemed to decipher that although I was pretty rudimentary in my language skills and having trouble understanding his rapid explanations, I was trying hard.

Listening with furrowed brow I finally understood that the last passport's number was not in sequence with the other four passports. Somehow the consulate in San Francisco had switched the last two numbers. What could we do? The kids were exhausted and excited and overwhelmed all at the same time. Were we not going to be allowed to enter the country because of this small error?

Waiting so patiently.

"God, how could you take us so far and not let us continue? We're trying to do the right thing!"

Fumbling in French, I tried to explain about transposing numbers. Surely this must have happened before to other travelers! Whether because of or in spite of my bumbling explanation the man stamped all our passports and granted us entrance into the country. Thank you, God! My heart slowed back down to normal.

At long last, with our ten suitcases which all arrived-- wonder of wonders-- and five awkward carry-on bags (into which were stuffed cherished but awkward things like a violin and roller skates), we arrived at our first night's destination, the CPE (Centre de Publication Evangelique) compound. This enclosed *village* housed the in-country Christian printing/publishing house as well as an International Church and numerous residential units, including guest housing where we were to stay.

Fifteen foot high elephant grass lined the roads.

Climbing up the grey concrete stairs with paint peeling off the walls, all we could think about was how wonderful it would be to finally sink into real beds and slide into oblivion.

However, God in His love and sense of humor had a variation on our plan. Our family of five was given one small room, with twin beds and just enough space to walk around them. Scouting around we found a couple of old deck chairs, the aluminum and nylon webbing kind, which we angled so as to prop our feet on a bed. I think Aimee wound up on the cement floor on a quilt, after we sprayed the floor for a trail of ants. It was hot, humid, and buggy. But our spirits were still high. A good thing we didn't know about the ubiquitous four-inch cockroaches that mercifully didn't make their presence known that night. But dozens of mosquitoes zeroed in on us, sensing fresh blood. At 2 a.m. I was making oatmeal in the communal kitchen downstairs for those awake with jet-lag and disoriented stomachs. Needless to say, no one slept much that night.

Morning broke bright and beautiful, heedless of our sleepy heads. Fortified with delicious éclairs, croissants, and hot-fresh French baguettes from the boulangerie around the corner, we were once again bright-eyed and excited to explore the amazing locale in which we found ourselves. Soon the ten Vaughans and Baldwins were packed back into vehicles for the five-hour drive upcountry to our final destination, Bouaké, smack dab in the middle of this glorious country

in the beautiful central Bandama Valley.

The relatively smooth modern highway soon changed into a curvy, pot-holed two-lane road as we left Abidjan and headed north. Dark rain clouds doused us with huge drops of water which quickly became a raging torrent. Moments later the sun would break out and it would be brilliantly clear.

Patches of elephant grass growing to fifteen feet high blocked our view from time to time, but in between we caught glimpses of green fields of potato-like inyams and bananas and rubber plantations. Muscular men glistening with sweat and rain used their dabas, a short hoe-like tool, to work their patches; women with babies on their backs worked alongside the men and boys. Many young sisters had babies on their backs, too, or entertained them in the shade of mango trees. As we drove through sleepy villages of mud-baked or cement brick with tin roofs or thatch, children broke out in enormous smiles as they danced up and down, waving wildly in greeting. Wizened old men dozed in homemade wooden chairs. Chickens and goats wandered free. Wow! We were in Africa!

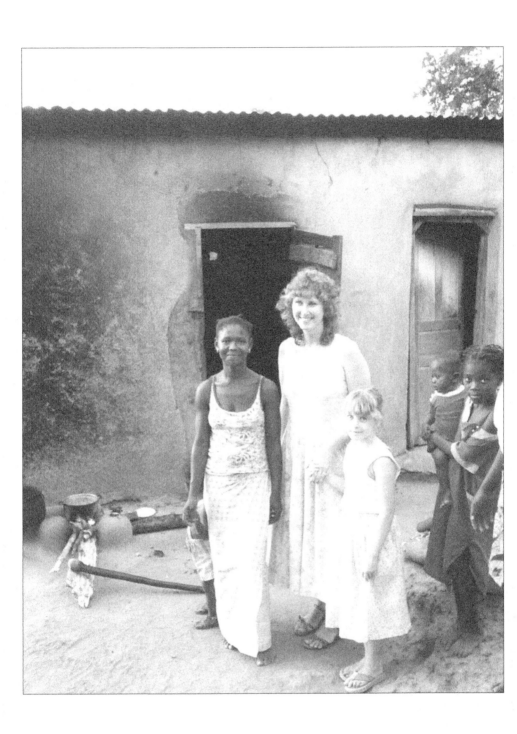

*T*rust in the Lord with all your heart
In all your ways acknowledge Him
And He will direct your paths."
Proverbs 3:5-6

Chapter 4

How often have I gone back to these verses since I claimed them as my favorites when I was twelve years old! Like a tune you can't get out of your head, these wise words have given me peace especially when I had no idea how to make a decision or if I was making the correct or best one. I am a firm believer, as a Jesus follower, that part of the Holy Spirit's job description is to guide us into truth. I also firmly believe that God is truly and utterly sovereign—He is in control of not only the world but every part of my life. He is worthy of my trust. So, if I do indeed put my trust in Him and give Him full control I can rest assured that He will direct my decisions, and my very path.

Ken and I sought God's direction when, a few months into our time in Africa, we came to a crossroad. Did God want us to serve in Africa at ICA (International Christian Academy) only for the two years we'd signed up for and then return to the United States, or did He want us to continue on as career missionaries? This was a huge decision we did not consider lightly.

Those first few months had been challenging. Laura had been sick with pneumonia; Aimee with the first of fourteen bouts of malaria. Andy had broken his wrist; Ken had injured his knee. It was a particularly bad year for snakes with an average of eight poisonous snakes per week killed on campus, mostly cobras, vipers, and adders. We missed our family and friends stateside. We missed Burger King. We missed our dishwasher. We missed air conditioning. Letters took at least six weeks each way; the internet and email were still in the distant future. Phone calls were nearly $10 a minute. A new teacher had come down

with malaria and died six days later. Not only was this sad but it was frightening as well. Living in Africa was tough. Why on earth would we want to stay?

This crossroad sent us exactly where we should go: To the cross. Claiming the power of the cross we cried to God in search of His will for our family.

Ken and I had been praying and talking about the possibility for weeks. We came to strongly believe that staying long term was what God wanted for us. However, like the decision to come out short-term, there were many things that had to occur before we could take any action. One of the first things we did was approach the school administration and our mission field leader to see if they were even interested in our joining their team permanently. The responses were encouraging as they whole-heartedly extended their invitations to us, saying they'd been praying that we would want to join them in long-term ministry.

As previously, we discussed the possibilities with each of our children separately, again not wanting them to influence each other's decision. Each child replied something to the effect of, "Of course I want to live in Africa until I graduate from high school! I am happy here!" We took those replies as yet another affirmation of our desire to stay long term.

The process stretched another year and a half before we were formally accepted and appointed by the Conservative Baptist Foreign Mission Society* but in our hearts we were already committed to the long haul. Soon after we began the process of applying for career service, our family saw first- hand what the cost for such service could be.

Doris Betty was a dignified, elegant-looking lady who arrived at ICA to take up the position of middle school teacher. Laura was one of her students. I enjoyed spending time with her as she described her life in the USA, recounting stories of her students. She loved being a part of ICA and was confident that God wanted her teaching in the Ivory Coast. Doris told me she'd never been sick a day in her life, but one Tuesday after school she came back to her apartment feeling unwell.

* The Conservative Baptist Foreign Missions Society has since been renamed World Venture.

Overnight she began running a high fever. One of the school nurses diagnosed her with malaria and started her on a treatment that Wednesday morning. Thursday she seemed a bit better, but by Friday she took a turn for the worse. A local French doctor made a house call to examine her. She was too ill to be moved. Our nurses took turns staying in her home to care for her. Saturday she seemed unchanged, but in the early hours of Sunday morning she died and entered the presence of her Lord.

Doris had never married. When she first arrived in Africa, she had written her siblings that if she were to die overseas she wanted to be buried there. We found a copy of the letter on her desk so the school administrators decided to do just that, after contacting Doris' family.

We had a tearful funeral service at the school, attended by all the students, staff, and African workers. In that short time, Miss Betty had already made quite an impact on those around her. Unknown to us, in the next few years our students would lose several of their mothers, fathers, and siblings to childbirth complications, malaria, heart attacks, cancer, and a cerebral hemorrhage. A few years earlier, a student had drowned on a beach outing and another student had been electrocuted in a work accident. So much death! We Americans are not accustomed to seeing so much death among younger people. What a comfort we have to know we believe in a God of Resurrection!

Doris Betty's burial plot was in the cemetery in our town of Bouaké, unremarkable among all the graves of the local people. After the graveside service, I was pulled aside by the director, Russ Ragsdale. He quietly told me that the local custom was to cover the cement brick-lined grave with a slab of formed cement. This dry slab was then coated with a fresh layer of cement, sealing the cracks on all sides. The deceased person's name and dates of birth and death were scratched into the wet cement using a stick. Russ requested that I do the engraving in the damp cement in calligraphy.

As a freshman at Biola I had my heart set on taking Calligraphy, a very selective course for upper classmen. The class was already full by the time freshmen registered. The very demanding course required three hours of homework each class day, plus a final project taking up to eighty hours of work. Daunted but still hopeful, I started praying, telling God that my utmost desire was to use the skills I would learn to

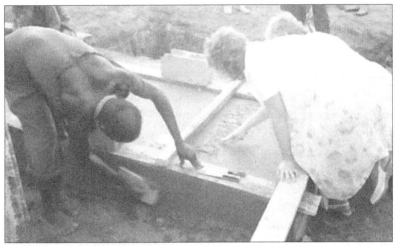

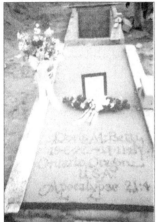

Julie kneeling, carving a dedication into the fresh cement on Doris' grave.

"Whatever you've done
and whatever skills
you have developed,
however rudimentary
or obscure,
will eventually be used
on the mission field."

His honor and glory.

Despite my prayers, I was surprised when I received approval to take the class. I found the class all I'd hoped, even as I enjoyed putting in all the long hours to reach a level of mastery. Through the years I had indeed been able to use this skill in service to my Lord, including teaching the skills to others. But, this grave side request was a first, a challenge.

I knelt down, in my cotton Sunday dress, upon an old plank which straddled across the wet cement of the grave top. Someone volunteered his trunk's tool box where I found an assortment of screwdrivers and a putty knife. Russ gave me a paper upon which had been written, in French, what I was to carve. In addition to the basic, necessary information was a quotation from the book of Revelation in French, as

Julie teaching a Money Management class.

Laura and her friend, Rene, in new glasses

testimony to Doris' faith. I saw no other evidence of Christianity in that cemetery; no crosses, no verses, no hope. These words I carved would be unique and surely eagerly read by many, as they came grieving to this place of death. These words would plant seeds in people's hearts.

I began with a sense of fear, responsibility, and a little insecurity, even as I counted this an honor. God was using me to do this act of service! Doris would have been pleased to see her grave bear a testimony of Jesus Christ here in Africa. I know it pleased Jesus too.

God had indeed prepared us in ways we never could have imagined to serve in West Africa. We quickly appreciated the local missionaries' saying "Whatever you've done and whatever skills you have developed, however rudimentary or obscure, will eventually be used on the mission field." This proved true for us.

After Doris' death the classes she taught were added to the already busy schedules of other teachers, including Ken. Everyone was glad to help out in these difficult circumstances, even though it meant an extra heavy work load.

The principal, Dave Baldwin, came to me and asked, "Would you be willing to add a class called *Money Management*, primarily for twelfth

Our First home in Côte d'Ivoive

graders, to your schedule? Doris was to have begun teaching it in
January and there is no one else to pick it up. I'm sure you can do it!"

"Oh, and by the way, there are no text books; you'll need to write
your own curriculum for it," he added as he scooted out the door.

After I agreed to develop the course I wondered aloud what on
earth I had gotten myself into! This is crazy! I don't have the time! I
don't have the experience! I don't have the materials! I've never taught
twelfth graders! How am I going to do this, God?! Help!

Somehow I muddled my way through and wound up loving it all:
writing the curriculum, teaching the course, and especially the students.
They were bright and funny and inquisitive and open and easy to like. I
fell in love with all of them, just as I had the other students in our lives.

While teaching the Money Management course I found myself
having to 'walk the talk' on more than one occasion. I had been
suggesting to my students that always, when we have a need, we should
first take it to God before we share it with others. We should wait to
see what God may do, rather than jumping ahead of Him to seek help
from others. This sounds good in theory. When we found that Laura
now needed eyeglasses we put it to the test.

We had not arrived in Africa with an excess of support. Our
family had what it needed to survive but no more. Laura's glasses were
going to cost $300 as the local optician, Docteur Amadou Bamba, had
to order them from France. What were we going to do?

We began by praying as a family, then waited on God. Waiting is the hard part, especially when no one else knows. Did George Mueller feel like this? There have certainly been times when we felt God wanted us to share our needs with others, but this was not one of them.

Within two weeks we received a card from the mother of one of Ken's students when we lived in Yuba City. When her father had died, Ken had run the sound system for his service. She wrote that she'd just received her inheritance and prayed about what to do with the money.

She wrote, "It was as if God was verbally telling me to send the Vaughans $300 of the total amount. I do not know why He impressed me with the rather odd amount of $300 but perhaps you do."

God had supplied our need!

The second instance of 'walking the talk' came when the school nurse noticed Andy walking a bit oddly and sent him to a French pediatrician on temporary assignment in Bouaké. The doctor examined him, ran some tests, then told us she feared he had a muscle-wasting disease in his left leg. Fearful and full of questions, we asked her what we could do. She did not feel it was urgent enough for an immediate

medical evacuation but sent us to a French physical therapist who, in turn, told us Andy must have special shoes fitted with custom orthotics. However, such shoes and orthotics were not available in Africa. They would cost upwards of $185 and would have to be made in the USA. Again, we went to God.

Again, God answered in an amazing way! My sister Sue, who is a registered nurse, expedited the complicated process of getting custom orthotics made from half a world away. She also purchased and mailed the specialty shoes. Several people pitched in to cover all the costs! Thank you, God! Between the shoes, orthotics, and physical therapy, Andy's leg began to improve. Before long, his left leg was as strong as his right! When we saw the doctor in three months, she was happily surprised to see the dramatic change and revised her diagnosis. Andy continued

following her directions and has not had further problems with his leg. We can trust God!

Finally, the last major screaming-out-to-God opportunity that term had nothing to do with money but everything to do with health and survival.

Easter break of 1988 saw our family, along with a number of other staff families, at Camp Higher Ground. Situated in the beautiful western rain forest, in the mountains near the borders of Liberia and Guinea, it was a wonderful place to enjoy God's creation. The accommodations were rustic but adequate. Our family had come to absolutely love the sound of the rain on the tin roofs and here we heard it nearly every night.

Each cabin was outfitted with a very simple water filter system consisting of two plastic buckets; the one which contained three ceramic *candles* was kept on top of the refrigerator. This top bucket, which we filled with tap water, had a hole near the bottom into which was fixed a length of medical tubing. This tubing entered a hole cut into the top of the second plastic bucket which set on the counter. Drip. Drip. Drip. Gravity brought the filtered water down. With the top bucket filled at night, by morning we'd have a full gallon or so. Or, that's how it was supposed to work.

When we arrived our filter's tubing was so filthy no water was coming through. In a hot, humid climate it is crucial to drink a lot. There were no shops where we could buy drinking water or new tubing, so Ken sat down to clean out the blocked tubing. He'd done this many times before but this was the worst clog he'd ever worked on. Using a straightened wire clothes hanger and bits of cotton, he worked on that crazy tubing for hours, pausing from time to time to wipe the sweat from his face.

It was a wonderful vacation until the last day when everyone started to get sick, leaving us questioning the cause. A Virus? Worms? Parasites? The school nurse later determined that the campground's well was contaminated! So many people were so sick that re-opening the school had to be postponed a few days. No fun! Eventually we all got better and returned to normal life. All except Ken.

After showing some initial improvement Ken started showing some different, odd symptoms. Along with a low-grade fever, he

developed painful blisters all over the inside of his mouth, had no appetite and only wanted to sleep. He was treated with antibiotics, then anti-malarial medication, to no avail. As his symptoms moved to his stomach and intestines, he got medications for worms, parasites, and dysentery. Still, he didn't get better. He would stagger the fifty steps to his classroom, teach, then stagger back to the house where he flopped on our bamboo couch and slept until his next class. He lost weight and was fading away before our eyes. I remembered Doris Betty and cried out to God all the harder.

After nearly a month of treating Ken, the nurse marched into his classroom and told him to pack a bag. She was sending him up to l'Hopitale Baptiste at Ferkessedougou, five hours north. His case baffled her and she was at the end of her resources. The only lab test we could get locally showed he had an infection but gave no clues what else should be done that hadn't already been tried. The doctors and technicians at the Ferké Hospital were able to further define what type of medication he needed, along with bed rest. Within a week he began the slow but sure path back to full health. Thank you, Jesus!!!

In August, physical exams were done for all staff and students, along with recording height and weight. After finally climbing back to health and regaining weight Ken was now up to 126 pounds! He had lost over 30 pounds with his ordeal but God was gracious in restoring him to us. He still had work for Ken to do. My dear husband could not wait to get back to the classroom and the ministry God had given him.

I was to vividly remember this incident nearly ten years later. Besides being committed to advancing the Gospel in West Africa, Ken and I had both fallen in love with our students and colleagues at International Christian Academy (ICA). The atmosphere was like a big family, all 300 of us. We studied together, we prayed for each other, we worked on projects together, we sobbed on each other's shoulders, we worshiped together, we killed snakes together, we baked cookies together, we played together; we both celebrated and mourned as a family.

Ken, up to 126 pounds, in his classroom

Like all families we had moments of misunderstanding or discord and not all was rosy all the time as we were still very human! But we did grow to love each other.

Our deep relationships were largely due to the proximity and shared living experiences at this residential school for the children of missionaries (MKs). As part of sharing their lives, we got to know many of the parents of our students when they came to visit. From nearly twenty different evangelical mission agencies, serving in one of seventeen West African countries, they were engaged in a variety of ministries throughout sub-Saharan Africa. We even had kids from Timbuktou, Mali! Most parents were serving in remote or dangerous locations, some in restricted access countries or countries in political turmoil. Numerous families lived with no running water or electricity. They really had no easy access to educational alternatives for their children. The Internet was a not even a dream yet.

Many missionary families home schooled during the elementary years but by the teen years their children yearned to do the things we take for granted: talk with other teens, act in a play, sing in a choir, play on sports teams, and dress more Western (and I don't mean cowboy boots!). All of this was important to just re-connect with Western culture before they had to re-enter it after they graduated. Would it be

possible for a missionary kid to home school for grades K-12 in the African bush, then successfully enter a fast-paced, high-tech college in America? While it's not impossible, for most teens I see it as a recipe for 'crash and burn'. The re-entry chasm is just too deep and wide. Schools like ICA serve as a transition, greatly helping these special children feel more comfortable in their *home* cultures. By third world African standards our school was pretty cool; by first-world standards we lacked many of the bells and whistles, although we provided an outstanding academic and extracurricular program. Thus, we were a bridge between the two worlds.

The late Dave Pollock, founder of InterAction, refined the definition of the term Third Culture Kid, which Ruth Hill Useem originally coined. "A Third Culture Kid can be defined as any person who has spent a significant part of their developmental years outside the parents' culture. The TCK frequently builds relationships to all of the cultures, while not having full ownership in any. Although elements from each culture may be assimilated into the TCK's life experience, the sense of belonging is in relationship to others of similar background." *

* *Letters Never Sent*, by Ruth Van Reken, Foreward by John C. Pollock, Published by Summertime Publishing, Great Britain, 2012, Reprinted with permission from Ruth Van Reken.

These kids may dearly love their host culture, learn the language and customs, and form lasting friendships within that culture. However, they can never truly BECOME a member of that culture. On the other hand, because the TCK has had so many different experiences and made so many memories in the host culture, he or she is forever changed and is no longer fully a member of their own passport culture. These children grow up as hybrids, or a blend of both their host and *home* cultures to form a third unique culture, thus the term Third Culture Kids.

Missionary kids fit well in this category as do many MBs or Military Brats, and children of Foreign Service or embassy workers. When ICA had room it accepted international non-mission students, many who were in the country with their parents who were involved in agricultural projects or other NGO (Non-Governmental Organization) projects. Virtually all students who attended the International Christian Academy were TCKs.

TCK students from around the world wrote the humorous but true description of themselves on the following page.

I think it reveals the practical aspect of growing up 'among two worlds.' Those who have not grown up with this system ask how a parent could send their child to a school like ICA. Where are virtually ALL parents most vulnerable? Their kids! If the Enemy wants to attack the parents or the parents' ministry, often it is through their children. If a good schooling situation is not found; if a child needs more help than the parents can give; if a child struggles developmentally or has learning challenges, all of these situations can be addressed at a school like ours. If a child is floundering or is simply not thriving or reaching his or her potential, the parents have no place to turn. Returning to their home country is often the only option. That is, if they don't have a school like ICA.

Other considerations or causes for consternation are when the parents are posted in less-secure areas, whether politically precarious or religiously hazardous. Having their children attend a school where they do not have to face the dangers or restrictions which the parents encounter frequently, can provide both parents and children peace of mind. In certain areas of West and North Africa, girls beyond the age of nine find themselves shut off from the general population, with

You Know You're a TCK When . . .

- "Where are you from?" has more than one reasonable answer.
- You speak two languages, but can't spell in either.
- You feel odd being in the ethnic majority.
- You have a passport but no driver's license.
- You get confused because US money isn't color-coded.
- You think VISA is a document that's stamped in your passport, not a plastic card you carry in your wallet.
- You believe vehemently that football is played with a round, spotted ball.
- You consider a city 500 miles away 'very close.'
- You get homesick reading National Geographic.
- You haggle with the checkout clerk for a lower price.
- You've gotten out of school because of monsoons, bomb threats, and/or popular demonstrations.
- You speak with authority on the subject of airline travel.
- You know how to pack.
- You have the urge to move to a new country every couple of years.
- You have friends from 29 different countries.
- You have a time zone map next to your telephone.
- You realize what a small world it is, after all."

(From the book *You Know You're a TCK When….*, also on the website tckid.com)

ICA Middle School class-

their activities and dress restricted according to Muslim tradition. There are regions where rebels and Al-Qaeda in the Islamic Maghreb (AQIM) have joined ranks and are threatening to spread across North and West Africa. Boko Haram and Al-Shabab are two more groups who have targeted Christians. Both military and rebel coups d'états are not uncommon with ensuing instability. Parents want their children in a safer place.

ICA also taught valuable life skills, ones which are not as valued in native villages but are necessary in Western cultures, whether for university survival or on-the-job success. Skills like using a clock to tell time and to be punctual for class and other events rather than showing up whenever you can make it; wearing shoes or sandals rather than bare feet; and using a knife, fork, and spoon, rather than hands or a large spoon. In the village kids learn the importance of relationships. People are the most important thing in the world, not projects or programs. It can drive Westerners crazy when they're trying to get a work project done, using the American work philosophy. But children enriched by being raised in such a relational environment learn much from their host culture. Our goal is for our students to combine the best of all these important skills, knowing when and how to prioritize their time

and energy. In fact, it's the goal for us adults, too!

These relational skills were often put to the test as students from around the globe learned to live together. Although most of our missionary students originated in the USA, students also came from such diverse locations as the Netherlands, New Zealand, France, South Korea, China, Israel, Germany, Great Britain, Canada, Australia, and various African countries. Their parents were ministering in one of the seventeen West African countries or in restricted access North African countries, some traveling many days by plane, bus, and boat.

The face of evangelical missions, or, global outreach, has changed over time. While every believer is called to share their faith—the Good News of the Gospel--the methods for doing so have expanded. They now include well-digging to present Jesus as the Living Water while providing clean water to needy people, and agricultural projects where the truth is taught that "man does not live by bread alone" as villagers learned to better feed their families. Parents work with street children

Dave Johnson teaching a science class to upper level students.

and orphans. They translate the Bible so people can read the Good News in their heart language. They provide literacy training so the people can read once they did have the Bible. They help with AIDS

prevention programs as well as offer comfort to those already suffering with the still-deadly-in-Africa disease. Medical missionaries trained in Tropical Medicine work tirelessly meeting people's overwhelming physical needs so they can share the Great Physician with them.

Preaching the Gospel, making disciples, and planting churches will continue to be the core focus for advancing the kingdom of God as well as developing strong, solidly trained Christian leaders. Working at the International Christian Academy enabled us to have a part in all these ministries, as we ministered to the children. We felt honored to serve in such a role! What an amazing circle of partnership as our supporters and partners in the States in turn made it possible for us to be part of this team!

TCK! Hangin' around!

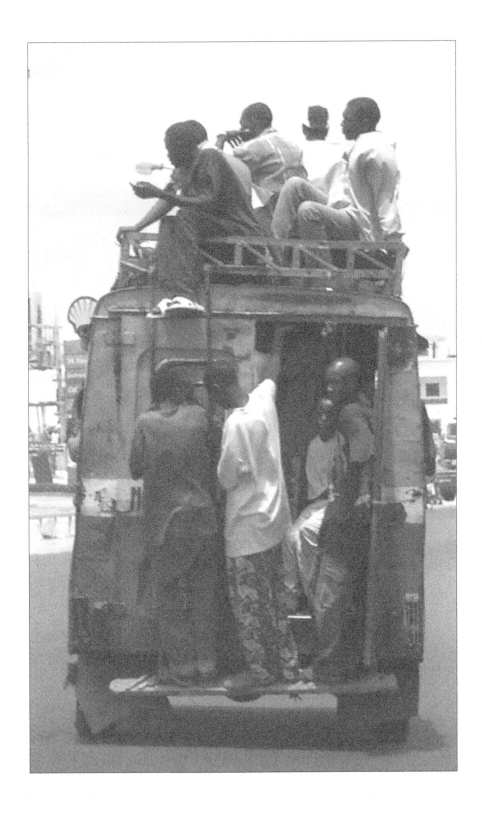

L ife is like a roller coaster;
 It has its ups and downs.
It's up to you to choose
 To scream
Or to enjoy the ride."
--author unknown

Chapter 5

Our first home assignment was a fruitful one. New churches and
individuals joined our ministry in partnership. They vowed to support
us in the most important way: faithful prayers. Financial assistance was
promised. Our next term was to last four years, and we needed to set
up our own household instead of borrowing like we did the previous
term. Through the generosity of others we purchased mattresses,
linens, basic kitchenware, and items not available in Africa. My dad built
sturdy water-proof crates and kind men trucked them to the Oakland
port where they'd be packed into a container and shipped to Abidjan.

Just weeks before we flew out of San Francisco, my brother
Dave Alloway married Anne Scott in Long Beach, California. It was a
glorious and fun wedding, with Dave sporting a kilt and full Scottish
regalia. The strains of a bagpiper accompanied them down the aisle of
the stained glass church. It was a celebration to remember and a happy
farewell for us.

Tears were to come, though, as we said our goodbyes to loved
ones. Leaving for two years was difficult enough; leaving for four
was heart-wrenching. We were taking our parents' grandchildren out
of their lives once again; when they returned they would no long be
children, they would be teenagers. Yet, our folks were encouraging us
to continue with the work God had called us to, despite their personal
sacrifices. Years later, I can better understand how very difficult this was

My sisters and I united to marry off wee Davey,
our kilt-clad brother.

for them. Not all parents are so supportive so I appreciate how much
we have been blessed.

The summer of 1991 we began our four-year term in the capital
city of Abidjan, after installing Laura, Andy, and Aimee at ICA, a four
and a half drive upcountry. Part of the agreement when we signed up
as career missionaries was to do a stint in language and culture study.
I'd taken French classes when I was in high school; Ken had studied
German and Spanish. We needed to learn our host language well, for
more effective survival but also to demonstrate to our Ivorian neigh-
bors that we were committed to them long-term and respected them
and their language.

During our pre-field training Ken and I had been introduced to
the Barefoot Language Learning method, and we thought it would
work well for our situation. Instead of studying in France, we requested
and received approval to do our studies in Abidjan, while our kids
continued their studies at ICA where they already had friends and felt
at home.

With the help of Navigator missionaries Mike and Karen Kotecki,
we hired two language helpers. Issoufou Ouattara was from a Muslim

background, a younger son of his father's number two wife. He was bi-lingual, having learned English from classes at school as well as by listening to BBC radio. Bernard Mambo was from a coastal village with a Catholic background but had a similar English-learning story. These two were already great friends and worked well together as they helped us. Mike had been having English lessons with them, using the Bible as a text. Early on, the two young men revealed to us that they had each become Christians and were eager to learn more about Jesus and the Christian life.

Thus began a long friendship with these two young believers. They grew in their faith and we grew in our French skills. Beginning with listening and verbal skills, we did not study written French until we had mastered French conversation. So, each morning we met and explained in English to Bernard and Ouattara what we wanted to learn that day. They taught us the French phrases, worked on our pronunciation, listened and corrected us as we practiced; then we plunged into the community to continue practicing with a variety of strangers. All in French! All alone! At the beginning our conversations were rather one-sided. It was both humorous and nerve-wracking as we stepped out of our comfort zone. Way, way out!

Practicing French with my language helpers at the zoo.

Julie with two beggars in the Bouaké Market.

"Good day!" we smiled, knowing greetings were very important in Africa.

"I am learning French: could you please listen to me and correct me?"

"Yes? Thank you."

"My name is Madame Julie Vaughan; I am married and I have three children."

"That's all I know for today."

"Have a good day."

"Thank you for listening!"

"Good bye!"

People were always so gracious and we always left them smiling—because they found us humorous or just because they were friendly we never knew.

The hardest part of language-learning is accepting the fact that you are going to sound like a babbling baby and feel like a blithering idiot when you start out. People will laugh at you and you will make many blunders. You will compliment ladies on their horses instead of their hair-dos. The temptation is to keep your mouth shut and not practice. Like a baby learning to walk, we stumbled and fell many times but eventually felt comfortable in our new language and culture. We

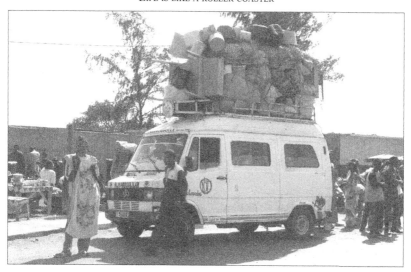

Gbaka piled high.

learned to laugh at ourselves.

Toward the end of our time in Abidjan, Bernard and Ouattara took us on campus to visit with the university students. It was a fabulous time, linguistically, culturally, and socially! We were building friendships as we heard their life stories, African folk tales, and their personal struggles. We were also active in the local Mission Baptiste church in Adjamé, finding it an amazing spiritual and relational experience. It was so marvelous to worship with our Ivorian brothers and sisters as they sang, accompanied by the big drums and tympanic balafon; attending baptismal services in the water-lily-filled lagoon; and working on manual labor projects together. Ken and I were so glad we'd chosen to learn language among the people we'd be living with. We happily came away with African French accents rather than Parisian accents. We had learned far, far more than just language!

Our kids, meanwhile, were learning more about communal living. Of course there were the normal ups and downs, but they all had loving dorm parents and good roommates. Each home-like dorm housed around twenty or so students, with an attached dorm parent's apartment. The eight dorms housed the on-campus population of about 225 students. Our three enjoyed their independence as well as the unique culture found only in dorm life. We visited as often as we could, usually taking the rickety public bus, stuffed with moms and their

61

View across campus from our home in Marigot Manor.

babies, men with chickens under their seats, the sheep, goats, and baggage tied to the bus roof. More rich experiences!

Despite bouts with malaria, we passed our written and oral examinations in French. Rejoicing in our accomplishment, we moved up to Bouaké. Our possessions had arrived in the shipping container, so we hired a truck and driver to move us up to our brand new home. While we were states-side, the school had built five new cement brick and tin-roofed houses down below the soccer field, not far from the creek, or, marigot (mahr-ee-go), as we called it in French. For fun, I called our little neighborhood 'Marigot Manor' and the name stuck. The Baldwins were moving in next door so we were in *hog heaven*. Three bedrooms and one bathroom set back from the dirt road, with the missionary-requisite screened porch, it was perfect for our family of five.

Our lovely new house was surrounded by bare ground, so I promptly made friends with all the roadside plant vendors in Bouaké. They advised me as we chatted away in French. We planted fragrant pink-flowering cassia de java trees in the front, with a border of purple-flowering thunbergia from Guinea. We bought baby citrus trees from up north in Korhogo, within the year enjoying our own oranges, lemons and pink grapefruit. Our banana trees grew quickly and regularly produced large regimes of tasty fruit. Papaya plants would mysteriously appear as volunteers. I loved designing the outside of

Education outdoors!

our house as much as the inside. We were the last house on the school property so we had a lot of open space around us; we were surrounded by fields and pastures. It was well worth the ten minute walk up to the classrooms. What a blessing this house was! No bat dung dropping down from the ceiling, not even cracks in the grey cement floor yet! We were to enjoy many sleepovers, work projects, Sunday school classes, mentoring sessions, scores of cookies baked with both our own kids as well as with students, and just plain living. Lots of good memories.

Along with enjoying a new home, Ken was thrilled to start a new Outdoor Education program which he had long envisioned for ICA. He had first participated in an Outdoor Education program while he was teaching in Los Gatos. By the time we moved to Yuba City he had developed his own teaching modules from a Christian world view and began running a program for all the Christian schools in the Northern Sacramento Valley.

Swimming in the river - no Hippos!

63

The class of '94

Now Ken had the rain forest of West Africa as an environment! He wrote ten new teaching modules for the eighth graders who would be participating in this wonderful new program. Twelfth grade students would be selected to be the camp counselors for this unforgettable week. My team and I worked for six weeks to prepare fifteen meals for thirty-five people. Even though it was an educational week, Ken made it fun, interesting, and memorable. To this day, former students recall to us the highlights of their week at Camp Higher Ground. The program gave the eighth graders, who are often caught in the gap between elementary and high school, a sense of identity and set them on a positive course before they entered high school.

Ken and I also accepted the job as Junior Class sponsors for the class of 1994. A diverse group, we were to experience much laughter and tears in the next two years. As for tears, one of the causes was a bloody and brutal civil war which had exploded in our neighboring country, Liberia. Because a number of our students called Liberia home, many a night found us praying and crying together as we awaited word via ham radio what was happening to their parents. By 1992 a number of families had evacuated to Cote d'Ivoire, most having lost everything in the war. It was very difficult for these students who had lost their homes, never to return. They simply felt lost and needed lots of love and healing. Ken and I, along with many other staff members, tried to supply some of that love through mentoring and sponsoring activities.

Each year the Junior Class put on a Junior-Senior Banquet, working literally from scratch. Besides wanting a high quality event, we knew that our working together would be healing for those who were hurting and a time of bonding for the entire group. The students chose the theme of the Roaring 20's, so we designed outfits for the sophomores who were to be the waiters and waitresses, found the fabric in the open air market, then sewed them. The girls became flappers and the boys newsies, complete with caps and knickers. Each evening after dinner students arrived to work on decorations or to prepare food. There were no stores like Safeway, Walmart, Michaels, Costco or anything resembling a party store. Even basic materials were hard to find in the African marché. We had no choice but to be creative! Student leaders threw themselves into the work, inspiring their classmates, as they also planned a delightful program.

Finally, the long weeks of preparation were over and the Juniors and Seniors dressed up in their special outfits, many made locally while others were bought when on furlough. They looked dazzling. During the evening, a group of Junior boys led their puzzled dates to the front of the room. They then stooped down on one knee and began singing to them in acapella "Let Me Call You Sweetheart". The crowd loved it, as did our Laura, who was one of the ladies being serenaded. It was indeed a sweet evening, one of many good memories with this group.

All too soon it was time for Laura to graduate. How could our beautiful daughter have grown up so quickly? With graduation came all the emotional farewells, including good-bye to her best friend Renee, who was from Australia. Not knowing if they'd ever see each other again, there were many tears. To make TCK's cross-cultural transition easier, Dave Pollock suggests taking a detour in their return to their passport country so the

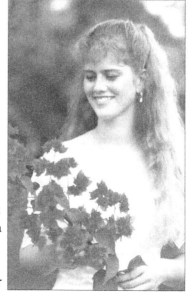

Laura in her senior year

graduates have some time to adjust to Western culture. They re-discover sidewalks! People speaking English! No goats in the road! This detour also gives the graduates something positive to anticipate. As a graduation gift we told Laura to pick a country on our route and she chose Scotland, land of her ancestors.

Our little rental car took us from Edinburgh castle to the Isle of Skye. The charming owners of out- of-the-way bed and breakfast inns welcomed us with open arms and steaming cups of tea and shortbread. Laura and I trundled alongside the lochs, ogled the majestic castles and soaked up the scenic countryside. It was a week to remember. Laura now felt more ready to re-enter American culture.

Sight unseen, Laura had chosen the Master's College in Santa Clarita, California. She didn't know a soul. The nearest relative was my brother, David, and his wife, Anne, an hour and a half away in Whittier, who helped bridge the gap that first year. ICA didn't have the Internet or email yet, so the monthly telephone calls were truly cherished. We learned how hard it can be to send a child away to college! Our family would not be re-united for two years. I think I cried non-stop from LAX to Colorado.

My prayer was that God would send individuals into Laura's life to meet those needs which I could no longer supply, and that her first dependence would be on God Himself. Our family had built a history trusting God so this separation was to be yet another opportunity to see how He was going to take care of our daughter as His own daughter.

I landed back in Côte d'Ivoire knowing God would fulfill His promises and be Laura's loving Father.

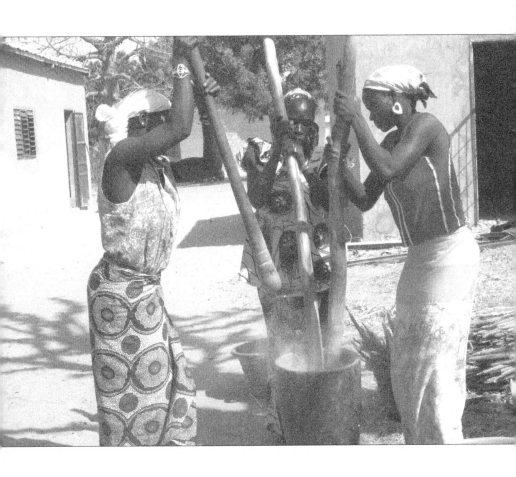

*B*ut God doesn't call us to be comfortable.
He calls us to trust Him so completely
that we are unafraid to put ourselves
in situations where we will be in trouble
if He doesn't come through."

Francis Chan
Crazy Love: Overwhelmed by a Relentless God

Chapter 6

Bang! Bang! Bang! I was awakened in the middle of the night by loud pounding. It must be the neighbor's horse kicking her stall, again. Good grief! I hadn't been back in Bouaké long enough to get over my jet lag yet. Rolling over to resume my slumber, a frantic shout joined the banging.

"Help! Ken! Mike!"

Our friend and neighbor, Barb Baldwin, was in trouble!

I shook Ken awake and helped him find his clothes. He threw them on as he dashed out the door. I tied the belt of my bathrobe as I waited in my flip flops on the edge of our patio, trying to see what was going on next door. The banging and shouting had stopped; I only heard Ken, Mike, and Barb's agitated voices. Had a robber tried to break in? Was that the banging we'd heard?

As I stood shivering in the seventy-five degree December cold, I heard faint music coming from the side of our house. That was nothing unusual. Often the herders would listen to a radio during the long nights as they kept watch over their cattle. But then I noticed that there was no

static, it sure sounded close!

I tiptoed around the corner of our house, peering into the night. There, sitting against our house in the flower bed was a man—no shirt, no sandals, sweating and singing and talking to himself. The night was too dark to see if he had a weapon. Either he had not seen me or he was in his own world; my heart pounding, I shot up a quick prayer as I crept back to the far side of the patio.

"Ken! He's down here!" I whispered hoarsely. "Hurry!"

Crouching down, I wrapped my arms around the neck of our big dog. Normally very vocal and very protective, our German shepherd from Timbuktou, had quietly sidled up to me. What was wrong with her? Any other time Lacey would have been viciously barking to warn off any trespassers. She was a friendly dog with the kids but she could also bring terror to anyone who shouldn't be on our property. Not tonight. Despite my encouraging her to bark and scare away this intruder she stuck to my side, silent except for an occasional whimper. What would cause this fearless and protective dog to act like this?

Ken silently appeared at my side on the patio. Andy and Aimee were watching from inside the safety of our house. My brave husband walked alone to confront the stranger. Jumping to his feet, the man turned swiftly to confront Ken with a frightening boldness. Separated by mere inches, the stranger began wildly shouting at Ken in French. Most of what he said was illogical rambling. He was becoming increasingly agitated, despite Ken's attempts at finding out why he was on campus and what he wanted. Pacing jerkily, he flailed his arms as he continued shouting. He pushed Ken in the chest. They struggled; Ken's glasses went flying as the intruder hit him on the side of his head. The blow knocked him to the ground.

"Andy, go get the machete!" I screamed, hoping just the sight of it would bring the man to his senses and subdue him. Running swiftly, Andy found the long, sharp knife in the store room and tried to hand it to his dad.

"No!" Ken shouted, as the man caught sight of it glinting in the

moonlight.

"Take it away! Now!" Ken was afraid the man would grab it and use it against him.

"No!" screamed the intruder, "Use it on me!"

He dropped to the ground, spread eagled.

"I am God! I can prove it! You can cut me and I will not die! Here," his gestures formed a large X across his torso, "Open me from here to here. I will not bleed and I will not die!" His sweat-stained face was eerily calm.

Ken and I knew we were in the presence of something dark, much bigger than us. This was one of the most frightening moments we had experienced. Was this man demon-possessed? Was that why even our dog was afraid of him? He certainly was not rational.

The stranger reached down and picked up something from the flowerbed. We started, but it was just a paperback book. I thought I recognized it. The tattered book was from Barb's porch and he had grabbed it when he was trying to break into their home.

"I am God and this is my Holy Book!" he proclaimed loudly.

Despite the tension we nearly laughed. He was proudly holding up a worn copy of *How to Breastfeed Your Baby.*

The light moment fled as our stranger became increasingly agitated again. He ran up to our front door, pounding on it and jiggling the locked door handle. Reaching up, he tore down my Christmas wreath. He jiggled the door handle again. We watched him with bated breath, knowing our two children were just on the other side of the door. The lock held fast.

Frustrated, he turned away, ready to take off again. Ken didn't want him loose and alone on campus so he grasped his bare arm. The man didn't seem aware of Ken's touch. Ken began guiding him away from the house. They haltingly started walking up towards the main part of campus. Then, the man started moving erratically, darting back and forth; Ken had to repeatedly force him back onto the path. Beside the soccer

field they encountered Director Dave Baldwin, who'd gotten a call from security that there was an intruder on campus. Dave had gone to look for him with the night guard, never thinking the stranger would double back and try to break into his own house, endangering his wife and children.

Dave called the police, but since the police department did not own any patrol cars, the men would have to bring the intruder to the station themselves. The man's hands tied, all four men piled into the Baldwin's Trooper for the trip; Dave and Ken in the front seat, the intruder and the guard in the back.

The kids and I went back to bed, after hugs and thanks to God for keeping us safe. But I could not sleep. What was that sound? Was there someone else out there? Ken finally dragged in around 4:30, physically and emotionally exhausted. We dozed fitfully until we awoke at dawn.

Despite his own sleeplessness, Dave had to return to the police station early that morning to complete the paper work for the arrest of the intruder. From the front desk, he could see him in the cell, lying on the dirty cement floor. He had been badly beaten. When Dave inquired as to what would happen to him, the officer told him, "Don't you worry; he'll be taken care of." Dave returned to campus, relieved that the ordeal was over.

A day later, the police called back again.

"You'll be happy to hear that your voleur (thief) will not be bothering anyone anymore."

"What do you mean?"

"Just that; he will never bother anyone ever again."

We shook our heads sadly, in disbelief that such a thing could happen. But there was nothing we could do. We were not in America. We grieved over this loss of life and at our own helplessness, while paradoxically finding comfort in knowing that God had protected us. It was a crazy world!

Ours was a world embroiled in a spiritual battle.

Ours was a world embroiled in a spiritual battle. The Enemy does not want Africans to forsake Animism, or Islam, and embrace the one true God. The Enemy wants us to be fearful whether we face physical dangers or spiritual ones. The Enemy wants us to retreat.

The Enemy also struck students at ICA. Some of our high school boys were dabbling in things they should not, secretly engaging in activities mostly hurtful to only themselves but negatively impacting the entire campus. I was asked to serve on a small committee of discovery to seek the truth in the complex situation. Before each meeting we prayed, tearfully asking God for guidance and wisdom. What we discovered was not good. It was heart-wrenching. We cried out to God in our distress. Most boys repented of their actions and attitudes, and were even glad they'd been found out. Others remained stubbornly defiant. The ministries of many parents would be negatively impacted; some parents would have to leave their fields. The repercussions were far reaching. I wondered if there was any way this could have been prevented. I wished we'd had a counselor on staff.

These boys did not fit into the mainstream; they felt they were outsiders. Yes, they were going through rebellion, floundering, seeking solutions in the wrong places. Yet, nearly all of these teens were very creative in one way or another. I knew their potential as I headed up an Art Club, trying to fill in the gap since ICA didn't have an Art program. Of the twenty students in my club, every one of them had been impacted by the discipline handed down by the Administration. Either they were under discipline, or were the good friends or siblings of those under discipline. It was a traumatic time.

During this time Ken and I were reflecting on our long-term professional goals, as we did each year in the fall. For years I had been praying that God would send an art teacher to ICA. Having a real art program would be so good for the students to develop and use their creative skills. Maybe, I wondered, if ICA had had an art program where students could explore their creativity and receive praise for their work, perhaps the

73

recent discipline problem could have been averted.

"How about you, Julie?" The thought, though not audible, still echoed very clearly in my head.

"But I'm not an Art teacher!"

"What about next year?"

Right! We were going on furlough for Home Assignment the following year. My mind began spinning. Plans popped into my head. I could take a full load of art classes! I could write my own art program! I could start Art classes at ICA!

But first I had to see if the school would go for it. I sat down and wrote a letter to the Administration outlining my ideas and plans for accomplishing them. I felt very inadequate and not very hopeful.

Their response was surprisingly encouraging: yes, we think it's a great idea. Now write to the school board for approval. So, I penned another letter putting forth my strongest arguments and trying to be my most persuasive. This was such a huge step for me.

The school board was even more enthusiastic in their approval. They told me that they'd felt the lack of an art program too, and had been praying for someone to come teach. Not only did they approve of my educational plans but they said they'd pay for all of my expenses, tuition, books, materials, and allocate $3,000 for me to purchase supplies stateside so we could begin upon my return. Wow! This was above and beyond what I'd imagined! Now I was committed! God was using the traumatic discipline issue to produce something good. God was to confirm this direction many times in the years to come.

Along with approving my Art courses, the School Board also requested that Ken begin a Master's Program at the end of our Home Assignment. He would work intensely during the next three summers with the end result of a double Master's degree, one in Education and one in School Administration. The school board was pleased with Ken's work as interim principal. They now wanted Ken to accept the assignment of principal. They would pay all of his costs as well. God was

continuing to show Himself
trustworthy, preparing us in ways
we could never have expected
for a future we never could have
imagined.

For the rest of Andy's
senior year, we tried to make the
most of the last of our four-year
term. I was the only one who
had been out of Africa during
that entire time. When we left
California in 1991 Andy had just
graduated from eighth grade; he
now was about to graduate from
high school, receiving the MVP
award all three years of his varsity
volleyball career. Aimee had com-

Andy, graduating from high school

pleted middle school, and was finishing her ninth grade at ICA, a social
people-person and volleyball player, too.

The kids continued to love life in Africa and had great reservations
about returning to the United States, a country which had faded in their
memory. Africa they knew; America, not so much anymore. Where in
America could you find a friend like Andy's friend, Jesse Zimmerman,
who'd grown up in rural Guinea? Jesse could throw a rock at a yellow-
head lizard and take off its head at twenty feet! Cool! Or, Chinwezé, a
student from Nigeria who could sneak around back of a hooded cobra
and with lightning speed grab it with both hands and break its neck?
Double cool. The kids would have to find new friends and new adven-
tures in far off exotic America!

Our sights set on the Land of the Free and the Home of the Brave,
we bid au revoir to our beloved Africa.

P*eace is not the absence of problems;*
it's the presence of Christ.
Sheila Walsh

Chapter 7

We kicked off our second Home Assignment by taking Andy to the
Master's College in southern California, where he would join Laura in
her studies. Along with a strong academic program driven by a Biblical
world view, Master's also boasts an excellent international students'
program where both of our kids felt right at home. This bonus really
helped them transition to the fast-paced, high-tech American life.

While still in Africa, Laura had participated in a transition seminar
where she learned some of the American terminology she would be
encountering, including the use of the word plastic when referring to a
credit card. So, when she went to the grocery store for the first time on
her own, the checker asked her, "Paper or plastic?"

Her mind flew over the list of expressions she'd learned. "Um.
Paper, I guess. I have dollar bills." The clerk furrowed her brow and
gave Laura a funny look as she reached for a bag. Laura's eyes opened
wide as she realized her mistake and mumbled, "Oh, uh, sure, yes,
paper!" It was to be one of many learning experiences for our TCK
children.

Even Ken and I experienced reverse culture shock as we returned
to America after four years. All of the streets were wide and paved and
so smooth—no big potholes! Actual street signs guided us rather than
obscure landmarks (second right turn after the big dead tree). There
were lovely sidewalks for people to safely walk on! We didn't have to
stop or swerve around goats or cattle or dozens of people in the road!
Traffic lights worked and people even drove on their own side of the
road! Items for purchase had set price tags on them so you didn't have

to bargain for everything! Eggs were white and clean! Meat came in clean, wrapped packages, not sliced off a fly-infested carcass hanging from a rafter! Air conditioning instead of comforting squeaky fans lulling us to sleep at night! Sights! Sounds! Smells! Customs! All of this added up to a major transition from third-world Africa to first-world America.

While gracious friends made it possible for Aimee to attend the local Christian high school during our Home Assignment year, I eagerly enrolled in college for my art courses, excited to fulfill a dream I'd had since I was a child, and now that dream made possible by the ICA School Board. Now I would find out if I could actually create real art in order to pass along the artistic gift to students in Africa. Although we college students were advised to take no more than two art courses per semester due to the time-consuming nature of the projects required, I signed up for five each semester, for a total of ten classes. Yes, I was crazy, but I had a dream to fulfill.

Each weekend Ken and I traveled to churches and schools to give presentations about our work in Africa, usually being gone Friday afternoon through Sunday evening. During the week I attended my classes and did my homework and projects, which took an average of thirty hours each week to complete. Yes, the time demand was taxing but I really loved what I was learning and producing. During the spring semester I also began writing my own art program, tailoring the lessons to meet the needs of my future students. I observed as many school art classes as I could, including the class at Faith Christian School in Yuba City, where Aimee was attending. Both taking classes myself and observing classes helped me decide on the methods I wanted to use to teach my classes as well as the content I wanted to teach.

Near the end of our Home Assignment Ken also went back to school, to Columbia International University in Columbia, South Carolina to begin work on his double Masters' degrees. He thoroughly enjoyed his first experience in the South, reveling in the natural beauty of his surroundings, soaking up the deep but practical teaching, and forming strong and lasting friendships among his colleagues. Later, God was to use these same friends to show His faithfulness and love to Ken.

Our remaining time flew by and soon we were winging it back to

Côte d'Ivoire, meeting up with Ken in Atlanta along the way. This term, only fifteen-year-old Aimee returned with us as her siblings stayed in California. Ken had been assigned the role of Principal but he'd made sure he would be teaching a couple of classes as well. I was excited about launching the new Art program. Aimee was looking forward to seeing all her friends again and enjoying all the activities of her junior year. So, with smiles on our faces and eager attitudes we stepped off the plane onto African soil.

Within hours of arriving in the steamy capital, Ken and I found that in addition to our school responsibilities we had been appointed temporary dorm parents for Baraka, one of the high school girls' dormitories. The long-anticipated new dorm parents, Bill and Nancy McComb, with their toddler JJ had run into some difficulties. They would not be arriving in time to begin the school year. In fact, no one knew when they would arrive but we were to hold down the fort until they did. Hopefully they would arrive within a month or two.

Needless to say neither Ken nor I were overjoyed at this news. We wanted to begin teaching. We were eager to apply all the new things we had learned. Surrogate parenting twenty-six high school girls was not part of our plan. We groused to each other. We questioned why this was happening. We asked if there was anyone else on planet earth that could do it. Repeatedly, we were told that we were the best people for the job. Besides, there was no one else. We were supposedly not just their best but their only alternative. God needed to do a work in our hearts.

Aimee was happy to be in the dorm, which had been her home-away-from-home. Through the years, if there was room in a dorm and the dorm parents were willing to take them in, we often arranged for our kids to stay one trimester in the dorm. Dorms have their own life, their own culture, and our kids enjoyed sharing in it. Our kids had always been invited to join their chosen dorm in devotions each evening, which helped draw the bonds even closer. So, Aimee was thrilled to have the best of both worlds: to live in the dorm and live with her parents.

Setting aside our frustration we decided: if we're going to be dorm parents, let's do it with good grace and do it right. Where to start? Empty buildings in the rural areas of the tropics tend to deteriorate

Baraka dormitory porch

fast. Dirt, bugs, cockroaches, plumbing, everything had to be dealt with
not only in the dorm but also in our house and in our classrooms. We
sometimes felt like we were running a three-ring circus!

We worked long, hard days cleaning the dorm. The dorm kitchen
needed special attention, so I was scrubbing away, wiping the sweat
from my face with my shoulder when shrieks erupted from one of the
communal bathrooms. What on earth? Yet another snake? I hoped
not! House lizards? No, who would yell because of a friendly reptile.
Breathless from our dash, Ken and I arrived to see a geyser spouting
water from the back of one of the toilets, spraying water over the entire
room and drenching the startled African house helper who had been
cleaning it. Despite the streaming water, the walls were still black from
the gas bombe (bottle) water heater exploding and sending flames and
billows of smoke into the once-white room, right before our arrival.
Oh, boy. We had our work cut out for us!

As we worked to make the dorm clean and welcoming, anoth-
er drama was unfolding which made our problems seem petty. Our
friends, Dan and Nancy Grudda, arrived on campus to stay with Dan's
brother, Bill, his wife Dianne, and their four boys. Dan was teaching at
the Yamossoukro Bible Institute and their two boys, David and
Steven, were attending the small New Tribes School there in Yamo.
Their five- year-old curly-haired moppet, Julianne, had been sick off
and on for several months. Dan and Nancy came to Bouaké to have

more tests done to determine if her problem was more than just malaria. Most people, after treatment, were better in less than a week; but, beautiful little Julianne just wasn't bouncing back.

Aimee visited the Gruddas that Saturday, putting on a tea party for Julianne, who seemed to be feeling better. With two older brothers and four boy cousins, she seemed to enjoy the *girlie* attention. They laughed and played underneath the banana plants, just as they'd done many times before. Surely, we thought, this darling little girl was going to be fine. The results of the blood tests would be ready Monday.

But on Sunday afternoon Julianne's fever skyrocketed again. The Gruddas decided not to wait for the test results but to drive the five hours north to the mission hospital in Ferkessedougou where she could get better medical care, where everyone who would take care of her had known her since birth and loved her. This was her dad and uncle's old stomping grounds; where they were raised and where they, too, were respected and loved.

We at ICA began to fervently pray; now knowing her illness to be very serious. While we continued to work we couldn't help but pray without ceasing. We got updates several times each day which helped guide our prayers, but I had difficulty concentrating on the tasks at hand. Yet, there was nothing more we could do, nothing more important than to pray. Tuesday night Julianne's fever caused a seizure which stopped her heart. The doctors were able to resuscitate her, but she did not regain consciousness.

The American embassy, ten hours' drive away, sent a helicopter to med-evac Julianne and her family to the Canadian hospital in Abidjan. Her little body was hooked up to tubes and wires. Wednesday passed. Thursday passed. Everyone was on edge waiting and praying.

Thursday evening the doctor spoke to Dan and Nancy, saying what was surely difficult for him to say and devastating for parents to hear: their precious Julianne had no detectable brain waves--only the machines were keeping her alive. Did they want her to continue in that state or did they want the life-support turned off? He wanted their answer the next morning.

How could any parent sleep after hearing such news? Dan and Nancy didn't, spending the night weeping and praying. As they called on God in the midst of their fog of suffering, Julianne's machines

shrieked an alarm. Doctors and nurses came running as the child's small body stiffened in convulsions, then segued into a fatal cardiac arrest. God in His compassion took little Julianne home, now healed of the tormenting effects of cerebral malaria. Her parents did not have to make that heart-wrenching decision. God made that decision for them.

My heart ached for my friend Nancy, and for all the family. They decided to take Julianne back to Maine, to be buried near her grandparents' home town. Before leaving, they wanted a service for her at ICA.

Our staff divided up the labor in organizing the service. I was assigned to arrange a meal for over two hundred Ivorian pastors and lay leaders who were expected to attend the service. I also cut flowers for the chapel and arranged tables with photos of Julianne and gathered some of her favorite things, symbolizing who she was: the little tea set, her little white New Testament, a favorite doll, flowers which she, too, loved to pick. I wept the entire time I worked.

The heavens cried too as huge drops of rain poured relentlessly down, drumming a sad African dirge on the tin roof of the chapel. Our Father God was weeping with the Gruddas and us: loss is real and a time of grieving is necessary. We knew we'd see Julianne one day in heaven, but for now it was still almost unbearably painful. God's heart hurt with our broken hearts.

No matter how broken up we all were, the students were still arriving in one week. How could we possibly be emotionally ready to welcome them, let alone have everything physically ready in the dorm?

I have no memory how everything was accomplished, except that somehow and by God's grace we bumbled through, doing what had to be done one day at a time. As I anticipated being a dorm mom I felt so inadequate. Now I felt unprepared as well. Wracking my brain for easy and creative projects, I painted signs with each girl's name for their doors. Ken made sure the outside was in good shape, including the porch swing. I made and froze special treats for the girls snacks. I designed and painted a new sign with the dorm's name, Baraka, surrounded by a flower border. We made their beds and set out their towels. Still feeling inadequate, we opened our doors and our hearts to the twenty six girls God had given us.

Julie Abuhl, Elizabeth Befus, and several of the other girls went

out of their way to be helpful and kind. Many of Aimee's friends, including Susanne Eadelman, Becky Robertson, and Jori Anderson were already almost like daughters. There were a few snags as new girls tested the waters but within days we were blending into a family, enjoying each other's company. We decided this was going to be a fun year!

"Aunt Julie, I don't feel very well," Susanne admitted apologetically.

"That's okay, sweetheart, let's take your temperature," I murmured sleepily in the middle of the night.

"Oh my! 105F!" I was wide awake now. "Let me get you a cool cloth and something to take down that fever!"

As I gently sponged her face, another girl dragged into the room coughing.

"Aunt Julie……"

I cut her off, "Lay down next to Susanne and I'll take your temp, too."

By the next day the living room looked like a MASH unit with mattresses lined up along the floor of the living room. Within the next 10 days I'd have 10 very sick girls, including Aimee, and a sick husband. The school nurses advised me on what needed to be done. I spent most of my days and nights mopping brows, dispensing medicine, and making sure my patients were drinking liquids in an already hot and humid environment as we fought to bring down their fevers. Diagnoses: Nine malaria, one case of pneumonia (with possible malaria too). I'd guessed as much with the symptoms. We called malaria 'shake and bake.' First you shake with intense chills then bake with high fevers. The expression added a light note to a difficult time.

My classes were put on indefinite hold. I was so exhausted and sleep-deprived I could barely stand. After Julianne's and Doris Betty's deaths I worried about Aimee and my dorm girls and my husband. I was such a zombie I started hoping that I'd get sick—then maybe I'd get some rest! I was on the verge of collapse. This can't go on!

Finally the wave of illness came to an end. Just one more event in the life of a TCK in West Africa! Aimee was our family record holder when it came to malaria: she racked up fourteen separate episodes by the time she was 18! She remembers well sitting in a plastic chair in the shower while I sprayed her down with cool water. Ah, such sweet

mother-daughter bonding memories!

The McCombs finally arrived that fall of 1996, Nancy large with their second son, due in early December. We accepted their invitation to serve as dorm parents once again for the week or two when they went up to the hospital at Ferkessedougou to have Ian. Ah, but this time we had no major disasters, no surprises, no illnesses. It was pure joy!

It was already a memorable year, both happy and sad, but there was more in store for us in the rest of the school year. God was getting us ready for Him to do some truly amazing things! We had NO idea!

I certainly had no idea what was in store for me either. Our 25th anniversary was approaching on December 17 and friends and students kept asking me what special thing we were going to do. My stateside friends and relatives took cruises, went on elaborate vacations, bought nice jewelry, whooped it up. What WOULD we do? People asked if our kids would be flying out to help celebrate. Right! As if!

Ken asked me what I wanted to do. Years earlier we'd started a tradition of driving down to the coast, taking a rickety ferry (how far can I swim if it sinks?) to a small island inhabited by fishermen and enjoying a week camping with friends, usually the Baldwin family and/ or Mike and Amy Young and their four girls. I loved lying in the dark at night with the sound of the waves lulling me to sleep. It was tempting. But, I wanted something different to mark this special anniversary.

Since we'd never visited the Comoé Game Reserve I thought this was the perfect destination for our celebration. So I eagerly awaited our romantic get-away for two. However, Ken, ever the man of mystery and secrets, had been scheming for two years, saving money, to bring Laura and Andy to Africa to celebrate with us.

When we entered the dining hall at Comoé's rustic lodge that evening, the entire African staff was lined up along the walls, all with huge smiles on their faces. They knew what I didn't: all three of our kids were waiting to surprise me. I was indeed surprised, even shocked. Could this be possible? I had to hug them hard to make sure they were real and not a dream. What a sweet and sneaky man I married!

When Laura and Andy were accepted for a semester's study in Israel, it made his plot even easier to carry out. Their plan included leaving California for the Ivory Coast as soon as their semester ended,

staying through Christmas and their interim session, then flying up to London to meet up with their group which would continue on to Jerusalem, where they'd live on a moshav outside of town for the next five months. It was a special time for all of us to be able to share Christmas together, especially with the year that was to come. God was giving us our heart's desire right before putting us through the fire again.

The last time we came together as a family in Côte d'Ivoire.

My Art classes were developing very well. My students were terrific, happy to be learning and creating art. My program called for teaching ceramics so I found some local clay in Katiola, an hour north. My students produced various hand-building projects, of which they were so very proud. But, where could I get the pieces fired? I went to the local lyceé (high school) and paid them to fire a batch in their gas kiln. But that source dried up when the kiln went on the fritz and was not repaired. So, I decided to ask my potter friend, Gada, from the local

Baoulé tribe.

Julian Gada was the manager of his village's pottery co-op since his mother, Mme Gada-Tanou-Sakassor in the photo, was the founder. Certain villages in Côte d'Ivoire are known by their principal occupa-

tion, such as Weavers Village, or Fishermen Village, or Pottery Village. Tanou-Sakassou was such a village, just three kilometers from our school. Traditionally, pottery is created solely by the women but Julian learned how to create pottery at his mother's knee. He also knew French and had a good network that spanned the country for selling their pieces. I'd take my art classes out to the village, where Julian would patiently show them how the clay was dug from the river bank, dried, pounded in the huge upright mortar using pestles more than half the size of the ladies. The resulting crushed clay was then sifted before being re-constituted with water, then pounded once again. It was quite the intensive process! My students also got to see the women as they built huge pots using large moist coils, decorating them later with distinctive patterns and designs. It was fascinating to me and I enjoyed building relationships in the village as they built their pottery.

When I explained my dilemma about the kiln Julian opened his arms in an expansive gesture. "Of course you can fire your students' pieces here! Our kiln is your kiln!"

Their kiln was unlike any other I'd ever seen. At first glance it

looked like a big mud igloo with holes in it. Julian explained its construction: First you find a big termite mound that has been abandoned (termite mounds can grow to ten feet high, or more). Then you take your mallet (handmade, of course) and start chipping away pieces of the hard mound. Back in the village you put the pieces in the big mortar and pound it until it looks like sand. Then you mix something else into it (which he didn't explain) before you add water and make it into *mud*.

Quickly, you spread the mixture over the temporary structure you've built to support the walls and roof while you're building. When the layers are thick enough and dried hard, the

Andy a top termite hill

A visit to the Potters Village

87

temporary supports are removed. Logs of a particular tree are pushed through the several gaps in the walls; just enough so they can be set alit inside the kiln. Ingenious! In a place where fire-brick cannot be found, natural gas is not available, and there is no electricity, these people have used their creativity and natural resources to find a solution. Brilliant! What a blessing that my students could learn from and appreciate their Ivorian neighbors! Me too!

Another of our African friends was a source of blessing as well. Magloire was a mason by trade from Benin. His name means *My Glory*. He helped built the cement seats that surround the trees in the school's plaza which I had the honor and pleasure of designing. The design and actualization of my plan brought me great joy and satisfaction, but that's not the important part of my story.

Magloire came to our school on the recommendation of his uncle, Pascal, who was the master carpenter in the shop. Magloire did excellent work and always had a smile on his face. He eventually fell head over heels in love and married the daughter of another school employee. They eagerly awaited the birth of their first-born. But Helene's delivery went dreadfully wrong and both she and the baby boy died. Magloire told me that it was his faith in God that kept him sane during those dark times of sorrow.

When I asked him about his spiritual journey he told me a fascinating tale. Born the son of a king in Benin, he was raised in the traditional animist religion. His father had fifteen wives and seventy-five children, which was perfectly normal for a king. Not in line for the throne any time soon, young Magloire decided to travel. He landed in Abidjan where he started an apprenticeship in masonry. It was there that he had a dream one night. In the dream a great flood was covering the earth and he felt incredibly frightened. When he awoke he remembered hearing a story from a Christian friend about a great flood. So Magloire sought out a Christian church to find out more about the story. There he heard not only the story of the flood but of Jesus Christ who came to save us from the *whelming flood* of sin. Magloire began *walking the Jesus road* and shared his faith with everyone. He was such a dear young man, and an encouragement to many, including me. What an example of God's drawing us to Himself!

The first semester of the 1996-1997 school year had been memorable, both happy and sad, but there was more in store for us. God was getting us ready for Him to do some truly amazing things! We had NO idea!

Y*ou, O God, restored me to health and let me live.*
Surely it was for my benefit
that I suffered such anguish.
Isaiah 38: 17

Chapter 8

The second semester of the 1996-1997 school year at ICA was
a benchmark time for Ken, so he'll share his story of that life-changing
time:

Ken

God is Good All the Time!

The spiritual *weather report* as we began the new semester
appeared to be *hazy, with no change in sight.* Although the
Grudda children did not yet attend ICA, their family was well
known. Many were still recovering from the shock of the death
of Julianne. But shouldn't a wake-up call to our mortality draw us
closer to God? Yet, that didn't seem to be happening. The spiritual
fire and fervor was lacking, and many were concerned about it.
Even the outreach programs bore little fruit. No matter what we
tried in order to stoke the fire, it refused to burst into flame – that
is until April.

Pastor Fred came from the United States to be the main
speaker for ICA's Spiritual Emphasis Week. The words Fred spoke
were not profound but they were clear and to the point. They were
powerful – powerful because the Holy Spirit was at work stoking
up the fire in the hearts of those on campus. The theme that came
out of the spiritual revival was, "God is good all the time! All the
time God is good!" Evening meetings that were scheduled for an
hour and a half were extended into the wee hours of the mornings
as the students spontaneously yielded to the Spirit's leading in

repentance and praise to God. Bonfires became the center of testimonies, praises, reconciliation, repentance, and burning of items that would not be pleasing to the Lord. That included, with the dorm dad's approval, beds, desks, and chairs, from one of the boy's dorm that had been marked with inappropriate words. The Holy Spirit was moving in a mighty way and a genuine spiritual revival was taking place on the campus of ICA.

To top things off, toward the end of the week, a Jewish boy, whom we'd been praying for and working with for four years, stood up and announced to the whole school that he was giving his life to Jesus Christ. The roar of praise to God that you heard from the chapel, upon hearing that announcement, rivaled roaring crowds you would hear at a football game! It was an amazing week!

As further confirmation of what had happened, two weeks later the outreach team went to a Muslim village to share the Gospel, and 50 villagers, including the chief and his son, put their faith in Jesus Christ! Everyone was very excited about what God had done both on campus and in the village. I was especially excited because I knew I was going to have the chance to share the goodness of God a couple of months later at Columbia International University.

The ICA administration had asked me to earn a dual Master's degree in education and in Christian School Administration, offering to pay for it. The program spanned seven weeks for each of three consecutive summers. I had already completed the first of the summer sessions and was looking forward to the next one. The courses were very condensed – each day was comparable to one and a half weeks of traditional courses. So one only took two classes per two week session. There were hours and hours of homework each day, and very little time to relax. And as the beginning of my second summer of classes approached, I was very excited because I knew that on the first day of the summer session there would be a special chapel when all the students would have a chance to share what God had done during the past year, and I was anxious to share how God was good all the time!

Before I could begin summer classes, we had to complete the school year at ICA. Julie and I were the sponsors of the class of

1998, which was responsible for the Junior-Senior Banquet at the end of the year. Like the JSB we'd organized four years earlier, this JSB also involved a great deal of preparation. During the final few days leading up to the big event, we found ourselves exhausted from working all the extra hours, plus keeping up with our teaching responsibilities during the day. I felt I was coming down with something – a bad cold perhaps – I didn't know, but I had a gland that was getting to be quite sore. I visited the school nurse, and she gave me a round of antibiotics to knock it out.

With JSB on Friday night, Thursday night turned into an almost all-nighter with only a few hours of sleep as we finished preparations for the JSB. That would be the last sleep I would get until Monday morning!

After teaching our Friday classes, we began transporting everything to the banquet site thirty-five kilometers away, and setting up the decorations. The students had chosen a Scottish theme, complete with Scottish folk dancing, a caber toss, a movie, and other fun activities, as well as the dinner in the decorated banquet room. The large thatched hut was transformed into a Highland castle, complete with huge banners we'd sewn, hand-made shields on the supporting posts, and plaid table runners. It was a great night. I remember how tired I was but chalked it up to not sleeping much the night before. And then there was this swollen gland that continued to bother me, despite the antibiotics the school nurse was giving me.

After the festivities and clean-up Julie and I arrived back home after 3:00 in the morning. Friends were going to pick me up at 6:00 for the five-hour drive to Abidjan, so I finished packing instead of sleeping. I had a flight that evening on Air France to Paris, and then from there on to Washington D.C. where I would catch United Airlines flights to Cincinnati and finally to Columbia, South Carolina. I was hoping to be able to nap on the car trip to Abidjan, but with four of us in the car sleeping didn't happen. We arrived in Abidjan around 11:00 a.m. and try as I might, I couldn't get to sleep before I had to leave for the airport at 6:00 that evening. I couldn't stop thinking about the trip ahead and how excited I was to be able to share with my colleagues at Columbia

about the story of the spiritual revival at ICA and how God is good all the time!

The flight to Paris was uneventful, but I have never been able to sleep on an airplane and that night was no exception. But, I did have the time to slow down and reflect on the past few days and again on what I would share Monday morning at the chapel service. The swollen gland on the left side of my neck seemed to be actually growing bigger instead of responding to the antibiotics. For the first time I began to think about cancer as a remote possibility. My mother had died of breast cancer at the age of forty-seven. I was now forty-seven. From her experience I knew that lumps in your body are not a good thing, but I didn't give the idea serious thought. Yet.

I arrived in Paris early Sunday morning with a seven hour layover. I was too tired to go explore the airport, let alone Paris. Since I wasn't traveling with VIP status, there was no place to lie down and try to sleep. In a blur, I finally boarded the Air France bus which took us to the plane on the tarmac. And then we waited – we waited for an hour in the bus on the tarmac because the plane had not been cleaned from the previous flight, nor had the food service providers placed the food on the plane for the trip across the Atlantic.

Upon reaching Washington, DC, I had three hours to go through customs and check in to get my boarding pass for United Airlines, so I wasn't too worried about the one hour delay. However, once we actually boarded the plane, we had to wait another hour before the plane finally departed. A passenger was missing but his luggage had been put in the cargo hold. The cargo hold had to be unloaded and the luggage belonging to that passenger removed.

Now, I was beginning to worry. An hour to go through customs, reclaim my baggage and check in for a boarding pass was going to cut things close. I arrived at the ticket desk to get my boarding pass and that's when my trip began to unravel. After giving my itinerary to the ticket agent, she informed me that I was too early – in fact, I was a month too early! I hadn't caught the travel agency's error: they booked my United flights for July

3rd instead of June 3rd. The plane was scheduled to leave in twenty-five minutes. I hadn't slept since getting a few hours' sleep on Thursday night. This was the last thing I needed to hear.

The ticket agent explained to me that I could fly on standby, but I would have to hurry because boarding had started. I checked in my luggage, hurried through security, and arrived at the gate. Everyone had boarded except for those who were flying standby. Much to my chagrin there were fifteen of us waiting to see if we could get on the same flight. I prayed – what else could I do? There were fifteen empty seats on the plane – I got the last one! I thanked God and decided that I would add this experience to the story I would share to my classmates about how God was good all the time! I was tired but I was rejuvenated with how God got me on that flight!

My final stop on United was in Cincinnati. Once again, I would collect my luggage and check in on stand-by. However, a major storm over Cincinnati left only one runway functional. The pilots of my plane had to maintain a holding pattern for an hour before we could land. When I arrived at the ticket counter, the agent told me that my connecting flight was scheduled to leave in five minutes but the gate was a twenty-minute walk. Furthermore, she informed me that the flight was full. Apologizing for the delay in landing, she offered me free lodging and a meal.

"Please go see that man over there. He will make the arrangements for you." I went to the person she pointed to but he wasn't much help.

"Yes, I can make the arrangements for you, but as you can see we are swamped right now because of the storm. When things settle down I will have one of my agents help you. Please wait over there." He pointed to an empty area about one hundred feet away.

I walked to the area, set down my luggage, and once again, I prayed. I told the Lord that everything was in His hands. He knew how important it was that I be in class at 7:30 tomorrow morning. He knew how concentrated my workload was and how important every single day was. He knew how I longed to share God's story with my classmates. He knew I was at the end of my rope.

As I lifted my weary head after praying I saw a man in a suit

walking toward me. I saw no identifying badge. As he approached me he asked if he could help me. He had seen me standing with my head down and my eyes closed. I described my predicament and was surprised when he told me that if I would give him my luggage he would check it in for me while I ran to the gate.

"I happen to know that this flight has not left yet because of the storm and that there is plenty of room on the plane."

What do I do? Do I leave my luggage with a complete stranger? I had been praying that God would help me, and this man could be God's answer. I made a quick decision to trust that this man was indeed the answer to my prayer. I gave him my luggage and hurried off, still taking twenty minutes to reach the gate. The plane had not left the gate yet, only one-third full! Wow! God is good all the time!!

I thanked God once again, mentally adding one more story to share with my classmates about God's goodness, even in seemingly impossible situations. As the plane took off for Columbia I asked God for one more thing. With the delays, the plane was now scheduled to arrive at 1:00 in the morning. Unfamiliar with the city, and just too sleep-deprived to function very well, I was not looking forward to hiring a taxi to take me across town in the wee hours of the morning. I asked God if it would be possible to have a friend there at the airport to meet me and transport me to the university. But, I hadn't told anyone my plans. How could it possibly happen?

As I got off the plane in Columbia, I could hardly believe my blood-shot eyes! There were two of my friends from last year who had waited for three hours for my plane to arrive not even knowing if I would be on it. Praise God! God is indeed good all the time!

For the first time since Thursday I was able to get a few precious hours' sleep before my first class began at 7:30 a.m. But my exhaustion didn't matter because I was excited at the chance to share how God is good all time. I thoroughly enjoyed testifying to that before my classmates in chapel later in the morning. That same morning one of my professors approached me and asked about the obvious lump on my neck. I told him that it seemed to be a swollen gland but a course of antibiotics didn't

seem to be working. Visibly concerned, he suggested that I get it checked out with the school nurse as soon as possible.

That night as I lay in bed thinking of the past few days, I noticed there was a lump in my groin area. Now there were two lumps and in different areas of my body. That gave me a scare. The growing lump plus the new lump and now the comment from my professor convinced me that I needed to see the school nurse as soon as I could. After several failed attempts to contact her, I was able to make an appointment to see her on Wednesday afternoon.

By the time I arrived for my appointment, the gland on my neck had grown considerably. Even my classmates were commenting on it. The nurse did a basic exam. With a worried expression she told me that there was nothing she could do, but she scheduled an appointment with the doctor contracted by CIU for Friday afternoon. The lump on my neck seemed to grow larger by the hour. Although very worried, I had to continue with my intense studies that the coursework required. I still had hopes that the problem would be something else. Friday afternoon seemed like a long way off.

I arrived on time for my appointment on Friday to a packed waiting room. Three hours later I finally was ushered into the doctor's examining room, tight with stress. After a brief examination, he said that he was hoping the lump might be a blocked salivary gland, but was making an appointment for me to see an ENT (Ear-Nose-Throat) specialist. He was the first person to actually use the word cancer. From the worried looks on the nurses' faces I could tell that they were thinking the same. I told him that I had considered the possibility, especially since my mother had died of cancer at the age I was now.

As he saw me out the door, he said, "Oh by the way, I'm a Christian and I'm not going to charge you for this visit. It's my way of supporting missionaries."

Wow! God is good all the time! That was my first reaction. Reality struck me about thirty seconds later. I just had testified to that fact in front of all the students. God is good ALL the time, including the worst of times too. How was I going to live out what

I testified to if this is indeed cancer? That thought hit me like a ton of bricks. Surely God wouldn't ask this of me! I couldn't do it! Over the next several months I would find out that I couldn't do it – not by my strength. Yet, God would give me the strength to live out my testimony.

The doctor's nurse called me on Monday morning and informed me that she had made an appointment for me with an ENT specialist for the end of July. I had planned to be back in the Ivory Coast by then. But, more importantly, the lump in my neck needed attention. Calling the nurse back, I was informed that it was impossible to move my appointment forward unless someone canceled their appointment; the ENT's schedule was packed. During prayer request time in my classes, I shared the problem with my colleagues and professors. A couple of my professors, and then the president of the university became involved and called the doctor's office on my behalf. The appointment was moved up to June 29. This was good news because my lump continued to grow. By Friday's appointment, it was a good four inches in length.

The ENT's diagnosis was that the lump was not a blocked salivary gland but a tumor, probably on the salivary gland itself. He remarked that such tumors are almost always benign, but, as a matter of procedure, he took a needle biopsy. His initial thoughts were that it didn't look malignant. He sent the sample to the lab to be analyzed and scheduled surgery for July 10, two weeks later, to remove the tumor. As I turned to leave, the doctor told me he was not going to charge me for his services – he was a Christian and this is what he could do to support missionaries. God is good all the time!

A few days later, the results of the biopsy came back as atypical. The sample wasn't normal but there was nothing conclusive to indicate the tumor's composition. The nebulous results came back the day before the long Fourth of July weekend. I tried calling Julie in Africa but the communication was down on both sides. There were the typical problems with the phone system at ICA, but there was also something wrong with the phone system at CIU. Because of the holiday, no one was available

to fix the problem.

With the communication breakdown, Julie and Aimee decided to pack and go to Abidjan where the communication was better. They would be near the airport in case the news from the biopsy was not good news. Finally, the following Tuesday afternoon, after school resumed and the phones at CIU were fixed, Julie got through to me. I told her about the results of the biopsy. We felt there was hope that the tumor was not malignant but also knew that the inconclusive results could also mean that cancer was not ruled out. We decided that she and Aimee should go back to Bouaké until after the surgery to remove the tumor. It turned out to be easier said than done. The days between the biopsy and the surgery were perhaps the hardest days of my life – not knowing if I had cancer or not, not knowing whether I'd be alive next year, not being able to communicate with Julie consistently, and still trying to concentrate on my studies – all the while remembering that I had testified in front of dozens of people that God was good all the time.

In one sense, the intense summer Master's program was a help. During the day I was kept so busy that it took my mind off what was going on in my body. But at night, when my head hit the pillow, I prayed and cried until I fell asleep. What was my future? What about my family? Why was I bothering going through the intense pressure of this program if I wasn't going to be around to use it? These and a lot of other questions ran through my mind over and over again. As I said, these were the hardest days of my life. There was nothing I could do but wait on the Lord for the answers and trust Him that my testimony would stand strong – that I would be a living example that God was good all the time.

God did give me comfort in some verses during these days of waiting for answers and after the answers began to become clear. They are found in Isaiah 43:2, 4a, "When you pass through the waters, I will be with you; and when you pass through the rivers, they will not sweep over you. When you walk through the fire, you will not be burned; the flames will not set you ablaze... Since you are precious and honored in my sight and because I love you..."

I found peace in the fact that I did not have to go through this

alone. No matter what the end of my journey would be, God would be right there with me. And that the reason He would be there with me was because I was precious in His sight, and that He loved me.

Finally the day for my surgery came. The doctor would remove the huge tumor that had grown on the left side of my neck, now so large it was difficult to turn my head. Some friends drove me to the hospital and made sure I was checked in ok. They would go back to CIU while I was in surgery because of the heavy study load, but they would come back to pick me up later that afternoon. I really don't remember much of anything about the minutes leading up to the operation, and I certainly don't remember anything during the operation, but I do remember the doctor telling me he would see me when I woke up from the anesthesia.

When I woke up, the doctor wasn't there, and the nurse told me that he would see me the next morning in his office. Two of my friends from CIU were there with cheery smiles and encouraging words. They took me back to my room at CIU, and made sure I was comfortable. Actually I was feeling surprisingly good. I didn't seem to have any after effects of the anesthesia.

But the next morning I was feeling very sick as the after-effects of the anesthesia finally caught up with me. I had an early morning appointment with the doctor. A friend at ICU drove me down to the doctor's office in his van. I remember feeling so nauseous that I lay on the floor of the van all the way to the office. Once I got to the office, I couldn't even sit in one of the chairs in the waiting room. I lay on the floor again, at the feet of several other patients in the waiting room. When the nurses saw me they felt so sorry for me, they took me right into the office. Right into the line of fire.

The doctor told me that I had cancer - as soon as he opened up my neck and saw the tumor, he knew it was malignant. I had lymphoma. Just what kind of lymphoma he couldn't tell. He would send the specimens to Vanderbilt University to be analyzed by the man who invented the classification system for lymphoma. He then made an appointment with an oncologist for me.

I was numb. I had been preparing myself for this news these

past two weeks, but when you actually hear the news, it still shocks and numbs you.

I left the doctor's office not even conscious of feeling nauseous, too numb to even notice. After arriving back at CIU, word traveled fast of the results of the operation and the cancer. I had testified to the goodness of God, and now this had happened. It was a weird feeling walking down the hallway, rounding a corner, and coming across a group of people talking in hushed voices. As they caught sight of me, they would stop talking altogether and avoided eye contact with me. I wasn't offended – they didn't know what they should say. It was ok with me because I didn't know what to say either. What does one say in those awkward moments? But as the days passed they became great paracletes to me. With their encouragement and support, and through God's strength, I was still able to testify that God was good all the time – even in the worst of times.

After returning from the doctor's office I had to call Julie with the results. With growing frustration, I called repeatedly but the single phone line was down at ICA. Finally, out of desperation, I sent a fax to her, hoping that at least the one fax line at ICA would be working. I really didn't want to break the news to her through a fax but there was no other choice. The director of ICA received the fax, and he and his wife took it to Julie. Also close personal friends, Elmer and Pearl stayed and prayed with her as she decided on a course of action. She and Aimee were already cleaning and packing – preparing for the worst. They made plans to fly from Abidjan to South Carolina as soon as possible.

Meanwhile, I considered the fact that Laura was in Yemen, Andy in Los Angeles, and Julie and Aimee in Côte d'Ivoire. While I was going through the hardest time in my life my family was spread around the world. I was thrown into complete dependence on God. By faith, I was still trusting God even as He gave me the strength to testify that He is good all the time. My classmates and professors gathered around me in amazing ways. They met together to pray with me, even stopping mid-class to gather around me, lay hands on me, and pray for my healing. I will never forget their support during that most difficult time when my family

could not be there.

My appointment with the oncologist was scheduled for Thursday, July 24. Julie and Aimee were to arrive in Columbia on Tuesday night, July 22. I really needed Julie and wanted her to be with me for the oncologist appointment. I would like to say that the ten days until Julie's arrival were full of hope and encourage-ment. Honestly, that wasn't always the case. There were times when I felt hopeless and depressed.

After what seemed like an eternity, Julie and Aimee were due to arrive. I couldn't wait to see them! But the plane didn't come. Delay followed delay. My stress level increased. Hours later, an agent finally informed me that the plane was sitting on the tarmac in Atlanta, unable to take off for some reason. She suggested I go home and wait. Already upset, I was in panic mode now. Needing Julie and Aimee with me, I couldn't understand why God wasn't meeting my need. Returning to campus, I asked my support group to pray for me, trying to explain the situation as my panic rose. I told them I was struggling and needed them to pray hard for me as I returned to the airport. They could see that I was in no state to be driving, so one friend drove me to the airport, promising to stay with me no matter how long it took. What a friend!

Just as we arrived, we found that the plane had landed and was in the process of debarking. Soon, Julie and Aimee walked through the doors! I was relieved beyond imagination!

Julie explained that their flight had been delayed because the tail end of a hurricane was passing through Atlanta, closing the airport. Julie's flight was the last flight to leave. Despite my uncertainty, God had been truly good all the time! When all the other flights had been canceled, He let Julie's flight go. I cried to God, asking forgiveness for doubting Him. That experience forever cemented my faith in God's goodness! I would need that faith because there were a lot of hard times yet ahead.

Two days later, Julie and I sat in front of the oncologist wait-ing to hear the official results of the specimens that the surgeon had sent to the lab, as well as the diagnosis and prognosis from the oncologist. However, the oncologist began by saying that he did not have all the results yet. Although the lab was having

difficulty narrowing down the exact type of lymphoma, they cate-gorized it as non-Hodgkin's. From the results that he did have, and from my symptoms, that most likely I had two to three months to live. Two to three months! Both of us sat stunned at the news. Then, he qualified his statement. I had two to three months if the cancer was left untreated, but I might make it to two years with treatment. Well, of course we wanted to treat it!

The treatment would consist of chemotherapy which we decided I would receive in San Jose, California, where we grew up, with the support of friends and family. Our first choice of facilities was Stanford Medical Center which had a 94% success rate in treating lymphoma patients. Our hopes were high as we submitted our application for treatment.

While all the arrangements were being processed, we need-ed a temporary place to stay and transportation in Columbia. The administration at CIU graciously offered us a house on campus and a car free of charge for as long as we needed them. God is good all the time!

When I was not accepted into the Stanford Medical Cancer treatment program, my dad turned to an oncologist in his Sunday School class. The oncologist was on the Medical Board of Stanford, taught at Stanford, and had access to all the tests and facilities that Stanford had to offer but for a quarter of the price! God is good all the time! We made plans to head out to California for my treatment as soon as the doctor released me.

While we were waiting, yet more tests needed to be done. Though very stressful at times, those days were among the most precious two weeks in my life, spending time with Julie and Aimee – taking walks through the forest together, playing games in the campus Student Union, and just enjoying each other's company, not knowing how much longer we would have together. At the end of those two weeks Aimee flew back to Africa to begin her senior year in the dorm while Julie and I flew to California.

The new oncologist told us that my chemotherapy would consist of eight treatments three weeks apart. The first two weeks after each treatment I would have to stay isolated as my immune system would be so weakened that I could die from a common

cold. By the third week my immune system might be strong enough for me to get out, but I still needed to be careful. After yet another examination and undergoing a battery of tests, a date was set to begin my chemotherapy. The cancer was determined to be in stage two, limited to the region above my diaphragm. Stage two meant the lump which had been in my groin area was probably not a cancer. I was convinced beyond a shadow of doubt that God had put it there to grab my attention and convincing me to quickly see a doctor. God is good all the time!

One week before my chemotherapy was scheduled to begin, the cancer began to spread and grow very rapidly. When the doctor saw me he immediately arranged treatment to begin—that day! As I sat down in the chair to take my first round of poison, I was very nervous and, I have to admit, a bit scared. But we have an amazing God! The nurse brought the chemicals, sat down in front of me, and the first thing she said was, "I've been praying for you for a month."

I was astonished! I had never seen this lady before! But she was a member of Calvary Church in Los Gatos, the largest of our supporting churches. A month earlier I had written to all of our churches about my situation, asking for prayer. Out of the thousands of nurses in the Silicon Valley, God gave me the one who had been praying for me for a month! God is good all the time!

He demonstrated over and over again during the next five months how much He loved me. I was given a bottle of the strongest anti-nausea medicine available. I never opened it. God spared me the misery of nausea which is so typical of that kind of treatment. He gave me special friends who found incredible things for me to do during the times when I could escape the house. Calvary Church gave us a house and a car to use free of charge during my treatment time. Lamar Allen, one of the pastors on staff, came over regularly to encourage me and pray for me. I was taken to a pro hockey game, football games, basketball games, and even the Formula One Grand Prix at Laguna Seca. The ultimate experience was a week-long trip back East to visit each Hall of Fame for football, basketball, and baseball. I was over-

whelmed by the generosity of our great friends Ken and Maria Groza. It was an amazing experience!

With each treatment I became progressively weaker as the battle was waged in my body. My small motor skills were in such bad shape that I found it difficult to unscrew the lid off the toothpaste tube or write my name legibly. It was a shock to realize how bad my large motor skills had become when I tried the jump-reach activity at the Basketball Hall of Fame in Boston. Try as hard as I could, I could only manage a three-inch jump!

Even as I was discouraged by my physical deterioration, I had to acknowledge that my body was responding to the chemotherapy very well. After the first treatment, the x-rays showed no visible cancer cells in my body. I was thrilled and thought the oncologist would give me a clean bill of health and cancel the rest of the treatments. But,

> "Whether I lived or died, God was good all the time. Circumstances did not change that truth."

he explained, one tiny dot on the x-rays indicated about a billion cancer cells. So even though cancer was not visible to the eye on the x-rays, there were likely still cancer cells in my body. The treatments must go on. We did begin discussing the possibility that the number of treatments might be reduced from eight to six.

There were certainly negative side-effects from the treatment – loss of all the hair on my body (even my cherished moustache), loss of my motor skills, a terribly weakened body and immune system, ill effects from the steroids to counteract the poison, and being confined to the house for long periods of time. Yet God did great and wonderful things for me. Besides the special outings, He gave me a house, a car, prayer partners, great friends, and special times with Julie. We both saw God working in my life and body, demonstrating His love for us as He continued to show us that He is good all the time.

Despite the encouraging report from the doctor, there were times when I felt so ill that I came to the point where I was ready to die. I knew that God would be with me all the way through to the end of my journey in one way or another. Let me inject an important realization here. Whether the end of my journey was

remission from cancer or whether it was to end my time here on earth and be with God in heaven for eternity, I knew that God was with me, He loved me. I was precious in His sight. Whether I lived or died, God was good all the time. Circumstances did not change that truth. I never did get to the point where I was ready to leave my family. To this day, I don't know how one can get to that point. I can only trust God for what He has for me at this point in time.

I knew that God had a purpose in my lymphoma. Besides being a living testimony that God is good all the time, He gave me many opportunities to share with people how God was with me through this journey. One particular instance has stayed with me.

Ken Groza took me to the Formula One qualifying heats at

Laguna Seca. Although I was not feeling well, I could not pass up this unique opportunity. At lunch time, Ken went to get some food as I rested at a picnic table. Another man came by and sat down at the table with me. I didn't recognize him as the pastor's son at my home church in Yuba City, but he recognized me. He had recently been released from prison after serving time for man-slaughter. A passenger in his car had been killed in an accident while he had been driving intoxicated. As he listened to my story he began to weep as he realized how God can be with you through the toughest of times. God used our time together to help him turn his life around, back toward God. I, in turn, realized anew that God

did have yet another purpose for the difficult times I was going through.

At last, the oncologist agreed that six treatments were enough as my body had responded amazingly well. I was very happy to hear the report and very excited to begin thinking about returning to my ministry at ICA. He would have liked me to stay in California for a full year post-treatment for follow-up and re-habilitation, but I just couldn't wait. We arranged flights for early February 1998.

In order to save money and use our return tickets, Julie and I had to fly separately on three of the four long legs of the journey. My trip back to Africa extended over a period of four days on four flights – San Jose to Atlanta to Washington D.C. to Paris and finally to Abidjan. The fifth day would be a road trip up to Bouaké. I was still very pale, weak, and hairless. God would once again show me that He is good all the time.

Julie and I flew to Atlanta together on a red-eye flight. There were lots of empty seats on that flight and both of us were able to find empty rows where we could stretch out and sleep for that long flight. Julie flew on from Atlanta by herself while I stayed overnight in Atlanta before continuing my journey. The flight from Atlanta to Washington D.C. was a morning commuter flight and most of the seats were full, but not the two next to me. Once again I was able to lie down and sleep. God knew how much I needed the rest.

The flight from Washington D.C. to Paris was a well-travelled flight, yet once again the seats next to me were empty. I slept and rested knowing that God was taking care of me. The flight from Paris to Abidjan is always completely full. This trip was an exception. There were actually two vacant seats on the plane. And you guessed it – they were next to me! God gave me the space to rest on all four of my flights back to Côte d'Ivoire! God is good all the time!

Arriving back at ICA, I was given the opportunity during the Sunday service to give my testimony. I testified to what God had done with my life over the past several months. They, too, had been praying hard for me. At the end of my testimony, the stu-

dents and staff rose with a standing ovation for several minutes. I knew that the standing ovation was for God as much as for anything else. The story I shared with them was not so much my story as it was God's story. God is good all the time!

*I*f *I never had a problem*
I wouldn't know that
He could solve them
I wouldn't know what faith in God could do.
Bill Gaither

Chapter 9

Hooray! Wahoo! Homemade banners expressing love and congratulations greeted us at our home on the ICA campus. Students and friends hugged my hairless, splotchy-skinned, cancer-survivor husband. It warmed the cockles of my heart to see the response of these dear people who had held prayer vigils during Ken's chemo treatments, who had sacrificially raised money for Aimee's plane ticket to California so she could spend Christmas with her dad, and who just plain loved us. These were wonderful people; they were family.

Although Ken returned in a weakened physical condition, his attitude was amazingly positive and enthusiastic. His oncologist had tried to convince him to stay longer in California so Ken could build up his strength, but when he saw how passionately my dear husband longed to return to Africa I think this insightful doctor realized that fulfilling Ken's desires would be the best medicine for him.

The second day we were back, February 4th, 1998, Ken wholeheartedly jumped into his role as Principal. He'd already organized his classes so he could smoothly begin teaching as well. But Ken was not content to remain physically inactive. He'd had his fill of resting during the past seven months. He was ready to see what he could do. He found out the hard way the first time he put himself to the test.

While walking home from the classrooms, Ken passed by the soccer field. A couple of his former students, David Abuhl and William Haun, were tossing an American football back and forth. Ken hollered

out a greeting to them. They shouted back an invitation to join them.

"All right! This is going to be fun!" Ken remembers thinking.

Ken suggested they do the play that guys do, where one person hikes the ball, the second person catches it then throws it long, out to the third person running across the field. Ken volunteered to be the guy running across the field.

My imagination plays the scene in slow motion. As David hiked the ball William caught it and turned to throw it. Ken had taken one running step. And fell flat on his face. Kaboom!

The boys hesitated, not knowing whether to run to help or to burst out hooting.

Ken gave a surprised laugh, then shook his head to clear it while he brushed his dirty hands together. Ha! That was weird. But he insisted he was fine and that they try it again.

The three of them lined up, the play was reenacted with the exact same results. Kersplat! Ken did another face plant. Now the boys were worried.

"I don't think we should do this anymore, Mr. Vaughan."

Ken reluctantly agreed, realizing that his chemotherapy treatment had caused a time lapse between his brain and his extremities; his brain was sending out signals to his legs to run but they weren't getting the message until much too late. It was a sobering moment, but it didn't discourage Ken—he just began working all the harder.

As for me, I was reveling, back in our own home, being a mom to Aimee once again. We all were enjoying our puppy Cobie. I was thoroughly enjoying teaching my art classes. Aimee and several of her friends were in one of my classes which made teaching all the sweeter for me. Dave and Barb Baldwin, Tim and Eliz Carden, and Ken and I were also the Senior Class sponsors, planning and participating in special activities. We also resumed mentoring one-on-one several high school students.

During Spring Break Ken flew to the Black Forest Academy in southern Germany for an ACSI international Christian schools conference. Aimee and I decided to have a final mother-daughter cross-country adventure. Destination: Camp Higher Ground.

Camp Higher Ground in the western rain forest.

We packed our food and linens and clothes, making sure we had shoes for hiking and not just our everyday sandals or flip flops. We drug out a couple of blankets from the tops of our closet, hoping it would be cold enough that we'd want to use them. I excavated a partial bag of rationed marshmallows from the freezer so we could roast them over an open fire before sandwiching them between Petit Beurre (little butter) cookies, with a chunk of delicious Ivorian chocolate oozing out the edges. Making African S'mores was most definitely one of our important traditions!

Leaving in the early morning mists we passed through our town of Bouaké. Farming families were already walking in from the countryside to sell their produce. Large inyam tubers, huge basins carefully piled high with colorful mangoes, lettuces tied up in a bundle with pagnes (African cloth) were all gracefully balanced on their heads. As usual, babies slept or played or squalled, tied onto their mama's backs. Everyone helped. Even little 3 or 4 year old children had one mango which they would proudly place on their curly heads, learning to walk with chins tilted up just so, trying to glide along smoothly, then stooping to grab up the fruit when they failed. Families work together in Africa.

113

I love the African countryside with the rich variety of plant and animal life found there. We drove through towns and villages, passing Catholic churches and fetish houses and even an occasional evangelical church. Aimee navigated, pointing out road signs, potholes, and turnoffs as we wended our way East. Fifteen-foot tall elephant grass bordered the road on the gently rolling hills during the first part of our trip. Then we started climbing up into the mountains of the western rain forest. The six-hour trip brought us to our little tin-roofed cabin on the side of a hill with a rushing creek murmuring in the distance.

With only a few hours of daylight remaining we began exploring around the camp. The chattering of tree-hopping monkeys accompanied our walk as we checked out the surrounding fields. Cocoa pods and coffee beans were ripening. Côte d'Ivoire is the number one producer of cocoa and the number three producer of coffee, exporting their harvests to the rest of the world! God had called us to the right country!

That night we fell asleep to the strumming of rain on a tin roof, one of our favorite sounds. It was music to our ears. Thankfully, the roof was in good repair so we were not awakened by leaks, which is a common occurrence. Nor was our sleep broken by lizards skittering or bugs buzzing or other critters, which can be bothersome. Instead we awoke well rested to a brilliant, clear blue sky and a day just made for hiking.

As we set off toward the summit of the mountain we kept our eyes peeled to enjoy God's beautiful creation, but also to avoid his less welcome creations like snakes. We knew the importance of watching where we stepped. Once, while on an Outdoor Education hike, we came upon a village boy and stopped to chat with him. When we asked him what he was doing with his stick and homemade sack, he told us a story.

His job in his village was to periodically track a big python which lived on the mountain. When I say big, I mean enormous! I mean more than twenty feet long and as thick as a log. I was skeptical of his description until he showed us the snake's huge, slithery trail. I immediately became a believer. So, why would a village send a teenager to track a monster snake? The boy's job was not to kill or catch the giant serpent. It was to collect its feces. The villagers believed that this particular snake contained magical forces. As it had not killed any of their animals or people, this python was deemed a good snake which would bring good luck to the mountain. In fact, even its excrement was treasured like a magic potion. Smear some on your forehead and your headache disappeared! Infertile? Rub some on your belly and you could have a baby! Treat the snake well and your crops would produce abundantly.

Aimee and I did not see either the boy or the magic snake or any other snake that day, thank goodness! We saw the towering rain forest trees creating a canopy above us, as well as the lush foliage growing below. We heard drums from one village being answered by drums

One huge python skin!

115

from a neighboring village. We greeted men and women as their straightened their backs from hoeing their fields with wood-hewn dabas. Birds favored us with their calls and melodies. Or, was that a monkey? Sometimes it was hard to tell the difference.

Breathless, we finally arrived at the summit. We soaked in the amazing view. Was that Guinea or Liberia over in the distance? It was a toss up; we just knew we were on top of our world and loving it! Aimee and I collapsed onto the massive granite outcropping and dug into our backpacks for food and water. Glancing at the expression on my daughter's face, I saw a wistful look as she mentally said her good-byes to this beautiful place. I hoped this trip would be a wonderful memory for our sweet Aimee to carry with her to college—a memory to also give her closure as she embarked on the next phase of her life in that foreign country of America.

As we journeyed back to Bouaké we talked about the crazy past year. After we'd shared our hearts about Ken's illness and Aimee's separation from us during his treatment we felt closer to each other than ever before. Drying our tears, we turned to a more light-hearted subject: our puppy. Less than a year earlier we'd chosen a furry golden mutt from a friend's litter, thinking we would have all summer to train it and love on it while Ken was in South Carolina. Instead, within a month Aimee and I found ourselves flying back to join him as he began his fight against cancer. Had it been the best decision to send Aimee back to ICA on her own to begin her senior year? Staying in the dorm, trying to care for a puppy, making momentous choices without us--this was not in our plan book! Yet, God was to use each of our choices in His yet-to-be revealed plan for our family.

That fall, as she evaluated various colleges all on her own, Aimee made the choice that would forever impact each member of our family. Her single decision eventu-

Aimee, age 18

116

ally resulted in four inter-state moves, three weddings and four house purchases. But that was in the future. Aimee's college criteria included where she would NOT be seen as our daughter, nor where she would be known as someone's sibling, thus ruling out both Biola University and The Master's College. She wanted to be known for herself in a small school with a good elementary education program. She hadn't visited any other colleges so than these two, so Aimee was flying in the dark on this one. Her dorm parents, Bill and Nancy McComb, praised their alma mater, Southwestern College (now Arizona Christian University) in Phoenix for their elementary education program and positive campus life. Taking their advice, Aimee applied to Southwestern and was promptly accepted. Our strongest-willed child, she decided she was ready to venture off on her own.

The Senior Class Outing was a major highlight for these TCK's growing up in rural Africa. They had saved and prepared three years for this memory-making event. The Siemens, a godly missionary couple with the Nazarene mission, drove up from Abidjan to be our speakers. Ken had written and organized a mystery drama which unfolded throughout the five day trip, beginning with the murder of Mr. Potato Head, whose body parts were discovered amongst a plate of fries at dinner. Oh, dear!

As we anticipated graduation, we reflected on the time we'd shared with this class. We felt bonded with this class, beginning with their 8th grade year. Then, working together on the Scotland themed Junior-Senior Banquet was so much fun. The kids were creative, hard workers, with terrific attitudes. We were all still riding high after the spiritual revival and Amir's decision to follow his Messiah the previous year. And, we had our silly moments as well.

One night a group was working on a project in our living room. Although it rained ten months of the year, this was the beginning of the heavy rainy season when the flying termites hatched. The rain woke them up during the day, and then the night lights drew them like magnets. The single street lamp light was obscured by a cloud of thousands of these insects. Their flight did not last long, perhaps a half hour or more. Normally, we would turn off all our house lights so that all the thousands of termites would fly to the bigger lights outside, leaving us alone. But on this night we were busy working and did not

117

realize what was happening outside.

Our houses on campus were great for Africa but there were a few things lacking, including molding or weather stripping around the doors. A long strip of old rubber from a tire kept out rats and snakes (although a scorpion had sneaked through once) but it could not prevent the hundreds of termites from creeping under the doors, seeking the light. We quickly turned off the lights and waited in the dark—the better to encourage the termites remaining outside to go elsewhere. All fine and good except that we still had a substantial number of termites trapped inside when we turned the lights back on. They do not sting and are not harmful, but they are pesky especially when they fly in your face or get caught in your hair or you accidentally suck one up. Africans love them because they are a good source of protein. They collect them by the sackful.

I was all for swooshing the escapees outside but Chad Clason, a student who grew up in Guinea stopped me.

"Aunt Julie! No! I have a better idea!" he said, with a mischievous grin.

"Where's your fresh garlic and oil? And a big bowl I can put water in."

A couple of his classmates joined him in the kitchen as I found what he requested. They got set up, abandoning their other projects. This was more important!

"All right," Chad called out to his classmates in the next room, "I'm going to fix you a treat! But first, these little guys need to take a swim." As he pushed the termites underwater their wings started to fall off. While he worked he explained to me the importance of this step.

"You DON'T want the wings on because they get caught between your teeth!" Chad said with a gleam in his eye.

The boys chased under tables and under people's legs, catching more termites. As they put them in the big bowl; they continued fluttering around. Chad added funny voices as he narrated his way through the process.

"Help! Help! I'm drowning."

"I'll come save you! Oops, no, I mean, I've come to DROWN you!"

"Give up!"

"No, I'll never give up!"

"Glug, glug, glug."

We were near tears with laughter as the boys continued their dastardly deed and hilarious dialogue. Finally, they started tossing the wingless bombers into the hot oil with chopped garlic. What doesn't taste good sautéed with garlic?

Hmmm. Tastes a bit like popcorn.

Just another typical night with TCKs!

Ken flew out of Abidjan early the morning after the Junior-Senior Banquet to complete the last of his three-summer master's program at Columbia. He had worked so hard to cram in all his studies, but he didn't know if he could finish in time to return and be part of Aimee's graduation in early July. She desperately wanted him to be there. This had been a rough year for us all but she needed her daddy to be at her graduation. However, he had one required course remaining, scheduled to last beyond the graduation date. Oh Lord, please work this out somehow! You know how much this means to Aimee!

Unexpectedly, Columbia accepted an equivalent course he had taken years earlier in California. So, with all requirements fulfilled to graduate, Ken elected to skip the ceremony—he had a more important event to attend. His friends, who had seen him through those difficult days of his cancer diagnosis and surgery the previous summer, bid him a warm and tearful farewell, demonstrating for a final time their deep and lasting affection and friendship. God was so good to send just the right people into Ken's life. Throwing his cap and gown into his bags, he flew back to Côte d'Ivoire, arriving just in time for Aimee's graduation.

Ken's heart was full, when as Principal he handed his daughter her diploma then wrapped her in a long bear hug. I wasn't the only one with eyes brimming with tears. A year ago, even nine months ago, we didn't know if Ken would still be alive and here he was, back in our embrace. God is good, all the time.

I flew with Aimee to the States to do all those things necessary for college: open a bank account, buy linens, shop for clothes and toiletries and laundry and kitchen stuff and a million and one other things. All too soon I had to say goodbye. TCKs have to say a lot of goodbyes and

they always hate them. Aimee was no exception. Her classmates would be returning to their home countries: Canada, the Netherlands, Israel, the USA, scattering all over the world. They, too, were starting the next phase of their lives, far from their adopted countries.

During a phone call to Ken from Arizona, I asked him to finish cleaning Aimee's room, especially to take down her posters and other crazy things she'd left hanging on her walls. I knew I'd be an emotional basket case when I returned and didn't want to face this reminder of our loss.

Returning emotionally spent and physically exhausted, I entered our girls' empty room. The walls were bare. I stood there bereft, as tears filled my eyes. The house was so quiet. As I turned to go, Ken appeared at my side. I sobbed on his shoulder as I thanked him for taking care of Aimee's things. With a rueful smile he replied, "Yeah, well, you're welcome. But just so you know, I bawled the whole time I was working, too."

Andy spent that summer in Croatia, working with young people in a local church; Laura was in Eritrea, living in the capital city of Asmara as she worked in an optical center for a year. Just as she was connecting with the culture, Ethiopia declared war on Eritrea over a border dispute and targeted Asmara. Ken and I began reading alarming reports in the news and hearing details over BBC radio.

"Don't worry, Mom!" Laura tried to ease our anxiety, "All the other ex-pats have evacuated but our team leader says we'll be okay. We shouldn't over-react." She should have stopped there.

"The national army trucks are roaring through town, picking up men off the street to become soldiers, whether they want to or not. There have been a lot of casualties." Not comforting words for any parent to hear.

Worrying about Laura distracted me from worrying about Aimee, although I was still concerned about my youngest. She was having some transition issues, not making as smooth of an adjustment as her siblings. She was our most *African* child, who insisted during our first term that American bread wasn't sliced and sold in plastic bags! How absurd! Either you baked bread yourself or you bought a bagette at the boulangerie and carried it out with the warm crust under your arm. Pre-sliced bread? Piffle!

One day Aimee telephoned us in distress. She felt like a fish out of water in America. She said no one understood her. When I asked if she'd talked to anyone about her concerns she replied, "No way, Mom. If I did they'd just think I was a dumb MK, which I am!"

I quickly sent out an SOS email to Palmcroft Church, where she was attending there in Phoenix. One of the staff arranged for her to meet with a professional counselor in the church. It helped. She met another MK, one who could understand her issues. Faith Young and her six siblings had grown up in the wilds of Mexico, where her parents worked with Gospel Recordings (now Global Recordings International). Faith became a true friend. She also had a cute brother who kept hanging around them. One thing led to another and by the fall of 1999, Aimee and Christian were dating.

After Andy graduated in May from The Master's College, he and Laura decided that since Mom and Dad weren't in the picture they needed to assume the responsibility of checking out this guy that their little sister was dating. They drove out to Phoenix from Southern California and put him through the ropes, grilling him on about every subject imaginable. It didn't scare Christian off. Andy and Laura left, satisfied that he was a *good guy* and Aimee could continue seeing him. Whew! Ken and I smiled when we heard about the encounter. Our kids were looking out for each other and that makes parents happy.

Ken and I were adapting to our empty nest at ICA, although living at a residential school was certainly not childless. We still had students in and out of our house every day, singly or in groups. I continued mentoring 12th grade girls, a few each year. Ken met with a small group of guys too, to sharpen their spiritual disciplines and share their struggles and pray. The girls I mentored became very close and I always referred to them as *my girls*. They still hold special places in my heart.

Our special Amir had entered the Israeli army to fulfill his required service, so we continued to pray extra hard for him, for his physical safety and his spiritual growth. We loved this young man too.

My art classes were going great guns and I loved every moment of it. I was asked to paint a mural for the local orphanage so I got my advanced art students together and we had a grand time designing and painting Jesus surrounded by 'all the children of the world.' It was to be the first of many murals I did with student teams, using our skills and gifts to the glory of God and to the benefit and enjoyment of a largely illiterate viewing audience. Hackneyed though it may be, it is so true that 'a picture is worth a thousand words.'

We loved teaching and living in West Africa. And, we loved the people of Côte d'Ivoire. Throughout the years students had participated in various outreach programs in the community of Bouaké and further afield in more remote villages. Helping out at the orphanage, sharing with interested people using Evangelism Explosion, showing the Jesus film in villages and schools, sharing their spiritual journeys with Ivorian students while helping them with English—these were all on-going ministries students could participate in.

Then there were the Village Outreaches, Evangelism Weekend, and Building Outreaches. These were the special events when groups of students and staff members spent an entire weekend reaching out to the Ivorian people. Evan and Jewel Evans, Brad Trosen, and Keith Ellenberger were the chief organizers, but it took many more people to plan and execute these labor-intensive outings. These folks, together with a few students like Dan Pinkston, wrote songs the group would memorize and sing. Great, right? Well, the songs were not only sound doctrine and catchy tunes but they were written with verses in as many as four African languages! The kids loved singing them, and I did too.

During these outreaches we broke into groups to accomplish various tasks. One team would make bricks, shoveling the wet cement into a metal form, pounding it down and scraping off the excess before upturning it on the ground to release it. One heavy brick at a time. Another team would dig into the hard dirt with pick axes and shovels to form a trench to pour a foundation for a village church. Later, when the villagers had built up the walls with the bricks we'd made, we would return and put up the joists and add a tin roof. These were very poor

Along with other teachers and staff, we loved teaching in Africa. Our wall-size murals brought God's love to the people of Côte dIvoire.

Medical Outreach

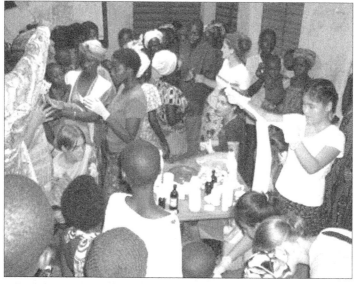

In the line of ministry, bandaged hands after an outreach.

villagers who did all they could and we were thrilled to be able to partner with our Ivorian brothers and sisters to advance God's kingdom. Having a permanent building is an important sign to the animists and Muslims in the village that the Christians are sincere and serious about their faith—it is not just a passing whim.

Another team reached out by holding a medical clinic, cleaning dirty and infected wounds, dispensing analgesics and antibiotic creams and anti-worm medication. Our ICA nurses headed up this team and were sometimes joined by a visiting missionary doctor who took on the more difficult and complicated cases.

Later, the teams would be expanded to include several other ministries, including a mural team, but for now in Côte d'Ivoire, it was enough to reach out to those in need around us in the name of Jesus— to be His hands and His feet to our neighbors. Our desire was also to fan the flames of servant hood in our students. We wanted them to see that when God called their parents to be missionaries, He also called them. They, too, could be used by God to impact their world.

The figure of 20% has remained consistent through the years as the percentage of our students who later choose to become career cross-cultural workers. It makes sense, doesn't it, that children who grow up surrounded by poverty and disease and spiritual darkness want to be part of the solution? Even as high school students they have overcome language and cultural barriers, and have experienced having a personal impact on those around them. One student, Ben Leppard, returned glowing from an Outreach Weekend where he'd prayed with several young men who chose *the Jesus road.*

"I don't know why anyone would need to take drugs to get high," he enthused. "Seeing people give their lives to Jesus is more than enough for me!"

Orphanage outreach: Babies lying on a blanket on the floor of a local orphanage.

Students cradling infants in their arms.

N ever wound a snake. Always kill it."
Harriet Tubman

Chapter 10

While we rejoiced that many people were meeting the Prince of Peace, the country of Côte d'Ivoire was experiencing an increasing amount of unrest and crime. It wasn't serious yet but the missionaries who had evacuated from Liberia's civil war warned us that the atmosphere was becoming distressingly similar to Liberia's prior to the outbreak of violence. But we agreed with our Ivorian friends that such a thing could never happen here; Ivorians are too peace-loving and would never resort to violence like Liberians. The Ivorian people were generally soft-spoken, polite, and peaceful people. Simply raising your voice to call out to a passing friend was considered bad manners. No. We were safe.

It was only mildly surprising when we were awakened by sporadic machine gun fire coming from the west of the school. There was a military camp about three kilometers away but they never did target practice this early. Hmmm. The shots didn't last long but there followed a pervading sense of unease. Later in the day we heard more gunfire. We turned on our radios to hear BBC announce that a military coup d'état was taking place in the Ivory Coast. It was Christmas Eve, 1999. Not a Silent Night.

Along with the rest of the world we were awaiting the millennial change. How would it impact us? This military action was not part of the complications we had envisioned. Now we added the question, how would this coup impact us? Despite the gunfire in the distance we decided to continue as normally as we could, including having our Christmas Eve service in the school's chapel. It was a more than usually sober service, ending with a special prayer time for our adopted

country. We walked back to our home under a star-studded sky, knowing our Father was still in control of the universe.

The city of Bouaké, and in fact the entire country, screeched to a halt. Gas stations closed. Stores shut their doors. No planes were permitted to land or take off at the airport. All borders closed. Road-blocks cropped up to prevent travel.

On December 23rd there had been a strange dog on the upper campus. Hearing loud barking, our friends, Timothy and Eliz Carden looked out their window just as this erratically-acting dog was about to attack their dog and their young son, as Gabriel ran to prevent the fight. Eliz dashed out the door to intervene, fully realizing that the dog was probably rabid. She was able to beat him off (he was later killed) but not before he bit her. She wrapped the wound and Timothy promptly drove her into town to get the first of the series of necessary anti-rabies shots. She was to return each day to receive another injection for the next several days.

With the coup and the subsequent lock-down, I worried that Eliz would not be able to get the rest of the life-saving shots. How could this situation get worse? But God provided a way, as she and Timothy hiked through the back fields to arrive at the clinic in time for her next injection. Whew! By the following day the roadblocks were moved and they were able to drive to the clinic. God is good, all the time.

The country settled down quickly after General Guie and his men took over. Newspapers reported that his reason for resorting to a coup d'état was the corruption and bad governance of the Bedié regime. President Bedié was said to not only be misusing funds and enriching his personal fortune but he also had instigated the concept of *Ivorité* (the definition of a true Ivorian citizen) and its ensuing xenophobia. Villages had been razed and many people killed or tortured for being of the wrong ethnic groups. General Guie declared that he wanted to right the wrongs and set the country on the course for democracy once again. He vowed he would not run for President when elections were next held. The people seemed to accept him, or, at least not oppose him—yet. After only a few days our lives were back to normal.

One of the normal things we dealt with was snakes as well as enjoying more pleasant activities like flower arranging. One day these two activities intersected. I delighted in creating fresh bouquets and

arrangements from the wide variety of flowers growing on campus. I gave them as gifts. I ornamented our home with their fragrance. I also had the joy of displaying God's beauty in the chapel each week for the Sunday services. I'd frequently be joined by a one high school girl or another who shared my passion.

Breathless from his exertions, a school gardener ran up to our porch where we were snipping the exotic blooms before plunging them into cold water. With pruners poised in my hand I paused to listen to him..

"While I was cutting the grass I frightened a big, long, black snake. I chased him so I could kill him but he was too fast. The last time I saw him he was headed for the bushes by your house. I just wanted to warn you to beware. Keep your eyes open."

His French was good, spoken clearly. I understood every word. As he left we investigated behind the washing machine and potted plants and other items on the porch but didn't find anything slithery. Snakes were not uncommon and although most are venomous they generally were not aggressive. Not unduly worried, we continued working on our flowers.

As I worked I thought of the night adder I'd almost grabbed when I automatically reached down to pick up the washing machine cord. The unwanted visitor was sleeping inches from the plug: I breathed a prayer of thanks to have escaped his ire. But in the next moment I forgot my thanks and fear and was simply irritated that I couldn't do my laundry until the snake moved on. I don't do snakes. I will shout for help so someone else can deal with them, but I don't mess with snakes, scorpions, or large spiders. A lady needs to draw the line somewhere.

So, I took this latest snake report in my stride. After we finished arranging the beautiful flowers we went inside for a visit over iced tea. The weather was steamy hot so the sweet tea and sweet conversation were a welcome relief after our efforts. We drained our glasses then hugged a farewell. As my friend left I hollered down the hall to Ken, telling him about the snake warning.

Cobie started barking furiously moments later. This was a truly great dog who expressed herself with different barks for different occasions, even different people. She had a special yippy bark reserved

*Cobie the brave
&
the black mamba*

exclusively for snakes and scor-
pions. Uh oh. Her bark had that
yippy twang to it. My stomach did
a flip flop despite the coolness of
my head.

Ken answered my call by
dashing to the storeroom for a
shovel, his tool of choice for
snake-killing. Gingerly, he poked
the handle into the bushes by the
garbage can, thinking that was where Cobie's attention was focused.
While he was poking he caught a movement out of the corner of his
eye. Did he jump back that quickly or did an angelic hand push him? As
he fell back, a coiled black snake shot across where his knees had been
a split second earlier. The venomous black mamba is one of Africa's
most aggressive snakes.

Within seconds the mamba had coiled again, ready to strike. Ken's
ankle had turned when he fell but he had no time for pain. He couldn't
regain his footing fast enough to get out of the way! He was going to
be bitten! I gasped in horror. I could never reach him in time.

Swiftly, Cobie bravely reached down and picked up the snake
between her teeth. She threw the long serpent high into the air. By the
time the snake landed, Ken had the shovel ready to strike, decapitating
it with one blow, plunging the shovel head into the ground nearly to its
hilt. Cobie saved the day! She saved Ken's life! Thank you God!

God is good, all the time! Our *normal* was never boring.

In early February of 2000 Christian Young wrote Ken, asking for his blessing to propose to our daughter. Less than two weeks later, we got the joyful Valentine's Day phone call from them announcing their engagement. They wanted an August wedding but they wanted to come visit us first. Christian had traveled to many countries in his life as an MK but he'd never been to West Africa. It would help him understand Aimee better if he could get a taste of the culture where his future bride grew up. So, it was set that they would time their visit so that they could fly back with us when we left for Home Assignment.

Before their visit, the country experienced more turmoil. General Guie kept his promise to hold Presidential elections. However, he changed his mind about being a candidate and made sure his name was on the list. Leading up to the election, various laws had been passed and amendments to the constitution made which disqualified nearly all of Guie's main contenders. Most of those remaining contenders withdrew in protest of the irregularities. In defiance, the General went ahead with the elections. The sole remaining contender of significance was a university history professor by the name of Laurent Gbagbo, who had strong support among the young people.

Voting day brought out only seventeen percent of the electors. People were disillusioned. Despite claims of voter fraud in the polling stations, the electoral commission began counting the votes. Before long, unofficial exit polls showed the General losing. He then announced that the commission must be overwhelmed with all the ballots to tally; he would send in some of his soldiers to help. By the next morning the results were announced: the General had won by a landslide!

The youthful supporters of Mr. Gbagbo, later called les Jeunes Patriots, refused to accept the decision and took to the streets. They burned tires and looted shops, physically ousting General Guie by their sheer numbers and fevered passion. With no one else in charge, Mr. Gbagbo was declared the democratically elected winner by his party, theoretically garnering the majority of the seventeen percent who had voted. He was to keep tight control of his precariously procured position for the next thirteen years.

We could not foresee the future but heard his promises that as a civilian he would fight corruption and instill his progressive ideas. The

country settled back down. We had no unusual problems when we drove to Abidjan to pick up Aimee and Christian. I assumed that our lives and the country would now be more peaceful. We were full of hope.

My suspicions that Christian was a good guy began to be confirmed when I began to prepare dinner the day of our arrival on campus. My kitchen knife glided through the tough beef as if it were butter!

"Who sharpened my knives?" I hooted. This was great!

Christian confessed to being the culprit, after attempting to cut some fruit earlier in the day. He'd found the sharpening stone encased in the perfectly mitered box my daddy had made for it. As my father had done for my mom, Christian had set about honing every single one of my knives.

After the dry months of January and February, the beginning of rainy season revealed that we had a leaky roof. Workers had attempted to repair it several times. Yet, each time it rained, water still leaked through the living room's quarter-inch plywood ceiling. One evening during an especially hard downpour I noticed that there were no drips descending from the ceiling. What on earth? The bucket we kept below the drip had even disappeared!

"Christian!" I turned to him as he nonchalantly read PG Wodehouse to Aimee on our white wicker sofa. Incredulously I asked,

"Did you fix the roof?"

He admitted to clambering up into our attic crawlspace, looking for holes in the corrugated metal. He'd never repaired a tin roof but that didn't stop him from solving our problem and saving the day. Christian was fast becoming my hero.

The week before we were to fly out of Abidjan the country went into lock-down again. There had been yet another coup attempt, this time against Mr. Gbabgo. As before, gas stations, airports, borders, were all closed. But we had tickets to fly out in just a few days! Even though we didn't see any roadblocks barring our route to town, we knew we could never make the five- hour drive without stopping for gas. At the last minute we received word that the coup danger was over and we could travel as planned. Thank you, God. We knew He would take care of us but we were sure glad he'd opened the roads and the air-

port! This was to be another faith building block we would remember in the future. God was preparing us.

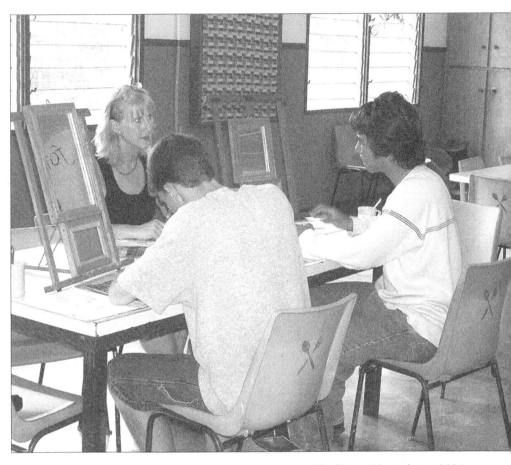

Working with students, 2004

P*recious in the sight*
 of the Lord
is the death of his saints.
Psalms 116:15

Chapter 11

Leaving Africa for our third home assignment was one of mixed emotions. I was not sorry to be leaving the uncertain political climate. Perhaps I was impatient as well, thinking that the country's leaders just needed to get their act together so the country could move past their differences. I was not fearful; I just wanted calm. I was sure peace would return. My positive attitude was surely influenced by the anticipation of Aimee and Christian's wedding followed by a year of sharing our ministry with our partners, as well as looking forward to returning to the art classroom for more professional training.

Aimee's wedding was only three weeks after we arrived in California. She'd decided to wear my wedding dress. Laura had done a lot of the footwork from her apartment in Southern California; Aimee did what she could from Arizona; and, church friends helped with preparations in Northern California. There wasn't much I could do physically from Africa but it was fun to be a part of it all. The girls took me shopping for my dress, not wanting me to cluelessly choose something "absolutely awful, Mom."

The wedding was relaxed and beautiful. We met Christian's family for the first time at the rehearsal dinner. Mom Judy and I both burst into tears at the rehearsal when Laura started tearing up as Aimee strode down the aisle on Ken's arm. We passed the tissues around, shared stories and laughed as well. Our daughter was marrying into a wonderful family! Ken and I breathed a huge sigh of relief and thankfulness.

135

We soon began visiting our supporting churches, sharing what God was doing in West Africa through their partnership. Ken and I loved communicating our passion, which made the many long miles on the road fly by. Our times with family and friends were always precious as well.

Like the previous Home Assignment I signed up for a full schedule of Art classes at the local college. One of my professor's insisted I apply for The Kingsley Art Award, a competitive and prestigious award bestowed on the top art student in the college and underwritten by the Crocker Art Foundation in Sacramento. To my surprise I received the award, presented at a ceremony at the Crocker Art Museum. What an honor! I felt that our Creator God had truly blessed me! I also felt affirmed in my decision to pursue teaching Art at ICA. Now, to return and put into practice what I'd been studying!

Within a month of our return to Bouaké in July of 2001 we heard tales of the increasing crime in the country. But we lived in a poor country so we reasoned that unemployed, disgruntled young men had simply found a new way to illegally gain money. We didn't know anyone who'd been hurt during the criminal acts, unlike many Western crimes. Our friends the Robertsons in Abidjan had experienced just the opposite. One evening, Carol's car doors were jerked open by young men. They asked her to get out. After they had jumped in they turned to her as she stood stunned on the side of the road. One reached out, dropping a handful of coins into her hand.

"Here, this is for a taxi. You shouldn't be out alone at night," he said before they sped away.

But just before Teacher Orientation another incident occurred. This time it was shocking.

One of our colleagues, Amy, picked up the child of an ICA staff member to accompany her and her young daughter into town to shop and have a bite to eat at one of the many small outdoor cafés. While they were relaxing and enjoying their treat, a taxi pulled up and stopped just feet away from them. Since this was a main thoroughfare they didn't pay any attention; taxis were stopping and starting around them as a matter of course.

But two large, gruff-looking men jumped out, quickly crossed

over to their table and proceeded to hustle her into the taxi, despite her struggles and cries for help. When one of the men brandished a gun, threatening her, she stifled the screams rising in her throat, wanting to protect the little girls from harm as well. The stolen taxi zoomed off. Amy began to pray, which helped her not panic.

Thus began a nightmare ride as the men continued to threaten her, hit her, and demand a larger amount of money than she was carrying. After what seemed a lifetime, they insisted she give them directions to the Christian and Missionary Alliance compound, where her family and other missionaries lived. She had little choice but to direct them, hoping all the while that the men there would be able to rescue her.

As they pulled into the entrance, one of the criminals leapt out, ran over to the African guard and beat him repeatedly before opening the gate. Horrified, Amy sat still as the taxi rolled past the gate and down the dirt road to the house of colleagues, Peter, and Kathy and their baby. No one ever discovered how these cruel men learned that the mission's safe had just been filled with a great deal of money— enough to pay the monthly salaries of dozens of pastors, utility bills, and make major necessary purchases.

One man took Kathy into a back bedroom. She later recounted that she was sure his intention was to rape her, but for some inexplicable reason he only pushed her onto the bed before leaving the room. Peter did not escape harm, however. Each time he refused to open the safe, the men struck him. Eventually, after cries from his friends that the money was not worth his life, bloodied and battered, Peter relented and gave up the combination.

This was the first of many violent crimes in our area and throughout the country. What was happening to our gentle, peace-loving Côte d'Ivoire? We could not understand what was going on. Amy was scheduled to be one of the speakers at our orientation meetings but another missionary took her place.

The topic was *Developing a Theology of Risk*. What does the Bible say about Christians in dangerous situations? At what point should Christians NOT take risks? As we discussed this weighty topic, we were challenged to develop our own person theology of risk.

Like all our colleagues, Ken and I soberly talked about how we

would respond. We no longer had children---especially girls—in our home, which impacted our thinking. But the bottom line was, we felt God still had much to do through us in Africa. Even after counting the costs, we were at peace about continuing to serve in Côte d'Ivoire.

The school year of 2001-2002 began without any major incidents. Check points along the roads were a way of life, manned by gendarmes or government soldiers. The soldiers at the check points were supposed to ensure that the driver and all the occupants were carrying their up-to-date identification, licenses, and car documents. In reality, the soldiers were becoming especially difficult, often requiring us to reason with them for up to forty-five minutes. As more checkpoints began appearing throughout the country, travel became increasingly stressful as well as time-consuming. As missionaries, we had decided it was wrong to give *gifts* to facilitate the process, which some soldiers respected but others reacted to with scorn.

One early evening Ken, a friend, and I were returning to campus after a high school class outing. Jewel needed to get home to her girls. Ken had come down with malaria so I was driving. The trunk was filled with bags with a mid-sized cooler wedged behind my driver's seat, leaving Jewel room enough to relax. We'd finally made it through town before being flagged down at the last checkpoint before school.

Improvised road block!

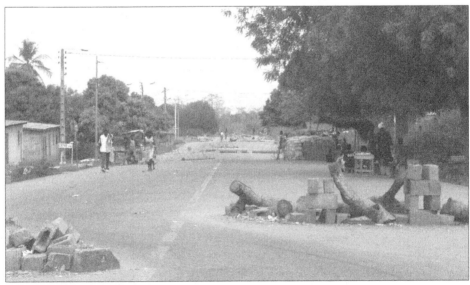

I handed the soldier all the paperwork he requested. He closely examined each piece, looking up at me, then down at the paper. He could find no fault in our documents. Then he began asking about where we'd been, where we were going, what I did for a living, who attended our school, and many other questions. I answered him as completely and respectfully as I could. He sniffed and stepped back. He stood just a few feet from us, his eyes riveted on me, his chin in his hand. Seeming to come to a decision, he called over another soldier. Their Kalashnikovs slung over their shoulders, they spoke quickly with eyes fixed on our car. Together they encircled the vehicle, examining it from every angle as I grew more uneasy. Finally, the men stopped to confer again, throwing glances our way. I saw a sudden look of triumph light the face of the first soldier as he returned to my open window.

"I am keeping all your papers, your driver's license, your car papers, everything!" he announced in French. "You have broken the law and you must pay 6,000 CFA. You cannot drive your car any more."

The air in the car was stifling hot. Ken was miserable with his fever and aches. Jewel was resting her head on the back of the seat, quiet but surely uncomfortable in the roasting sun. I struggled to maintain my composure; respecting—even admiring—a soldier's authority was the most effective way of dealing with such situations. But I was tired. It had been a long day. We were all parched. We just wanted to go home.

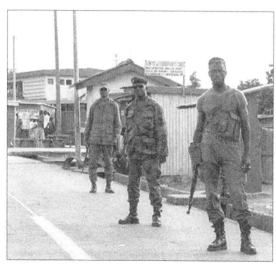

When approaching a checkpoint, we spoke very carefully and respectfully.

"Please, sir, what law have I broken? I know I am a guest in your beautiful country so I want to obey your laws."

"C'est interdict! It is forbidden to have mixed baggage," he smiled, satisfied with himself for discovering the infraction.

"What exactly is mixed baggage? All of our bags are in the trunk."

"Look for yourself! You have a box in the back sit where that woman is seated! That is very dangerous! This is against the law! You cannot mix people and baggage!" he said, heatedly.

"Ah," I replied. "Please forgive me, I have never heard of this law. Please tell me if there is a book or something I can read to find out what the driving laws are because I want to be a good citizen and obey every law."

I refrained from pointing out that nearly every African vehicle was packed with not just people but chickens and baskets and goats and other paraphernalia.

"Oh, no, there is no such book." He nearly laughed, the look on his face reflecting the absurdity of such a thing. A book of rules for the road? How silly!

Baffled, I ask, "Then, how can I avoid breaking the law if I do not know what it is?"

Shaking his head as if to a simple-minded child, he said very slowly, "You wait until you get a ticket for something. Then you know not to do it again!"

Our Suzuki at another time with Ken at the wheel.

Ah, of course! Silly me.

If only all future encounters with the military should be so innocuous. It was not to be.

The school year continued to unfurl as it did every year. Classes were taught, sports were played, art was produced, and music was performed. Students had crushes on each other. Mangoes ripened in the golden sun. Children splashed about in the marigot. Life was still beautiful.

Aimee and Christian had now been married two years and were expecting their first child. Aimee was also ready to graduate, having completed her coursework and finished her student teaching. When she asked for my help, I was all too willing to fly back to the United States, with the Board's permission, to share the joy of holding our first grandchild. Their original plan had been to return to Africa, to teach at ICA. Peter's birth changed their plans. Or did God, using a tiny baby boy? At the time, we were disappointed when they decided to settle in Flagstaff, Arizona. Later, I was to thank God that their little family did not come to join us. At the time I only felt the disappointment of a parent—and now grandparent--living far away.

The days of my visit passed in a blink and I found myself on yet another plane, back to Bouaké. Soon, our other children were on the move as well. Andy moved to Oklahoma with a good friend to work on his Master's degree in Business Administration, as well as to serve in the Air Force Reserves. Laura gave up her apartment in Santa Clarita to join her sister in Arizona. She soon landed a good job as a field officer doing research across northern Arizona.

Shortly after I left, Aimee and Christian's new little family and Laura moved north to Flagstaff, Arizona, where Christian's family home-based when they were in the States. After living in hot, flat Phoenix they couldn't wait to settle in the 7,000 foot high city, set in the beautiful, cooler ponderosa pine forests. Christian began working alongside contractor Randy Smith. Laura became Auntie Ya-Ya when she wasn't out traveling for business.

Back in Bouaké, I picked up teaching my art classes and started getting ready for the big end of year push, getting back into the swing of things. One evening we were just sitting down to eat when the

phone rang.

Prayer alert! "A missionary has been shot during a carjacking. The thieves took off with his four-year-old son in his car seat!"

A missionary serving in Dabakala, to the north of Bouaké, had left his very pregnant wife and young daughter to get supplies in our town. On the way home, father and son stopped by Poulet Show, a favorite curbside chicken eatery. Dad chatted with little Nathaniel through the open window while he waited for his order.

"It's done!" the vendor called out.

Gone less than a minute, the dad returned to the car with their food to discover a stranger sitting in the driver's seat. Dashing around the car to confront the man, a second man slipped into the passenger side.

"You can take my car and everything in it but let me get my son out first!" the dad pled. The stranger looked stonily ahead as if he hadn't heard.

Wildly thinking that maybe the stranger didn't understand him, he darted back over to appeal to the second man. The engine started, began to roll. Frantic, the dad jerked open the door and jumped onto the door frame. How could he stop these men? How could he rescue his son? The car picked up speed.

As he tried to pull himself inside, he felt the barrel of a gun gouging his chest. Refusing to let go, he shrieked for the men to stop even as they increased their speed. Desperate, he lunged toward his son even as a shot rang out. His body recoiled in sudden pain. Losing his grip, he fell from the speeding car and rolled to the side of the road.

Several hours later we heard that the dad would recover from his gunshot wound. His wife wound up joining him in the hospital, after the trauma caused her to go into labor. She delivered a healthy daughter that night, even as her heart cried out for her missing son. We continued to pray hard.

Very late that night we got word that little Nathaniel was found!! The carjackers had left him on the side of the road near a village north of Bouaké. He was hungry but unharmed. Praise God!!! We went to bed thanking God for a happy ending to an incredible story.

When ICA let out for the summer in early July the staff set about

working on various tasks around campus. We also caught up on projects we'd put on hold during the busy school year. We cleaned and made repairs in the classrooms and homes in readiness for the next school year. Although most of the staff was long-term, there was always an influx of new staff, coming to work for a year or two to fill in gaps or to replace staff on furlough. We rejoiced that we'd be blessed with a full staff in 2002-2003 but the blessing also created housing shortages.

To make room for our friends Dave and Connie Johnson and their three daughters we moved into a one-bedroom townhouse in Marigot Manor, saying goodbye to the home we had loved while our children lived with us. I was sure the Johnsons would enjoy all of our bananas and oranges and grapefruit and papaya and mangoes as well as all the flowers and trees. Planting a garden next to the townhouse helped ease the goodbyes to the house where all the pencil markings measuring our children's growth still remained on the kitchen door jamb.

After weeks of hard work moving and cleaning we packed up our little old Suzuki jeep. Cobie jumped in and we took off for the coast for a much-needed vacation.

On July 19th we retraced our route on the windy road, arriving

Our new home, the townhouse.

143

at our new home in the early afternoon. We arrived as Elmer Baxter was formally passing on the baton of Director to Dan Grudda. Nancy had shared with me how she and Dan had struggled after the death of Julianne, wondering if staying in Africa was worth the sacrifice. It was an honest question, one faced by scores of missionaries throughout the centuries. The Gruddas chose to stay and God continued to use them. As Dan accepted his responsibilities no one foresaw the traumatic, life-threatening events which would soon enfold. No one but God. He had placed Dan at ICA "for such a time as this" as our humble and able leader.

We ambled back to our house to unpack, walking down the packed-earth path, breathing in the frangipani-fragrant air. It was good to be home. Ken had hired men to build a paillotte (a thatched hut) to shade the porch swing he'd had built for my previous birthday. It was such a beautiful evening that I indulged in a few moments of swinging, filling my nostrils with the flower fragrance and my eyes with the beauty of God's creation. My heart was full with thankfulness and peace. With a sigh of contentment I entered our new little house, now ready to finish unpacking and cook dinner. What a life!

Our children finding ways to stay active while confined to the dorm.

And the God of all grace,
who called you
to His eternal glory in Christ,
After you have suffered a little while,
Will Himself restore you
and make you strong, firm and steadfast.
1 Peter 5:10

Chapter 12

As we lingered over our meal, the campus phone rang. An authoritative man's voice asked urgently, "What little boys are on campus right now?"

Who on earth was asking such an odd question? ICA was still on summer break so I didn't have to think too hard. I gave him the names of the two boys I knew of, Erik Friesen and Gabriel Carden, both five-year-old children of staff members. How very odd! Thinking this might be some sort of treasure hunt, I hung up and then dismissed the question from my mind.

Within moments, Mike Cousineau, the school's business manager, raced down the perimeter road in his four-wheel drive, passing near our house. Suddenly concerned, I hoped there had not been an accident! A work team from the US was staying in one of the dorms. I wondered if one of the men had been hurt, or had suffered a heart attack. Mike served as a point man for the crisis management team for the school. He was a good man for this assignment since he had grown up in Côte d'Ivoire and attended ICA. He knew the language, the culture, and how to get things done. Leaving Ken to do the dishes, I decided to walk up campus while it was still light to check my email in the teachers' workroom. I thought I might see someone who knew why Mike was in such a hurry. As I ambled along, enjoying the beauty of the campus landscape, Jan Friesen ran toward one of the dorms as the dorm mom ran out to greet her. Their body language even from a distance

communicated excitement. I waved but they were too distracted to see me so I continued along my merry way up campus.

When I arrived and turned on the computer I saw that the server was down. No email today! The wall phone rang. Ken spoke clearly and quickly, barely concealing his anxiety.

"Julie! There's been a break-in on campus! At least eight men are involved but no one knows if there are more guys out there. Stay there! I'll drive up and get you!"

Minutes later I heard a car pull up outside. Thinking it was Ken I opened the door and stepped into the corridor. Mike, bloodied, beaten, with torn and dirty clothes froze when he saw me. A big Ivorian man wearing camouflage and carrying a gun stood beside him.

Mike whirled towards me, screaming, "Get back inside and lock yourself in! NOW!"

Stunned, I jumped back inside, pulling the door closed and locking it securely. What was going on? Was this strange man one of the bad guys Ken was talking about? Dear God please protect Mike and us all! I heard doors opening, closing, a vehicle driving off. Then, all was eerily quiet.

Soon, another vehicle pulled onto the gravel outside. I dared another peek outside, poking only my head out the doorway. To my relief, it was my wonderful husband. Ken jumped out of the car to get me but I dashed out to him. Slamming and locking the car doors we sped off to our house.

Feeling secure in our home, we began to telephone one person after another, trying to discover just what was happening. Many people knew parts of the fear-filled story but it wasn't until the next day that we put the pieces of the puzzle together at an improvised meeting in the school library. With many unanswered questions on our minds, that night was a tense one for us all as no one knew if the robbers would return or if there were other men involved. Few people slept well.

The terrifying incident had begun at the guard station at the entrance to the school. The school board and administration had wisely enacted more stringent security measures. No one was permitted on campus who did not carry a pass or was a previously known tradesman. When a new silver Mercedes pulled up filled with men, the guard, Soro, left his station to investigate. The driver used the name of one of our

long-time tradesmen as Soro approached. As he came closer, one of the men pulled out a gun and aimed it at him.

Antoine at the compound gate.

He was forced to open the gate. They ripped out the phone in his station and forced him to accompany them onto campus. The group began walking down the town-side perimeter dirt road, the gun still trained on Soro. Thankfully, with summer vacation fewer people were on campus. Upon reaching the fifth house they saw lights and activity, Bruce and Jan Friesen were packing for their home assignment, flying out in just a few days.

Looking out through the open windows, Bruce saw the armed strangers approaching his house. He yelled to Jan and their four kids to run into the back bedroom and lock themselves in. As they crossed the living room, five-year-old Erik broke loose and ran out the kitchen door. He dashed to his friend Gabriel's house and grabbed the telephone.

"Uncle Mike! There are bad men with guns at my house! Please come help us!" Erik blurted out before slamming down the receiver. In his excitement he didn't identify himself.

Back at the Friesen house, some of the intruders began stuff-

149

ing easily portable items into bags—cameras, cash, jewelry. Two of
the men grabbed Jan. As Bruce lunged to protect her they turned and
struck him. Two other men forcibly restrained him as they dragged her
outside, barefoot, into the shadows of the growing dark.

Mike Cousineau

Just then, Mike's truck came barreling up the road. The men
dropped Jan to turn on Mike. Jan took off running as shots rang out
behind her. They were firing on Mike! Jan ran for her life to one of the
dorms.

As his vehicle was struck by bullets, Mike stomped on the brakes.
Immediately he was surrounded by angry men with automatic weapons.
They forced him out of his car, striking him, demanding money. He
assured them that as the Business Manager he said he could get them
money but begged them to not hurt anyone.

They grabbed his arms and hustled him down the road, toward
the dorm where the US work team was staying. Two other men had
Soro in tow. Drawing out more weapons they burst into the dorm's
living room, ordering everyone to lie down on the cement floor.
Riffling through wallets and bags, they took all the money they could
find and demanded more.

No, not just demanded, they angrily screamed that they
wanted MORE money than what they'd found. Attempting to calm
them down, Mike told them that he could open the school's safe giving

them more money, much more than they had found in the dorm. They brushed aside his offer. They may have known that they only had fifteen minutes from the time of their entry onto campus before our security service would arrive. Seizing Mike as a hostage, the eight men fled outside, piling into their stolen car and Mike's bullet-holed vehicle.

No sooner was everyone loaded into the cars than one man jumped back out and ran back into the dorm. Looking over all the prostrate figures still on the floor, he stepped over to Soro, spoke some angry, unintelligible words and pulled the trigger. The murderer then stalked back out to the waiting car.

Staff men, alerted by the gun shots and the Friesens, watched helplessly from behind trees. What could they possibly do? They were frantic with worry but quickly discarded as useless various schemes to help. Unarmed, against men who knew how to handle their weapons, they looked on hoping for an opportunity to intervene. As the cars sped down the campus road with bleeding and beaten Mike inside, dorm dad Dave Golding stepped into the open as they approached the empty guard station. Enraged by the bold criminals and terrified for Mike, he thrust out his arm full length and shook his finger at them. They responded by sticking a gun out the window and pointing it at

Main Street through the ICA campus.

151

him. Dave swiftly stepped behind the building as they zoomed away.

Mike, held prisoner, continued trying to reason with them, even sharing his faith. One struck a blow with his pistol butt across Mike's cheek, saying in French, "It's a good thing you know your God because you're going to be seeing him really soon." Mike later said one of the hardest moments came when they forced him to twist off his wedding ring and hand it to them.

After a kilometer or so, the drivers pulled the cars off the road to drive down a track into a heavily forested area. The men ominously repeated their threat to kill Mike. As the car slowed down, Mike surprised his captors by leaping from the still-rolling car. Running as fast as he could, he remembered old movies where the actor would zigzag to avoid being hit. So Mike fled, zigzagging through the forest while bullets flew over his head. As he ran past a cluster of huts, frightened villagers stepped back indoors. Wide-eyed, they saw this bloody, wounded white man pursued by armed men, their shots thudding into trees.

But Mike was physically fit and our prayers were surrounding him, rising to heaven. God led him back to the main road where he soon flagged down a car. The driver was a man Mike knew from his business dealings. No coincidence; God rescued Mike.

At Mike's request, the driver brought him back to school, not to a hospital, where he should have gone. Mike felt a strong sense of duty to the ICA family as well as a desire to be with his own family. He arrived soon after the armed security service, just when I peeped out from the work room. No one knew at that time if there were other robbers lurking on our twenty-six acre campus. Only later did we determine that all the criminals had fled.

What an initiation for Dan's first day on the job! But who better to speak with the authorities and the family of Soro, the murdered Senoufou guard? Dan's French was not only excellent but he also knew the northern Senoufou language. He was the only person on campus able to share the tragic news in their heart language, and in a culturally sensitive manner. Despite the actions of evil men, God is still good. All the time.

Dan and Nancy Grudda with sons David & Stephen

This same summer Murree Christian Academy in Pakistan was attacked by Al Qaeda terrorists. Their guard was able to hit an emergency switch before being killed, as the men swarmed over the campus. The brief warning enabled the people on campus to quickly lock down: lock or bolt all doors, close windows, draw blinds, turn off fans and lights, and huddle quietly on the floor against a wall. The terrorists could not tell which rooms were occupied and which were empty. Like our robbers, they knew they only had fifteen minutes before armed security personnel would respond, so their actions were limited.

Six Pakistani employees who were outdoors at the time of the warning signal were murdered when they unwittingly walked into the terrorists' paths. None of those who followed the lock down protocol was killed. Their tragedy rang as a warning for us in Africa. It was time for us to take action as well.

With the deteriorating situation in all of Côte d'Ivoire the school board and administrative team had created a Crisis Management Team. For many years we had practiced evacuating the campus. Each person kept an evacuation pack always ready. With caution, we had even evacuated during the unrest over elections in 2000, but no significant fighting occurred after all. The exercise wound up being more of an

extended vacation for the students. But with the increasing lawlessness everywhere, the general air of tension, the armed men on our own campus and the murder of Soro, the Crisis Management Team decided to institute some campus-wide measures to try to protect us.

Trying to anticipate potential intruders' demands, an old car with the keys in it was left parked by the front gate. Panic buttons were installed in several locations on campus which would set off warning sirens. Various combinations of siren blasts were to communicate the type of danger and the required response. Bundles of money were stashed in several safe but available places. Every effort was made to keep entry onto campus as secure as possible.

When the students returned in August an assembly was held to tell everyone about the new security measures and the various types of lock down we would begin practicing immediately. Some kids giggled, thinking it was a great joke. But those who had been through tough times before—whether in Liberia, the Congo, Sierra Leone or elsewhere—quickly squelched the goofing off. Yet, we didn't want the kids to be living in fear and insecurity. This new reality required a delicate balance.

But kids are kids and they were delighted to be back at school, if only to see their friends. The number of students enrolled was much lower than normal; some parents felt that Côte d'Ivoire was becoming too unstable and so decided to home school until our situation stabilized. But for the students who did arrive, classes resumed and the school year was off to a good start. My art students were showing terrific potential with skills and creativity to delight any art teacher's heart.

As the advisor to the National Honor Society I planned a kick-off Tea Party at our new home to welcome the members back and chat about projects for the year. Ken wasn't feeling well so he stayed upstairs in the bedroom.

When I have students or other guests over for tea I tell them the story about my teacups. Actually, the story is about God, but he used teacups.

During our first term at ICA I had developed my own dream. That dream was to bring back an assortment of china tea cups so I could show special hospitality to guests—students, staff, moms visiting from the bush—offering them a touch of home. I did not share my dream with anyone, even my family, even though my mom had her own

lovely tea cup collection. I wanted to do some research first, to see if my dream could become a reality.

I checked outlet stores, department stores, and other shops. To my chagrin the least expensive china cups and saucers were beyond my meager budget. I didn't pray about it, thinking that if there were even the barest possibility of fulfilling my dream, then I would surely pray. But, seeing the prices I realized that my dream was impossible. I didn't bother God about it.

My parents were two of the most generous people in the world. I knew that if I even mentioned my dream about tea cups my mom would insist on giving me some of her beloved collection. She had such cherished memories associated with each of those cups; I never even considered telling her about my desires. My dream was a good idea, just not a practical one.

During the fall of 1989 we returned to our church in Los Gatos to speak at a missions conference. I was stopped by Ruth, the leader of the ladies' missions group. She excitedly told me that I HAD to stop by the Missions Closet, where donated goods for visiting missionaries were stored. I knew these dear ladies worked hard to make our lives overseas a bit easier. But, instead of directing me to potholders and shampoo Ruth led me to shelves filled with beautiful vintage china tea cups!

"What? How?" I sputtered in confusion.

"Well," she explained, "You were here for the recent earthquake, right?" It had caused considerable damage throughout the greater San Francisco Bay Area.

"One of our ladies brought in boxes filled with her lifetime collection of tea cups which were undamaged by the earthquake. But she decided it was a good time to give them away, so people could use them rather than sit around waiting for another earthquake. When she brought them in, I immediately thought of YOU, Julie," Ruth said with a broad smile.

Why me? Of all the global workers this church supported, why think of me? Of course, because God is in control. He answered my prayer even though I did not even pray. I imagined him smiling, as the pleased father surprising his child with exactly what she was wishing for. What a God!

155

Sunday School Tea party with God's gift of tea cups

When I related this story to my sister, Bettie, she jumped up and left the room. She returned with a fragrant-smelling box. Opening it, I found a beautiful china tea pot filled with aromatic tea bags. How did she know? Bettie explained that when she and David were married they received two identical tea pots and she never returned the duplicate. Did God really plan this that long ago? As she placed the tea pot in my hands she said in a husky voice: Now, when you use this tea pot in Africa and I use my tea pot here in America it will be like a special bridge between us."

I think it's a worthy story to share, especially with young people, that God wants to hear our heart's desires and that he KNOWS us and longs to show us his faithfulness and love. My NHS students were touched as I challenged them to truly share with their Father, as His is a lavish love.

The NHS luncheon was to be the last I'd have at ICA so I'm glad it was such a happy and positive gathering. It was August 19th, 2002; exactly one month after the eight men invaded our campus and one month before another series of catastrophic events. God was leading us one step at a time, giving us sunshine between the storms.

Later that evening, Ken told me that he was still feeling quite ill, so I should call the administration to inform them that he couldn't

make it to class on Monday. Despite his high fever and other symptoms he responsibly put together his lesson plans for his substitute.

As I sat on the steps of our back porch, watching the grazing cattle while waiting for a friend to pick up Ken's plan book, I began to feel rather queer myself. Refusing to admit I was getting sick too, I later walked up-campus to teach my classes. I think I did a poor job of it before staggering home and collapsing in bed with a high fever like Ken's.

For the next few days we were both extremely ill. I could not even stand. Ken felt only slightly better but he slowly wobbled downstairs to bring back crackers and juice. I forced myself to eat a cracker or two a day and only sipped the juice. Head, stomach, intestines, body aches, fever—I could barely raise my eyelids and had to crawl to the bathroom, pausing every few moments along the way. I thought I was going to die but was too sick to even care.

A day or so into our sickness, Brenda Allen, the school nurse appeared at our bedroom door. She brought us an assortment of drinks, and took away vials of our blood. I only remember her fuzzily but felt a glimmer of hope, just having her nearby.

Brenda returned with word that we had some sort of bacteria dysentery, probably typhoid fever, and began treating us with strong anti-biotics. By the end of the first week Ken was much better and returned to teaching on Monday, although still very weak and fifteen pounds lighter.

I continued to feel utterly miserable until the end of the second week. One day I awoke feeling well enough to prop

Brenda Allen, our school nurse.

157

up a book and read. Brad Nelson, a pastor from John Piper's church in Minnesota had come out to be our school chaplain several years previously. He'd left a pile of books with us which I'd not had time to read. Now was the perfect time!

I began reading Jerry Bridges' book, *Trusting God*, and feasted on his words of truth. With all the events that had recently occurred, it was just what I needed. With all that was soon to happen, it would prove to be a needed source of comfort. Bridges pointed me to a new awareness of God's proving Himself faithful, again and again in my own life as well as throughout the Scriptures. Our God is worthy of our trust. When inexplicably bad things happen in our lives we do not need to ask "why?". We can know that God, the proven, faithful, constant God of love is in control. He will not allow anything in our lives which has not already passed through his loving hands. Sickness? Yes. Death? Yes. Unfairness? Yes. Trauma? Yes.

I don't remember where I first heard it but I've quoted it often: sometimes God stills the storm but sometimes he walks through the storm with us. Only He knows which is best for us, to mold us into His image.

Monday of the third week I decided I should return to teaching. Rather overambitious, I had to stop and rest every ten steps or so while walking to and from the classroom. I dropped back into bed as soon as I returned home. But, I did it! My students were such a joy and I loved teaching them so much, I felt that returning to the classroom was a part of my recuperation. My advanced students were working on facial portraits from life, illustrating the six basic emotions. Their work was looking great! Some were so well rendered, they were already professional level work. Seeing the students' growth was a reward in itself, a good medicine for my soul and spirit.

Gradually I regained my physical strength. Ken seemed to bounce back more quickly this time. Now a month after I fell sick, I'd regained about seventy-five percent of my energy. I would be thankful for even that much in the days to come.

My classroom, the last door on the left.

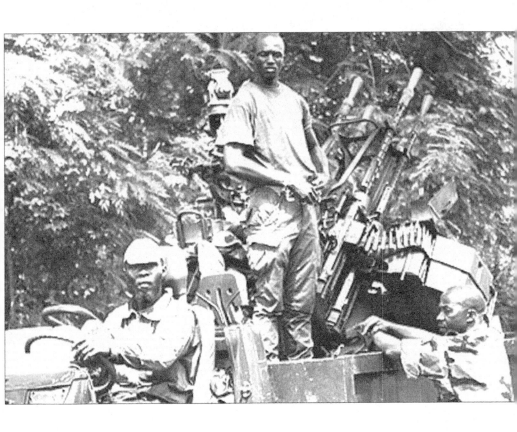

et us then approach the throne of grace
 with confidence
 so that we may receive mercy
 and find grace to help us
 in our time of need.
 Hebrews 4:16

Chapter 13

As Ken and I returned to classes after our bout with typhoid, we did so
with optimism. The 2002-2003 school year was beginning well, despite
the mounting tension outside our walls. Several new teachers had joined
us, including a Korean gal who came in response to the increasing
number of Korean missionary children at ICA. She submitted inter-
esting Korean vocabulary words to the daily bulletin, which we all tried
to practice and learn. Altogether, there were perhaps six or more new
singles, all who seemed to get along with each other really well. The
veteran teachers reached out to them, but they drew strength from each
other as well as from their faith. Coming to come serve in West Africa
required a big step of faith.

 With practice, everyone became quite proficient with lock-downs.
The Crisis Management Team tried to imagine every scenario and
how we as staff would respond—quite a daunting task. If one type
of situation arose, we would lock-down inside the closest building;
in another situation after an initial lock-down we'd walk quickly and
silently walk to the chapel, which was chosen for security reasons. In
yet another scenario, we would go through the first two types of action,
followed by an actual off-campus evacuation. Each person on campus
was assigned a place on a vehicle, knew where his/her evacuation bag
was kept, and had certain jobs to complete. We'd practice each different
scenario, including loading up our vehicles. The kids' attitudes were
great, even light-hearted. At times we'd have to remind them of the

seriousness of what they were doing.

The eight campus dorms were not as full as past years; a few parents had not sent their children due to the increasing crime rate, others were just on home assignment for the year. Our total enrollment was down about fifty students, but we were still fully functioning, including the two middle school dorms. One was for girls, the other for boys.

Dave and Denise Golding had responded to their mission's request (C&MA) to serve as dorm parents the previous year and stayed for the current year. They had three children, Josh in ninth grade, Mark in sixth, and Nikki in fourth grade. The family fit in well with their humor, optimism, and wisdom. They loved the boys placed in their care and the boys loved them. Dave, at well over six feet, worked out regularly but always spoke with a quiet smile, earning the nickname *Gentle Giant.*

After he experienced some chest discomfort, Brenda, our school nurse, sent Dave down to Abidjan to see a cardiologist and have some tests done. The doctor examined him, ran a couple of tests, and decided his problem was due to stress. He was to gradually return to his usual activities and try to relax more. So, Dave returned to Bouaké, and began to follow the doctor's instructions, always with a smile and as often with a joke or kind word.

Thursday, September 18th, 2002

Soon after Dave's return to campus, the emergency sirens went off, signally us to meet in the chapel.

Dave had collapsed on the track during his daily run with their German shepherd. Within minutes he was receiving CPR before being taken to the hospital in town. It was very serious. The students were sent to their dorms or homes immediately after the assembly informing them of Dave Golding's collapse, so their dorm parents or parents could break the final news in a more private and personal setting: The man they knew as Uncle Dave had died at age forty-four. Classes were put on hold as everyone tried to process this shocking news. He'd eaten breakfast in the dining hall, sent his dorm boys off to school, kissed Denise and left for his run. It was the last anyone saw of him alive. The loss was devastating. Our hearts went out to Denise and the kids. Most of the campus was in a state of shocked loss. But our

grieving was cut short.

Rumors were flying. There had been movement in town, of men with weapons. There were news reports that a coup d'état had been attempted in Abidjan and Yamoussoukro. Dan, our director, and Eliz, our principal, asked the day students to stay home the next day, as a precaution. With Dave's death fresh on our hearts no one expected to be able to teach or concentrate on studying, but we would hold classes for those able to attend. We were trying to hold onto some semblance of normalcy.

<p style="text-align:center">Friday, September 19th, 2002</p>

Whaaaaaaaaaaaaaaaaaaaaaaaa! Whaaaaaaaaaaaaaaaaaaaaaaaa! Whaaaaaaaaaaaaaaaaaaaaaaaa! The sirens drove us into another lock-down. What was going on?! With Dave's death, drills had been postponed indefinitely. Was it an accidental alert? Was the gunfire in the distance the usual military practice or something else?

The atmosphere was already tense; emotions were high. I had returned home, after my last class of the morning. Quickly dashing outside to see if anyone was left out in the open, I yelled to several African workers to run into our house. We took cover on the cement floor, along an inside wall, trying to avoid the large windows which could send shards of glass flying if they were to be shattered by bullets. Hearts pounding, we realized even our safest position could place us in the line of fire. No matter where we huddled, we were in the arms of Jesus. He would be the one to keep us safe.

The next forty minutes seemed to last forever. All was still, except for the occasional call of a bird. What was going on? We were far from the siren, and with the doors and windows closed I wondered if we'd missed a follow-up signal. Creeping on my hands and knees across the floor into the living room I found the phone was still working.

"Quick! Go to the chapel!" After a brief explanation that this was NOT a drill, we walked quickly together over to the chapel, on the far side of the soccer field.

We found organized chaos at the chapel. Soon, the Crisis Management Team (CMT) quieted down the excited student body. Many of them didn't realize this was not another practice. Ken and I each eventually found all the people on our lists. We waited tensely while

ICA Chapel

those who were missing were located. Nearly three hundred people were crammed into the simple rectangular building, sitting on the floor, standing, or leaning against the walls. The doors were closed and locked. It was stifling hot, easily 95 degrees Fahrenheit, and humid. Time passed. Stomachs started to growl. People needed a restroom, of which there was none in the building. How much longer could we stay here?

The lock-downs had been triggered first by gunfire. Then, men in military uniforms—rebels, vigilantes, or soldiers, we could not tell--pounded on the entry gate demanding they be allowed on campus. Our guards wisely ducked down and refused them entry. Before the men could batter their way through, more gunfire erupted. Realizing they were in an exposed position, they ran off into the bush. Simultaneously, the alarm was sounded and the lock-down put into motion. It was to be the first of many confrontations at our gate.

While we waited for what seemed like an eternity in the chapel, Dan, Mike and a couple of other adults stayed outside with their walkie-talkies, assessing the situation, gathering information, and trying to make wise decisions with very limited resources and much at stake. When the sounds of firing weapons began to diminish, the team made a bold move: To make a dash to the nearby high school guys' dorm, Beth-Eden. It was the largest dorm on campus, with the only

basement recreation room. Most of the African staff returned to the safety of other dorms or homes. The dining hall staff returned to their work in the kitchen. We packed just over two hundred people in a dorm built for twenty-eight! Before long, the dining hall staff courageously carried the hot food they'd prepared across the open road. They arrived to hearty applause and smiled in response, glad that they could do their part in helping out in time of crisis.

My assignment was to stand at the locked side door, notebook in hand, recording names with times of arrivals and departures. We wanted each person accounted for at all times. Only adults were allowed to leave when absolutely necessary. The Crisis Management Team (CMT) continued doing their job: managing our crisis.

Dan called the US Embassy in Abidjan. Due to the uncertainty of the situation, we tried to limit communication with the outside world. Part of the reasoning was to not cause panic and anxiety for our families, churches, and supporters. Surely this crisis would blow over quickly, like the coup d'etat of December 1999. Rumors were flying, but no one knew for sure who was behind the uprising or the reason for their actions. The supposition was that we were caught in the middle of another coup attempt. Eventually we would learn that the fighting was started by 700 disgruntled ex-soldiers, joined by other men from the North who felt disenfranchised. We hunkered down and tried to make the best of the situation.

AP students bemoaned not bringing their books with them so they could study and do their collateral reading. Other students found board games to play; groups sat on the floor talking; two students who'd come down with malaria were relegated to a bedroom. Many of the staff wrote emails to family members to tell them of the situation, assuring loved ones that they were fine. It was a time of waiting; a time of uncertainty. Many prayers were sent up. It was a long day.

Towards evening the dining hall brought us another welcomed meal. We'd been in lock down for eleven hours and everyone was getting cabin fever. The CMT made the decision that those staff living in houses or apartments would move into various dorms. Communication, and hopefully safety, would be better. The ten-foot high cement security wall that was being built around campus was nearly done, but a 100 foot gap at the bottom of the soccer field down to Marigot Manor

was open. The two strands of barbed wire bridging the space would not provide much protection. That gap was a real source of concern.

With the echoes of gunfire in the distance, Ken and I ventured out into the darkness, down the dirt path to our townhouse. Working quickly, we threw into a bag what we would need for several nights in Baraka dorm. So, we returned to a familiar place, already full of memories. Dorm parents Bill and Nancy McComb lent us their pull-out couch in their living room.

The gap in the wall surrounding our compound.

While the Johnson family stayed in a couple of the empty dorm rooms, Dave spent most of his nights on the sofa. He'd volunteered to get up every few hours during the night to add diesel to the large generator which powered the entire campus. The electricity supply from town had been cut off without warning, so using the generator was our only power option. With limited fuel and no re-supplies available, priorities had to be made. Night-time power was important because it pumped the school's water up into the well and water tower. Even more important were the lights which illuminated the perimeter wall. The men taking turns on night watch had to be able to see if anyone (soldier, rebel, or looter) was scaling the wall onto campus. With sporadic gunfire in the distance, sleep did not come easy but we finally dropped off into a troubled slumber.

Saturday,
September 20, 2002

All of us in the dorm awoke groggy but unscathed and hungry for breakfast. We'd brought back numerous loaves of bagettes from dinner the night before, not knowing what the security situation would be in the morning. The girls slapped butter or jam or Nutella onto their slabs of bread while they sipped their Nescafe instant coffee or tea.

The water tower stood along the wall, completely exposed.

Siphoning gas for our generators.

By now the staff was communicating across campus by walkie-talkies, originally purchased while stateside because of the unreliability of our phone system. Sharing information helped keep the tension level lower, rather than having the emergency siren blaring each time we needed to lock down. We sheltered the children from the more distressing updates. Word had gotten out to the world and journalists were calling from the four corners of the globe. Tim Carden was put in charge of communicating with them so the CMT could do their job.

With no electricity during the day, water was precious but all of the kids were getting restless from so much inactivity. When there were no sounds of fighting close by, we allowed the kids to play in the water, squirting each other with hoses, releasing some of their pent-up energy. For the first time in two days, the children had a whole hour to play out in the open.

Dan was communicating with the American Embassy in Abidjan, trying to get help with an evacuation. He was told repeatedly to just hold tight and we'd be okay. In response he would hold his cell phone in the air to better broadcast the weapons firing around us, then speak into the receiver.

"No! It is NOT okay! I need to get over 200 people out of here before someone gets hurt!"

His frustration with their broken promises and inaction led him

Dan and Mike talking over developments in the fighting.

to grant a phone interview with CNN. Surely the focus of international attention would bring help in our plight!

That evening, when the generator powered up again, we eagerly watched CNN on the school's TV, waiting for Dan's interview. Much to Dan's chagrin the headline emblazoned on the screen read, "Caught in the Crossfire!"

What?! We were not caught in crossfire! The report contained other discrepancies. While we were glad the word was out, we had hoped for greater accuracy. Dan decided that from then on he would only communicate with Reuter's news agency. Now we waited for action. Little did we know then how prophetic was the CNN headline.

As we waited we began planning a service for Uncle Dave Golding. The necessity of repeated and extended lock-downs had prevented us from expressing any true recognition of the loss and grieving our campus was undergoing. The service would allow us to honor Dave and comfort his wife, Denise, and their children. The memorial service was scheduled for Sunday afternoon, if it was at all possible. As I planned flower arrangements, I asked one of my advanced art students, Amber Falk, to draw a portrait of Uncle Dave for the program. Her drawing captured his gentle smile and twinkle in his eye. His son, Josh, would have relied on his dad to help him make a frame for the picture. Now, other dads helped and supported him as he worked--an act of love, accomplished in the dark of the night.

Sunday, September 21, 2002

Dashing back into the dorm after breakfast due to gunfire nearby, we remained locked down as the noise grew fainter. Girls painted toenails, told stories, and tried to keep occupied the rest of the morning. Lunch was another hasty affair in the dining hall, with another sprint back to the dorms as an alarm sounded. Lock-down! No one was allowed outside. Tension was building again.

Deafening mortar and machine-gunfire erupted. The walkie-talkie report confirmed what our own ears told us: a major battle was taking place within 100 yards of the school. Lock down NOW! And STAY locked down!

As the girls dove under their beds, curtains closed despite the tropical heat, Ken and I huddled in our makeshift bedroom. Minutes

passed. An hour. Two hours. I couldn't take the isolation from the girls any longer. As Nancy crept into one wing of the dorm I began at the other end of the hall and crawled into one dorm room after another, checking with the girls who were hiding under their beds. Trying to reassure them, I prayed with them, claimed Bible verses, and sang them a song. Usually I chose *His Eye Is on the Sparrow*, a song I sang to our own children growing up. The words declare comforting Biblical truth: God's eye is on the sparrow, and I know He watches YOU. The girls' smiles reminded me to trust Him if I grew anxious as well.

After three hours the battle had moved past us, so we finally climbed out of our hiding places, eager to gather for the memorial service. I didn't have much time to go cut the flowers for the service. Dorm dad Dave Shady kept watch while I clipped stems, gathering as many as my arms and basket would hold. Snipping and plunging the stems into the vases, a couple of the high school girls helped me arrange the bouquets. We carefully placed them in the chapel, surrounding the easel holding the newly framed portrait of Dave. Josh had done a good job on the frame. I hoped that making it helped ease his pain, if even a bit.

The service which followed was a true tribute to a wonderful man. Dorm administrator Evan Evans and Chaplain Randy Fudge had prepared a memorable time of worship and commemoration for their friend and colleague. For over two hours we honored this godly man, with student after student taking the microphone to relate memories of what Uncle Dave meant to them. There was a great deal of weeping as their loss was expressed. Then a staff member stepped up to sing Mercy Me's song, I Can Only Imagine, which renewed the tears but offered great comfort.

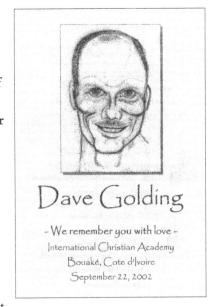

Dave Golding

- We remember you with love -
International Christian Academy
Bouaké, Cote d'Ivoire
September 22, 2002

I Can Only Imagine *
*I can only imagine what it will be like
When I walk by Your side.
I can only imagine
What my eyes will see when Your face is before me.
I can only imagine.
Surrounded by Your glory, what will my heart feel?
Will I dance for You, Jesus, or in awe of You be still?
Will I stand in Your presence or to my knees will I fall?
Will I sing Hallelujah—will I be able to speak at all?
I can only imagine.
I can only imagine when that day comes
And I find myself standing in the sun.
I can only imagine when all I will do is forever worship You.
I can only imagine.*

While the student body met in the chapel, behind closed doors, the Crisis Management Team kept watch outside manned with their ever-present walkie-talkies. Eliz Carden later told me that during the service the campus was entirely surrounded by heavily armed soldiers. The CMT waited tensely to see what they were going to do. Eliz said that the service was of such vital importance that she was NOT going to stop it, unless she saw soldiers crossing the soccer field marching toward the chapel. But inexplicably, the soldiers dispersed before the service was over. The students never knew the danger they had just passed through.

One might think we'd have gotten used to gunfire and mortars hitting in the distance but we had not. Sunday night was yet another stretch of broken sleep. Dave faithfully and inconspicuously refilled the generator, sleeping on the sofa so he wouldn't disturb anyone. The security lights were particularly important after such close contact with the fighters, who could have touched our walls as they passed. I don't know what we would have done if men did gain entry onto campus. We didn't have guns or other traditional weapons for our protection. But, we did have the weapon of prayer and God's guardian angels. I am

* Music and Lyrics by Bart Millard. Published by Simpleville Music, Reprinted by licence

convinced we were supernaturally protected. Prayers were being sent up from around the world. God was listening.

Monday, September 22, 2002

Groggy after repeatedly being jerked awake by the sounds of war, we welcomed the hot coffee awaiting us in the morning. Our conversation in the dining hall centered on the events of the previous day. Dave Golding's service was seen as a very positive step toward healing those bereaved, as well as a worthy recognition of a beloved man. Everyone was still in shock, to an extent, but the service was a good beginning to a sad ending. The 'Battle of the Bridge', as it was to be later called, was the second item of conversation. Our guards, covertly searching the countryside from their upper level lookout station, reported seeing men carrying bodies in wheelbarrows toward town.

Although there were some explosions in the distance, the morning was relatively calm closer to the school. We kept to our security measures, not knowing if fighting would erupt again. I wondered if the two sides were licking their wounds, using the day to regroup. Our students were getting restless again. Living much of their time outdoors, except when they were in class, they were not used to so much inactivity. We opened the gym for them to play in during the afternoon though they were not allowed to leave the building. Despite the fact that our tin roofs were so thin, we hoped that they would offer some protection against stray bullets.

Since the previous Friday morning no one had been permitted to enter or leave the campus. An armed soldier, or a contingent of soldiers were posted at the gate, preventing anyone from entering or leaving the school. We were virtual hostages. Were the soldiers in uniform rebels or loyalists? We did not know, we were just caught in the middle of an internal struggle. Although we didn't have any answers, we held tight to the faithfulness of our God, the sovereign omnipotence of our loving Father.

At dinner that evening Dan Grudda announced an adults-only meeting after we'd eaten; the children would play in the gym/ community center. A sense of nervous optimism prevailed as the countryside seemed calmer. I remember thinking back to the last coup d'etat in December of 1999. At that time, there was some gunfire at the

military camp nearby, and our ability to travel was restricted movement for a few days. But, soon life returned to normal for us. No big deal. Surely this would be another such event. We just needed to be patient. Yet, another voice inside me said, "This is far more serious."

I later learned what the meeting was supposed to cover, and it definitely was not for children's ears. The nurses were going to tell us what to do in case of serious injuries, bullet wounds or injuries from rocket propelled grenades or mortars. Another topic to discuss was what to do if soldiers forced their way onto campus, into the dorms and grabbed teen-age girls to rape. What would we do? What if the rebels started killing individuals to emphasize their position and bring attention to their demands? These were extremely difficult subjects to even think about, but they were certainly within the realm of possibility in our situation and the leadership wanted us to be prepared should we face violence on our campus.

We never had the meeting.

Instead, all hell broke loose.

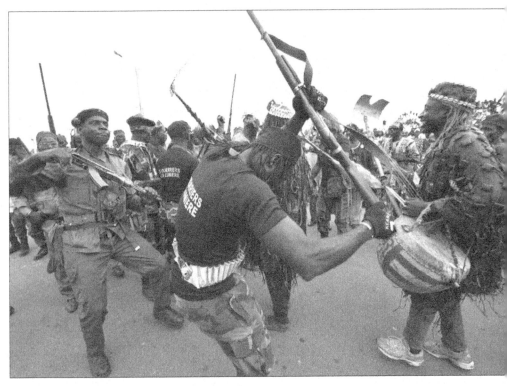

Traditional hunters, now soldiers, celebrating.

*We have no power to face this army
that is attacking us.
We do not know what to do,
but our eyes are upon You.*
2 Chronicles 20:12

Chapter 14

Monday Evening, September 22, 2002

Rat-tat-tat-tat-tat-tat! A round of machine gun fire pierced the night! The sound echoed outside our windows. Had the fighters stormed their way onto campus? We dropped to the floor, scooting along until we reached a wall, pulling the long dining tables over and around us for cover.

Tracer bullets lit up the sky as we watched in both shock and terror. Mortars and gunfire erupted all around us. The sound was deafening. Red tracers bullets arched across the campus.

The battle for our town of Bouaké had begun at our campus.

Ken and I landed near the doors closest to the dispensary, huddled under the table with three of the new teachers. With faces bunched in anguish, two of them were crying and repeating, "We're all going to die."

"No, we're not!" I said as calmly and decisively as I could. "It's going to be okay."

One teacher continued to cry and I realized that he was on the outside position of our huddled bodies. When I insisted that he change places with me to a more protected place he gratefully accepted. I turned to him and gently stroked and patted his shaking back, trying to settle him down. At one point I was patting the backs of two teachers at the same time. It certainly helped keep me from thinking about myself.

Our corner was not the only place where people were crying out. I could hear the tears in the voices of friends as they struggled to remain calm. After an especially loud burst of gunfire, a voice called out, "They're inside the campus!!!"

Dan Grudda stood up and shouted back, "No! They're NOT inside!" Surely he sought to calm us and prevent panic in the middle of the chaotic situation.

Everything was happening so fast.

When Dan stood, so did several other people, including the CMT and the dorm dads. What had happened to the children? They were determined to go outside and find out, despite bullets flying overhead. Brenda later told me that when she stepped outside she fully expected to see bodies of our precious children lying on the ground, wounded or dead.

Entrance to the dining hall.

But there were no children in sight. The adults ran frantically to find them. Where could they be? Thankfully most of the kids were in the gym, huddled against the wall as they'd been trained to do. Older kids took charge of younger kids. Although two sides of the gym were open-louvered doors no one was hurt. But the men quickly realized that not all the children were accounted for. Where were the rest of them?

Back in the dining hall I could hear Nancy McComb talking to

Bill on her walkie-talkie. Brady and Bryan, the two-year-old twins, with her but four-year-old Ian and five-year-old Josiah (JJ) had gone out to play with the other kids. I could hear only one side of the conversation. Long pauses stretched between the spoken phrases as she waited for a response to her questions.

"Bill, have you found Ian and JJ?" ………..

Minutes later, "Thank God! JJ is okay? Ian wasn't with him?"………..

"Bill, where's Ian?"………..

"Bill, have you found Ian?"………

"Bill, where could Ian be?"…………..

I then heard Nancy turn to her twins and tell them in the midst of the battle, "Brady and Bryan, it's going to be okay. Our family IS going to be together again. Whether it's here on earth or in heaven, we WILL be together."

I'd born up pretty well up to that point but when I heard those words I lost my fragile control. I couldn't prevent the tears from coursing down my cheeks. Yet, God is the one who created tears and I think he knew I needed that release right then. My tears were short-lived as I didn't have time to indulge myself with the world still crashing down on us.

The battle seemed to go on forever but of course it didn't. Almost as quickly as it started, the sounds of warfare passed on, moving on into the town of Bouaké itself, six kilometers away. The sounds of fighting grew more sporadic around us, eventually becoming more distant.

In the relative quiet we spilled out into the plaza between the dining hall and the gym. Everyone had been instructed to go directly to

their own dorms, where we'd take roll and try to comfort some pretty shaken up kids. This sounds very organized but in fact with so many traumatized people running around, many of them not knowing what to do or where to go, it took a good while to collect everyone and calm them down enough to get them inside a safe building. Walkie-talkies continued to provide communication as lost students were found, including little Ian McComb.

Ian later told us that when the first shots of the battle rang out, he ran into one of the gym's bathrooms and locked himself down. As he sat there on the floor waiting for the gunfire to stop and for someone to find him, he began to look around him.

"I was just staring at the tiles on the wall, when all of a sudden I saw something! I saw that where the tiles meet (the grout) they form a cross. Dozens and dozens of crosses! I knew Jesus was with me!"

As we tearfully but gladly reunited in the Baraka living room we counted noses and gave the girls some time to debrief. Our time was cut short as it was still a wild and crazy evening. We didn't know what was going to happen next. Suddenly, the generator began producing precious electricity. Several of the girls came to me with a seemingly unimportant but crucial need: they were out of underwear! With the daytime power cuts and strict conservation of water, we had been unable to do laundry since the crisis had begun Thursday. Now we faced an underwear crisis!

The laundry room was a simple concrete shack. To access it we'd have to dash fifty feet across the back yard, dipping under the clothes lines. Should I do it? I heard no gunfire nearby so decided to take the risk. Gathering up the large bag I ran as fast as I was able. Filling both machines took only a few moments. After carefully looking and listening for danger and discovering none, I darted back into the relative safety of the dorm.

The girls whose laundry I had taken met me at the door and thanked me with hugs. They also volunteered to help hang the garments on the clothes lines when they were ready. I kept checking my watch, trying to figure out how long the cycle would take. I didn't want to make a mad dash outside and find myself waiting alone in the darkness any longer than necessary. The very air smelled of smoke and spent ammunition. Again, after looking and listening for danger I

sprinted out to the laundry room and started pinning up the girls' important items. Eager to help, several girls jogged out and started pinning away like mad beside me. Going through a war is bad enough, but if you can't do it in clean underwear, then it's really bad!

Out of the darkness a flashlight swung around blinding us. My heart leapt.

"What on earth are you doing, Julie?!" Brenda demanded. As a CMT member she was out patrolling campus, making sure all was secure. She was NOT happy to see us.

"Get back inside! There could still be soldiers lurking around out here! You're in danger!"

As she turned to go, we hurriedly threw the rest of the things on the line. Looking up, we could see flames visible on the hill next door, lighting up the dark sky. The rebels had set fire to the large chicken farms which flanked the road into town. The flames confirmed Brenda's ominous warning.

No one slept much that night. Dave Johnson continued his pilgrimage to the generator house, accomplishing an increasingly important job. It was comforting to hear the constant rumbling of the generator, but the harmony to that soothing sound was the cacophony of mortar fire, machine guns, and rocket-propelled grenades, from the continuing battle in Bouaké. We had friends and day students in town. Several of our parents were attending an area-wide workshop on Crisis Management at the SIL (Wycliffe) Conference Center, only a kilometer away from the fighting. They heard the raging battle and knew it was across our campus. Unable to contact the school, parents were frantically worried. Knowing the fighting had turned in their direction, we on campus worried about them.

The short, sleepless nights and the stress of uncertainly were taking their toll on everyone. Again, I recounted God's faithfulness and protection as we lay on our makeshift bed. He had been preparing us for this time of crisis.

"If God be for me, who can stand against me?"

I fell into an interrupted sleep recounting the oft-repeated saying: God is good, all the time; all the time, God is good. Circumstances were not good, but God was.

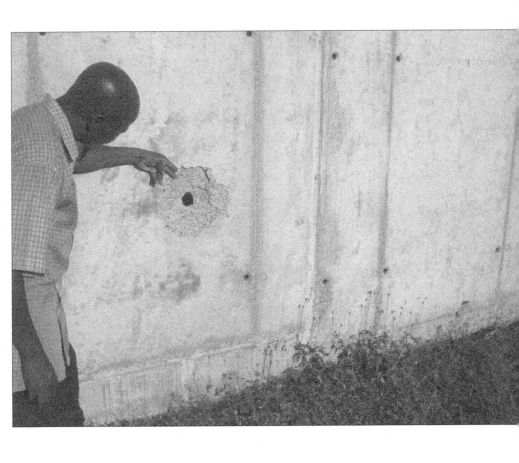

D*on't be afraid....*
 Those who are with us
Are more than those who are with them.
2 Kings 6:16

Chapter 15

Tuesday, September 23, 2002

Tuesday morning found us bleary-eyed and wondering what the day would hold. Surely today we would be evacuated! Surely the world would see the vital necessity of getting 150 children out of this war zone!

Our evacuation bags were ready, although now inadequately packed. The original plan for an evacuation was to walk some kilometers to a neighboring village, spending a week or however long it took for the crisis to blow over. Our packs held such essentials as a spoon and bowl, toilet paper, and a couple of changes of clothes. The bag was to be light enough to be carried easily for some distance.

Now our plans changed as it was not safe to walk to a village. The secondary plan of US Marine helicopters landing on the soccer field, taking small groups at a time to a safer location, was dropped as well. The rebels threatened to shoot down the helicopters if they tried to enter their space. Negotiations were taking place. Dan, knowing the language the rebels spoke, was doing his best to try to communicate with the rebels at our gate during calm periods. The rest of us laid low, ready to lock-down at a moment's notice.

"Open the gate! Let us onto your campus!!! You are surrounded!!!" the rebel soldiers screamed, threatening to shoot their way in. The alarm was sent out: LOCK DOWN!

Rat-tat-tat-tat!!!! Gunfire erupted into another hail of bullets whizzing overhead as Dan and Mike ran from the gate for cover. They felt

the breeze of the bullets passing through the leaves of the trees right over their heads. One large bullet crashed into the inside wall, passing through the eight inches of re-enforced concrete and leaving a large hole behind. Another battle had begun. The rebels outside of the gate ran for cover in the bush as the first bullets began to fly. They did not attempt another assault on our gate.

Despite the gap in the wall in Marigot Manor no soldiers entered campus. Although we'd been surrounded numerous times during the week, only once had a soldier crossed the space where the wire fence had been cut. Seconds before the battle the previous night one of our African workers reported that he saw the rebel step over with his Kalishnikov raised. As Silas dove into a trench he kept his eye on the man. With gun raised the rebel fired several rounds into the air then ran back over to join his fellow rebels.

His initial rounds of fire sent us all scurrying for cover. There was a brief pause before the true battle began. The rebel's shots probably saved us from injury or death. Did God direct him to fire?

Why didn't the rebels or government troops flood through the gap in the wall onto campus? It didn't make sense. We thought of the story of Elisha. Ken drew an excellent parallel to our situation. In the margin of my Bible, by 2 Kings 6, I made the notation "Lock-down Sept. ICA 2002 Wow!"

The strong army of Aram had surrounded the Israelites with horses and chariots. Elisha's servant asked, "What shall we do?"

"Don't be afraid," the prophet answered. "Those who are with us are more than those who are with them."

Then Elisha prayed, "O Lord, open his eyes so he may see." Then the Lord opened the servant's eyes, and he looked and saw the hills full of horses and chariots of fire all around Elisha.

Did the soldiers not cross the boundary onto campus because they saw chariots of fire or our guardian angels? Whatever the reason, we know God was in control. His mercy endures forever!

In between lock-downs that Tuesday Dan told us to get ready to evacuate campus. It was still uncertain how we would be leaving, but leaving was imminent. Surely, someone would come to rescue us!

As we prepared, those who had pets faced a difficult decision. What would happen to the animals? We couldn't take them with us. An

African worker, Desiré, volunteered to feed the dogs if we left enough money for their homemade food. We even signed a contract giving him guardianship of own precious canines. The agreement stated that if he didn't hear from us in three months he could give them away or put them to sleep. It was the best we could do. Sorrowfully, we hugged our faithful dog, Cobie, and our cat, Willie Mac.

All of the cats and birds and snakes and chameleons and other critters were set loose to fend for themselves in the bush. Our neighbor, Rhonda Rathbun, had one of the most difficult goodbyes. She had been raising a baby chimpanzee, teaching her various tasks and even dressing her in little overalls and shirts. This cute little chimp could not go with us, nor could she be left behind as she would not survive in the wild. After digging a small grave in a nearby field a dorm dad borrowed the sole gun on campus, then shot and buried her. There were so many painful goodbyes, it seemed just one more gut-wrenching passage. By now, most of us were near the end of our resources and just wanted to see an end of it all.

The rest of that day was spent in deep conversation among the students and staff. We didn't know how our situation would end. Our mortality was fresh on our minds, as we continued to grieve Uncle Dave's death. This was no time to wear a mask; people shared from their hearts. Pretenses were cut away, no more play-acting. Groups and individuals clustered in conversation and prayer. Relationships were healed and deepened. Kids and adults mutually expressed how much they loved each other.

The heartfelt expressions continued that night as the gym was opened for a time of saying goodbye to each other, a time for closure. Thankfully, relative peace reigned outside while this important event took place. Sober-faced, we returned to our dorms. After enduring a week of being held virtual hostages - rebels at the gate refused to let anyone enter or leave campus - I was at a near breaking point.

"Oh God, will we really ever get out of here?" I cried. I collapsed on the McCombs pull-out sofa next to Ken.

Yet again, my sleep was interrupted by distant gunfire. Would this ever end? Listening to the rain drumming on the tin roof eventually lulled me back to sleep. God in His goodness gave me one of my favorite sounds in the whole world to sooth my weary soul.

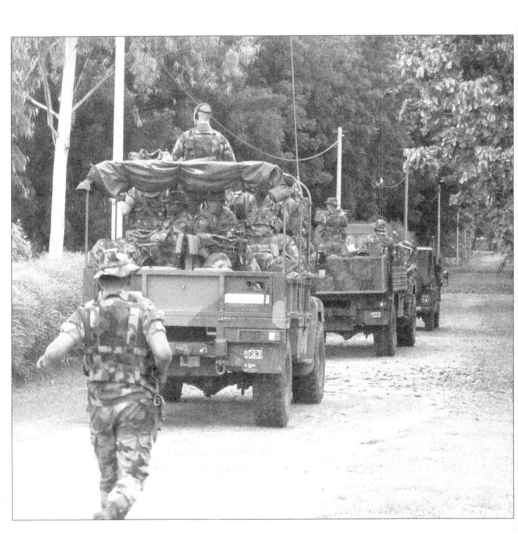

I *have made you and I will carry you.*
I will sustain you and
I will rescue you.
Isaiah 46:4

Chapter 16

Wednesday, September 24, 2002

Wednesday morning broke bright and sunny. Would this be the day? We knew our story was being covered by the international news agencies. Knowing that our family and friends would be worried for us, we were more concerned for our loved ones' peace of mind than our own. Somehow, not being there but hearing about the crisis must be even worse than experiencing it. When you're in the middle of something like this, you just do what needs to be done, and cope the best you can. I kept repeating "in our weakness, He is made strong." It was certainly my faith in an Almighty Sovereign God that was getting me through.

After breakfast the CMT passed the news through the walk-ie-talkie network: we would be leaving, hopefully that day. We had no idea what was happening behind the scenes to make this possible; we were just thankful to hear the welcome news. Over the next days and weeks we'd hear more bits and pieces of the story, including Dan's crucial role in mediating with the rebels for our rescue.

The morning dragged on as we awaited the arrival of our rescuers. Dark rain clouds moved across the horizon. As the adults pondered the crisis, we encouraged the kids to occupy themselves. Girls patted green facial masks on each other and painted their toenails. Guys played board games or tried to imagine what was going on militarily. Our two nurses packed emergency first-aid kits and medications. The dining hall staff continued to prepare our meals from the rapidly dwindling supplies of canned and frozen food.

One of the biggest concerns was transportation. Each vehicle on campus was originally slated to help in the evacuation. But, with the electricity cut off for so many days, the men had been forced to siphon diesel from many vehicles in order to use the fuel for the generator. We counted the number of heads and the number of seats. We would have enough room, squeezed in. No one would be left behind.

No one would be left behind—but Dan Grudda.

On Tuesday the previous evening, Nancy Grudda casually stopped and spoke with several of us after dinner in the dining hall. She asked if we had specific items like Spam, batteries, sardines, and crackers. Furrowing my brow, I asked her why she needed these things. Her reply was in hushed tones. She whispered that she was asking us in confidence; the information would not be announced. Dan would not be leaving with us; he would stay behind with several African workers to try to keep the school secure. They would keep the gates closed to soldiers of both sides of the war, as well as to opportunistic looters. Should the campus be overrun he would take off cross-country with

only a backpack containing survival items, hiking until he reached a safe location.

I thought Dan was a brave man, one after God's own heart, who took his responsibilities seriously. He also had one other important task to perform, which we were to find out about later. So, we ladies offered what little we had along with our tears, our prayers and our blessings.

As Wednesday morning passed, a ripple of excitement coursed through the campus; the French were coming! French Special Forces were breaking

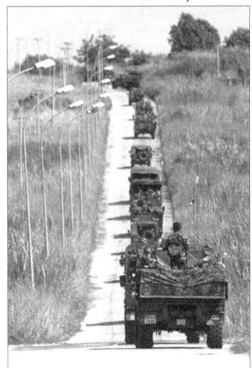

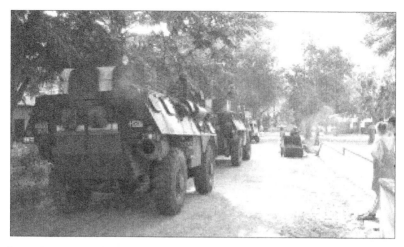

through the miles of hacked-down trees and branches the rebels had strewn across the only East-West road to Bouaké, to act as road blocks. Under a cloudy sky, with rain threatening any moment, the first vehicle was sighted, the French flag waving from an antenna!!

With true African hospitality a small contingent of Dan, his sons, Mike, and a couple of high school guys met the French commander at the gate, extending to him a live chicken, feet first. Since we didn't have

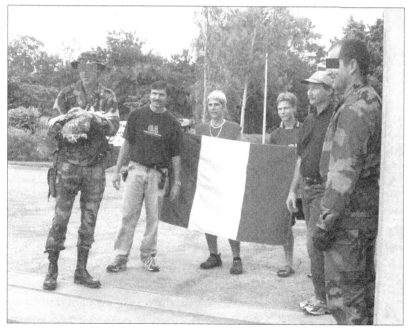

Greeting the French as they arrived on campus.

a goat handy, a chicken symbolized our welcome. These well-armed soldiers were a welcome sight! With a broad smile the commander accepted the chicken and posed for a picture beside a large French flag held by the boys.

The army vehicles started rolling onto campus: tanks, medical trucks, armored personnel carriers, jeeps, trucks—it looked like a whole army, including a mobile hospital! They arrived with a variety of weapons, from mounted machine guns, to automatic weapons, to canons and tanks. Weapons I'd never seen before began being unloaded from the vehicles. The impressive display added to our sense of security.

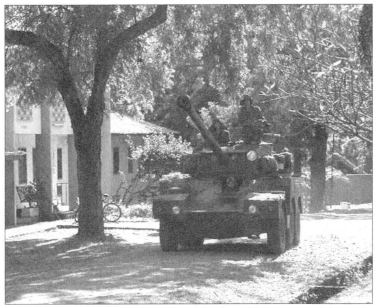

The campus secured.

We were told to stay in the dorms while the French soldiers secured the location. Contingents of troops moved into position: along the front of the school, on top of the water tower, at upper court, near the soccer field and around the perimeter of our thirty-four acre campus. Snipers with machine guns on tripods were positioned on every high place. I admit it was rather disconcerting to look out the dorm window and see soldiers setting up their weapons right outside the window. Our teenage girls broke the tension, remarking how cute certain of the soldiers were. At that, the boys rolled their eyes before

Sniper's nest on our balcony.

returning to check out the too-cool military stuff. Once the perimeter was deemed secure we were allowed out on campus, the first time in a week that we had near complete freedom of movement—out in the open, even! It was glorious! Still, no one was allowed down in Marigot Manor because of the gap in the wall, still open to the outside field. The French later install huge bails of cyclone barbed wire in the gap. I rued not being able to return to our home. After a joyous and rowdy lunch in the dining hall, Ken and I reveled in the freedom of being able to walk around campus, secure in being protected but with our walkie-talkie still in hand. Squawk! A male voice launched into a message for us.

"The French want to set up a sniper nest on your balcony. Could you open up your house for them?"

Could we? You betcha! That meant I could get back inside and repack my evacuation bag! Hooray! Thank you, God! We were given a whole fifteen minutes! Quickly I yanked out the old stained tank tops and cotton skirts and exchanged them for more precious items: irreplaceable photos, a better change of clothes, and my address book. As I glanced in the small study I swiped up a handful of my best paintbrushes. I wildly looked around, wondering what I should pack knowing I would probably never again see whatever I left behind. I breathed another goodbye—this time to our home, representing so many memories. Would we ever see it again? Thankful for the opportunity to

Dan, Mike and Wes Nevius stayed behind to close the campus.

grab a few items, I surrendered the rest to God, but the sacrifice was still painful.

"We're leaving in one hour!"

After such a long, long wait, everything seemed to be happening all too quickly. People dashed to and fro, gathering up bottles of water, sacks of food, and evacuation bags. Vehicles were checked and lined up in the order they were assigned. Checklists were consulted. Nose counts were made. Walkie-talkies squawked everywhere.

Finally, the caravan was ready to depart. French army vehicles led the convoy and were interspersed between every third or fourth vehicle. We passed the red warning flag posted outside the school office and approached the gate. At the guard station Uncle Dan stood waving at us, a smile on his weary face. Uncle Mike Cousineau and Wes Nevius stood beside him as their families drove by. These brave men had learned of Dan's plan of staying and insisted on staying with him! While we were relieved to be rescued we were still sad to be leaving Bouaké, especially leaving behind so many dear friends of all nationalities. Survivor's guilt is an apt term. I wished we could bring everyone with us! But, we didn't have that luxury. We did pray for their safety, as our long line of vehicles began the perilous journey.

Rolling onto the highway littered with the remains of the road-

190

blocks, I gazed into the trees and elephant grass beside the road. I was startled to see coal-blackened faces of French soldiers staring back at me from behind their hiding places. As we slowly snaked along, swerving to avoid the obstacles, I glance at the sky.

"Hey, look!" I called to the others. "I see a rainbow!"

Once again, in a beautiful display, God was reminding us that

He keeps His promises. We relaxed, knowing God was with us each kilometer of the way.

Eric and Jessica Debrah, high school students from Ghana, sat in the back seat of our little red jeep. Their dad was a scientist working for the West African Rice Development Association; their mom was an RN serving at the US Embassy in Mali. These two were kids we knew and loved. No sooner did we begin our trek than we discovered that Eric had forgotten to bring their liter bottles of water from the refrigerator. Ken and I reassured them: we would share our bottles with them. There was no going back and there would be no personal stops. Little did we know how long this usually-short ninety kilometer trip would wind up to be.

Since there was a curfew forbidding travel on the roads we were the only vehicles out and about for the entire trip. We must have made quite a spectacle: an army-green French truck leading our convoy of over twenty civilian vehicles with the armed military vehicles

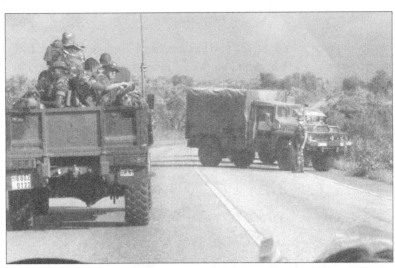

*From top:
Following our
French escort out
of Bouaké;
Sam, a student,
proudly displays
the American flag;
the convoy takes a
roadside break.*

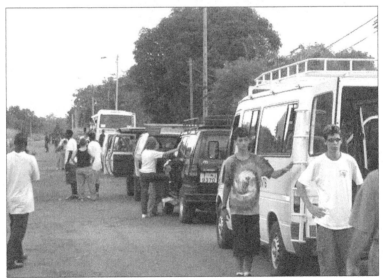

interspersed. The countryside was still in conflict. Were we traveling through friendly or non-friendly territory? Each time we slowed down to pass through a village, soldiers leapt out of their vehicles, landing in a crouch with weapons trained outwards, threatening anyone who would dare threaten us. While I felt protected, it was still pretty unsettling. Of course, the teenage boys thought it was pretty cool.

After slowly wending our way through all of the road blocks, we finally came to the first village not under the control of the rebels. Word came over the walkie-talkies that a mob of reporters from all over the world were waiting for us to pass. Not knowing what to say or do most of us just smiled and waved. But senior Sam Parham had come prepared and rolled down his window. He proudly displayed an American flag between his outstretched arms. We were to see that picture of Sam emblazoned in newspapers and magazines just a few days later, after leaving Côte d'Ivoire. Yet, our future was still unsure at that moment. We drove on through the bush, now wending our way off the main highway.

The heat of the evening was enervating, with no air conditioning in the car to give us relief. Rationing our water, we took sips while nibbling our snacks. Our caravan seemed to crawl, keeping the speed slow to make sure any obstacles or opposition would be seen in ample time to react. In the distance we could hear the thunder of mortars and gunfire. The heaven's rumbling thunder and flashes of lightning from the black clouds added to the surreal landscape.

Before we left the ICA campus we were told that if our vehicles broke down or ran out of gas along the evacuation route we should pull to the side of the road and climb into a French military vehicle. Most likely we would never see our vehicle again. As hour after hour of tense driving passed, our fuel gauge dipped lower and lower. I was just about to push the button on our walkie-talkie to announce our plight, when a voice broadcast good news: so many vehicles were about to run out of fuel that the military vehicles could not accommodate us all. Help was on its way.

Before long, our convoy pulled over. Before the tires came to a complete halt, soldiers jumped out, crouched, weapons ready, scanning the fields trying to see if danger lurked there. We listened but did not hear the sound of the French helicopters that were ferrying in the vital

fuel to us. Taking advantage of the stop, we quickly took a *bush stop* with girls walking in one direction and guys in the opposite direction, each carrying a wad of toilet paper. There was no lingering, as word was passed to quickly load back up. We had to leave NOW!

The French had received word of a possible ambush where we were stopped! We continued on, driving on fumes, until the convoy stopped once again. Soon, soldiers with jerry cans appeared from nowhere and began filling the empty tanks. For funnels they cut off the tops of empty plastic water bottles, unscrewed the caps and flipped them upside down to fit perfectly into the gas tanks. Clever!

We continued to hear the sounds of fighting in the distance. After

stretching our stiff legs and weary bums, we remounted our charges for the final leg of our journey. It seemed like we would never reach our destination. All were so very weary. Brenda Allen, one of our two nurses, had been under extreme stress. She was filling dual roles as Crisis Management Team member while still serving our medical needs. Driving her car full of people, she was in agony from back pain. As an extremely responsible and caring person, she was focused on others, not herself. Sheryl O'Bryan, a teacher, was a passenger. I suggested she take the wheel so Brenda could get some rest. Everyone was so exhausted—near to breaking point--that such a solution hadn't occurred to them.

Ken was bearing up well, considering. Although I volunteered

to share the wheel, he said that driving was actually less stressful because it kept his mind busy. Many hours earlier the four of us had polished off our two bottles of water and scarfed down what food we had. Jess and Eric were good company, using each other to cushion their heads on the bumpy road while trying to get some rest.

"We're almost there!"

As the excited voice rang across the walkie-talkie, I began recognizing landmarks. Normally the trip from Bouaké to Yamoussoukro took an hour and a half. We'd been on the road for ten hours. It was nearly one o'clock in the morning.

As we pulled onto the main highway into Yamossoukro we noticed a non-Ivorian soldier standing alone in the middle of the road. He was one of ours!!! Decked out head to toe in impressive battle gear, he looked like he could take on anything. We'd hear later how God put together this American Special Ops team to take care of us. At that moment, I smiled through my tears, weeping at the sight of this young man from home.

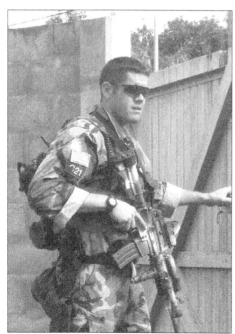

The officer stopped each vehicle as it rolled up to him. He clearly and politely reassured us.

"I am an officer with the United States military. You are being handed over from the French into our hands. We're going to take care of you. Drive to the next road where you'll see another officer and get more directions from him. Welcome!" If those weren't his exact words, they're pretty close.

At the end of our

ropes, this was a welcome reception. A complete surprise, we were unaware of all that had been happening behind the scenes. God was not surprised; He was in control. He wanted us to just trust Him for the details.

The soldier at the next street gave us a similar speech before directing us down the dirt road toward the New Tribes MK school campus. As we rounded the corner we were awestruck at the display of armored personnel carriers, tanks, and heavy-duty hummers, all with guns and mounted cannon. We were going to be well-protected!

Inside the compound were many more soldiers, some on duty, others relaxing, waiting to greet us alongside some of the New Tribes staff. No one seemed to be sleeping! With over 200 very exhausted people wanting

Exhausted!

Prayer circle, thanking God for our rescue and asking for strength in our uncertain future.

to stretch out cramped limbs and sleep, we scrambled to try to get semi-organized. To our amazement, the New Tribes students and staff had spread out mats and pads on the classrooms cement floors to make the remainder of our night more comfortable. With chunks of French bread in their stomachs and relief at real bathrooms, most of our people thankfully grabbed a piece of floor and slept.

Although we were safe, there was still work to be done. In addition to the New Tribes staff and the Special Ops troops, a delegation from the American Embassy had arrived to process us and gather information. After everyone else had given their personal information, Nancy Grudda and I were asked to stay and help them. One task we were given was compiling a list of the other American citizens we could remember who remained in Bouaké. We also made a list of all the families whose children attended ICA but did not live on campus. We finished the lists in the wee hours of the morning but we had one other important task to accomplish before retiring.

Nancy and I approached the ambassador's personal assistant with a request: please find room in your helicopter for a recent widow and her three children. We insisted the Goldings had to get out as soon as possible and her helicopter was the quickest way.

"There's no room. They're Canadians, not Americans."

We were turned away with several excuses. But Nancy and I were not going to give up. When it looked like our request was going to be denied, we told the aide in no uncertain terms that our ambassador would look much better in the media offering assistance to a traumatized and grieving family, rather than denying a simple request for help to a shocked and grief-stricken young widow and her three children. Denise and the kids left early the next morning.

The compound was hushed by the time Nancy and I crept into the classroom to lie on the floor. My mind was still in high gear and despite my fatigue I could not sleep. I wondered how Nancy was coping with the uncertainty of her husband's fate. Years earlier, Dan had served as director of the Yamoussoukro Bible Institute. Their boys had attended this same New Tribes School. With our arrival here, many memories must be reawakening for her. I finally dozed off for a few minutes as the first rays of dawn shone through the louvered window panes.

197

I rose early and helped set up the breakfast--loaves of fresh bread with coffee or tea, jam and chocolate spread optional. Yawn and stretch! The sustained stress we'd been under had taken its toll. Now we could relax at least a bit. We didn't even hear any gunfire! What peace!

The morning was spent organizing, visiting with friends, and basically decompressing a little. The boys were awed by the Special Forces officers—by their gear, their uniforms, and by the men themselves. The soldiers who were not on duty guarding the compound answered questions and explained different pieces of their equipment to the guys.

One officer walked up to our dorm director, Evan Evans, and asked him, "Do you remember me, Uncle Evan?"

Evan scrunched his face trying to remember but finally admitted he didn't recognize him. That is, until he told him his name. What?! What a *coincidence*! Ha! God put this all together, in His amazing fashion.

Jeff, this young soldier, was in a US First Responder Special Forces division quartered in Eastern Europe, training for a different mission when the call came for a mission in Côte d'Ivoire. Dropping everything, within hours they were flying over North Africa, speeding south toward Côte d'Ivoire.

While in flight, Jeff briefed the team, using a picture of the his former school now covered in symbols showing. all the buildings. The team was going to be ready for any eventuality, including fighting their way onto campus, rescuing us from where we were locked down. Once on location, the US forces worked with the French military who already had *boots on the ground* and could reach us sooner. The French were tasked with breaking through the many road blocks to reach ICA and then convoying us to the US troop position.

The Special Ops team had flown first to Accra, Ghana, then over to the Yamoussoukro airport, currently controlled by the Ivorian government forces. Huge C130 transport planes containing dissembled helicopters landed, then the crews quickly reassembled them. The helicopters were used for remote rescues - sometimes under fire. The planes were used for transporting evacuees. Over 900 US citizens were rescued by these brave men over the next few days, then the Special Forces seemed to melt into the background, never receiving any acclaim for their heroic feats. The 30 seats on a C130 offered to our group were

snatched up by the more traumatized people, many with young children. They would fly directly to Accra, Ghana, and debrief there.

In Yamossoukro, the men were intrigued by our military hosts, and the kids playing, we women took the opportunity to visit. Nancy Grudda solemnly walked up to us with something in her arms. Holding tight control over her deep emotions, she spoke in her soft, beautiful voice.

"Because you are my friends I want to share this with you, but please do not touch me or interrupt me." Her voice quavered.

In her arms was the plaque dedicating the school's new playground to their adorable five-year-old daughter, Julianne. At the time of her death from cerebral malaria the Gruddas asked that any memorial gifts be donated for the playground at the mission school. Nancy had not seen the playground or the plaque until this moment of our evacuation. While tears welled in our eyes and we longed to hold her, we respected our friend's wishes, but felt her palpable pain. She turned the plaque outwards so we could read the inscription.

"I'm going to take this and go into the empty principal's office for a couple of hours to be alone. Don't worry about me. I'll be okay. I just need this time."

And she turned and left. My mind flew to the words of this treasured old hymn.

"When through the deep waters I call thee to go
The rivers of sorrow shall not overflow
For I will be with thee, thy trouble to bless,
And sanctify to thee thy deepest distress.

When through fiery trials thy pathway shall lie
My grace all sufficient shall be thy supply
The flame shall not harm thee; I only design.
Thy dross to consume and thy gold to refine.
(John Keith 1787)

The Gruddas were certainly going through the Refiner's fire, and painfully coming out as pure gold. Agonizing to witness, their pain did not reveal some amazing master plan or deep lesson. No, it was just pure pain. God in his love allowed their suffering for reasons known

David and Stephen hold the plaque commemorating their sister, Julianne, in front of the playground donated in her memory.

THIS PLAYGROUND WAS

DONATED IN MEMORY OF

JULIANNE MAY GRUDDA

JULY 8, 1991 - AU

only to Himself. He was a Father who
had watched his own child die. We
knew He understood.

As preparations for leaving Yamossoukro fell into place, Brenda came
up to me and asked if Ken and I would assume responsibility for
Erica Campbell, a fourth grader, who was also with our mission World
Venture. The child was under great stress and needed more
personal care than Brenda could give her. Our passengers, Eric and
Jessica, would travel in another vehicle.

Erica's parents, Charlie and Sherrie, along with little brother Brian,
were trapped in Korhogo up north towards the Mali border. Should
anything happen to them, we wanted Erica to be with family. Ken and
I would be her *evacuation parents* until we arrived in Denver and I passed
her on to her grandparents. We gladly assumed the responsibility and
quickly formed a bond with her. Our shared experience became the
basis for a lasting special friendship with Erica.

Leaving Yamossoukro, we continued in a convoy down the
war-ravaged highway, burned tanks littering the sides of the road. This
time, instead of having the French Foreign Legion escorting us, the US
Embassy and the Special Ops troops travelled with us. Bombed out
vehicles and the debris of battles bore silent witness to the pain of the

past week's fighting. Again, though we were the only vehicles on the road, we traveled slowly. Normally a four-hour trip, we arrived six or seven hours later at the International School in Abidjan.

Each person had been assigned a family to stay with, unless other

Arriving in Abidjan to a warm greeting and hugs.

arrangements had been made by their family or mission. We wound up at Dr. David and Lauren Fort's home. A former missionary doctor in a clinic in northern Ghana for 13 years, he had found himself near burn-out. In response, he returned stateside, did a residency in psychiatry, then returned to Africa to help other missionaries. David and Lauren had just flown back from Ouagadougou, Burkina Faso, where they were helping missionaries in a crisis. Loving, kind, wise, and generous, the Forts were just the people we needed. Erica was soothed and comforted; Ken was given advice and painkillers for the kidney stone he had developed during our trip. We three settled for the night in the living room, expecting a call the next day for our flight out of the country.

Government soldiers with automatic weapons were patrolling the streets as well as posted on all four corners of every intersection. Some roads were blockaded and impassible. The debris of military skirmishes remained in the streets. The air bristled with tension. Rare for Africa, few people were out and about on the streets. Those who'd ventured out scurried quickly to accomplish their errands.

Meeting other missionaries at the Christian and Missionary Alliance guest house in Cocody the next morning, we learned that Brenda planned to take a taxi, across the tumultuous city to the American Embassy and obtain emergency travel papers for Erica. Barefoot and visibly near collapse, Brenda seemed oblivious to her own situation. On the way to the airport Ken and I were to find someplace that could take an ID picture of Erica for her travel papers.

Amazingly we found an open shop that not only offered identification photos, but also sold plastic flip flops. We picked up a pair for Brenda, then hurried on to the airport passing through multiple checkpoints along the way. Security was high and everyone was on high alert.

The airport was packed with anxious people, all wanting out of the country immediately. Adding to the number of people desperately evacuating were the hundreds of people who had missed their flights during the past several days when the airport was shut down. The atmosphere was chaotic. Ken and Erica and I settled down to wait, each with our one bag resting between our feet as we sat on the hard and dirty tile floor.. I cupped my ear each time the loud speaker crackled, trying to decipher the barely understandable announcements. The single large waiting room held several hundred noisy people, each loudly telling his neighbor his tale of woe.

A vaguely familiar man stepped up to us an introduced himself. Aren't you working in Mali or Burkina? Yes, he was. He quickly explained that Brenda Allen had heard through the Embassy that Erica's parents were being rescued by helicopter out of Korhogo, along with the group of missionaries and Peace Corp workers gathered there. Ken and I were to leave Erica with him and take the flight assigned to us. Brenda was on her way from the Embassy. How could we do that? How could I leave this little traumatized child with a total stranger? I'd promised Erica I would be there for her until I brought her to her Denver family. How could I desert her now—and to someone she doesn't even know!

"God, how could you ask me to do this?" I shot up a quick prayer.

No sooner had I breathed the prayer than I turned around, hearing my name called. Nanci Ike, a former colleague and friend at ICA, approached us. She was now working in Abidjan with Evangelism Explosion. We exchanged a few words and hugs before I explained our

plight with Erica and my misgivings about leaving her with someone she didn't know. Nanci immediately offered to take Erica under her wing. The tension in my shoulders relaxed even more when I saw that Alex, their little girl, was with Nancy. The two girls were already making friends. Thank you, God!

Erica was probably too dazed to understand my explanation, but she lit up when I told her of her soon-to-be reunion with her family. Ken and I left the little group with confidence that this was God's provision. I still felt reluctant to go, but remembering my prayer, I accepted His answer.

Ken and I got in line for our boarding passes. All flights to Europe were booked. The Ballards, fellow missionaries, had worked tirelessly getting tickets for all of us who were evacuating. Our group would fly to Europe on Kenya Air via Accra, Ghana. When we reached the desk the attendant informed us that we could not take our carry-on bags with us on the plane, they would have to be checked. But, but, but, but everything we owned in the world was in that one little bag! We had abandoned everything else. How could we release these final precious items? African airlines were famous for losing baggage.

My easy-going friend, Sheryl O'Bryan, was in line with us when she heard the announcement. Immediately, she burst out into unexpected tears, surely a culmination of all we'd been through. We surrendered our ragged but priceless-to-us bags as an offering to God. If he wanted us to get them back, He'd take care of them as He had taken care of us.

After an uneventful flight we arrived in Ghana for what turned out to be a long layover in the airport. Now mid-day, the two small food concessions in the airport were closed. Without proper documents we knew we couldn't leave the airport. Two men in our group approached an airport employee who smiled at us as he swept the floor. He gladly agreed to help us so we pooled our money to pay for the food he would buy for us in town. An hour later we were enjoying very, very spicy chicken and rice, using our fingers African-style. Thank you, God! As we sprawled out in the waiting area, still adjusting to the idea that we were not just leaving a war-torn country, but a much-beloved country, our losses were starting to sink in.

We boarded the Swiss Air flight later that day with a connecting flight in Munich. Six hours later as the doors to the plane opened for

us to disembark, the attendants told us to run as fast as we could to our next gate. We were still exhausted but our adrenaline started pumping as we raced across the airport, taking turns carrying the McComb toddler twins. Arriving breathless, an attendant met us at the gate with our precious carry-ons. They'd been marked 'Urgent'. We grabbed them on the fly as we continued to run the rest of the way. Praise God! We'd made it in time!

The short flight from Zurich to Amsterdam barely gave us time to settle in before we were walking the long hallways of the Schiphol airport. Our ragtag group surely looked out of place among the fashionable European crowds, but we didn't care. As soon as we plopped down in the waiting room we started thinking about food again. An official walked up to us and asked us to follow him into another room. There we found a veritable feast laid out for us: hearty sandwiches, fruit, drinks, goodies. The airline had heard of our evacuation and decided to offer this expression of their sympathy and aid, doing what they could to help us. Not only did it help our bodies but it lifted our spirits as well. How very kind of these strangers to reach out to us! God was showing his love to us through so many people!

When the time finally came to board we had to go through Schiphol's strict security. In my little make-up bag the officer found the pair of blunt-nosed children's scissors I use to trim my bangs. He knew our plight, so apologized to me with a sympathetic expression on his face that he would have to confiscate them. He waited for my response. Although unwanted tears came to my eyes I was able to laugh.

"Hey, I just abandoned everything I own: house, clothes, car, and pets. Trust me, losing one little pair of scissors is NOTHING. But thanks for your kindness."

With our arrival in New York, we realized just how inadequately dressed we were. All of us were wearing clothing designed for the tropics: sundresses and shorts with sandals. Even inside the airport we were feeling chilly; late September weather in America was decidedly brisker than what we were used to. Adjusting to fast-paced, high-tech Western culture was proving to be difficult, and now we looked like refugees, wrapping lengths of thin African cloth around our shivering, unwashed bodies, as we gazed at our surroundings through blood-shot eyes, bone weary.

From New York we flew to Detroit. From Detroit we flew to Denver, following directions from our mission agency, World Venture. Our debriefing would take place at headquarters in Littleton, Colorado. As we passed through the gates onto the concourse we caught sight of Jeff Denlinger, who was later to become the CEO of World Venture. He and other smiling people come to greet us and take us back with them to the mission's guest quarters. There were tears mingled with their smiles as they hugged us. Their expressions were so very kind and sympathetic but also held much concern. I think we must have looked like we felt. We were on the verge of collapse.

We were the first of the wave of evacuees that would be coming through. After settling in we were able to help prepare for those who were soon to arrive by sorting and organizing the flood of items pouring in. People from the mission and various churches had donated boxes and boxes of warm clothing, blankets, suitcases, toiletries, and other items we needed. Eventually, over fifty World Venture families from Côte d'Ivoire passed through the center, all arriving with almost nothing. Bundled up in someone's soft snuggly sweater, I breathed a prayer of thanks to a loving God before verbally thanking the ladies in charge. Working helped buffer my emotions. I knew we'd need to verbally process the trauma we had gone through. But I wasn't ready yet. Part of me was in shock. The rest of me was on the verge of tears.

The World Venture staff was terrific, trying their best to meet our physical, mental, and spiritual needs. Our Africa Director, Glenn Kendall, who had been on a sabbatical leave, had dropped everything to return and help deal with our crisis. His wife, Kathy, had been diligently contacting our family members stateside. True friends and godly people, Glenn and Kathy worked tirelessly for us throughout the crisis. Professional crisis counselors met with us as a group and as individuals, as needed. Sharing our experiences with each other helped begin the long journey to healing.

We learned that Dakar Academy, 1200 miles to the west of Bouaké as the cross flies, had invited our students to complete the school year on their campus. We wondered how many parents would accept their generous offer and send their kids. As for us, we just wanted to see our families and friends to reassure them that we were okay and catch our breath. Not knowing how many students would be

transferring, we had no idea if they would need our services but we were open to the idea.

Playing with Peter, our first grandson.

After the debriefing in Colorado and more emotional good-byes, we boarded another plane, this time to Arizona to visit Aimee, Christian and Peter, and Laura. It was a glorious reunion. Andy was still in Basic Training with the Air Force so we weren't able to see him. As the days passed, Ken and I continued healing, bit by bit. I think God sometimes uses babies to minister to our souls. Our five-month-old grandson, Peter, made us smile and laugh, fulfilling the promise that "a happy heart is good medicine."

We returned to California for a series of tearful but happy reunions as we reconnected with loved ones. We were visiting my sister, Bettie and David Peterson, when we received a phone call from Dakar. Expecting only twenty to thirty ICA students to transfer, the school was overwhelmed to have ninety of our MKs apply for enrollment, nearly doubling their student body of 113. Yikes!

Their request? Please, please, please, could we come help teach? Like, yesterday?

We prayed and talked it over. Yes, we would return to Africa to help out. Phone calls set our plans into motion. Calling to reserve plane tickets, we discovered that we could not get on a flight for another

week. The administration in Dakar was very happy to hear that we were coming but they were disappointed that we weren't coming sooner. Generous people quickly filled up our new suitcases. We said emotional goodbyes once again, barely three weeks since our evacuation.

What on earth were we doing? We'd just escaped from a war and now we were turning right around, jumping back into the fray? Why not kick back and take a few months to recuperate? Believe me, we did ask ourselves those questions. More than a few people told us to our faces that we were either crazy or just stupid. But, we felt God pulling us back. We chose to listen to His voice.

"Blessed be Your Name in the land that is plentiful
(Cote d'Ivoire),
Where your streams of abundance flow.
Blessed be Your Name!
Blessed be Your Name when I'm found
in the desert place (Senegal).
Though I walk through the wilderness,
blessed be Your Name.
Every blessing You pour out
I'll turn back to praise;
And when the darkness closes in, Lord,
still I will say
Blessed be the Name of the Lord,
Blessed be Your Name
Blessed be the Name of the Lord,
Blessed be Your Glorious Name.
Blessed be Your Name
when the sun's shining down on me
When the world's 'all as it should be,'
blessed be Your Name.
And blessed be Your Name
on the road marked with suffering
Though there's pain in the offering,
blessed be Your Name.
Blessed be the Name of the Lord!
Blessed be Your Glorious Name!
You give and take away
You give and take away
My heart will choose to say
Blessed be Your Name!
Matt Redman

Written by Matt & Beth Redman, Published by Thank You Music, reprinted by license

*M*y *heart will choose to say*
Blessed be your name.
Matt Redman

Chapter 17

Dakar

October, 2002

As we stepped off the Air France plane onto the warm tarmac, the ninety-eight degree heat and ninety-eight percent humidity struck us like a blow. It was midnight, now the 23rd of October. We'd left the chilly autumn climate in North America to land during Senegal's hottest season.

In years past we'd only stopped in Dakar for layovers, flying with the old Air Afrique airlines. We did not know what to expect from this strange country. Senegal is the westernmost country in Africa with Dakar located on the nose of a peninsula, jutting into the Atlantic Ocean. The architecture of the capital city of four million, reflects a strong Arabic or northern African influence with its flat roofs and thousands of mosques. Ninety-five percent of the people were Muslim, about three percent Catholic, with a scattering of solely traditional religion. Less than one percent are listed as Protestant or Other, which included everything, even the cults. Nearly all these religions were mixed with traditional animist beliefs. Estimates put true Jesus followers at .3%. That's three tenths of one percent!

Ken and I had arrived while the population was observing Ramadan, the month-long observation of day-time fasting with many mosques open twenty-four hours a day for prayer and chanting. The apartment we were assigned to was not far from a mosque from which emanated the rise and fall of Arabic chanting from loud speakers mounted outside every night, nearly all night long. No air-conditioning

Hundreds of men bow in prayer as the call echoes from the minerat

in our apartment, of course, and the small window in our bedroom afforded little ventilation. The single, squeaky old fan at the foot of our bed fought a losing battle trying to cool us down. Ken and I quickly realized that we were in for a big adjustment. At ICA, surrounded by open fields, we awoke each morning to the happy sounds of chirping birds. At Dakar, surrounded by high, dense, cement walls, we would be awakened each morning an hour before dawn by the sounds of prayer calls echoing through the city.

God had been preparing the way before us. There was no doubt in my mind that this was the place God wanted us to be. Dakar Academy was a convenient five-minute walk from our third floor walk-up apartment. When ICA was first invited to partner with DA the staff began searching for housing for everyone. Deb Mashburn worked tirelessly to make our adjustment easier; she negotiated with landlords and *shopped til she dropped* to furnish our abodes.

The Academy is situated in the middle of a residential neighborhood, on just six acres, with only a few apartments for staff and a single dorm, with boys on the ground level and girls on the first story. With over ninety new students, at least four more dorms were going to have to be found, but where? It seemed an impossible task. The Evans, the Schultzs and other dorm parents thought perhaps renting some of

the larger houses could work.

However, the nearby houses NEVER rented, they were told. Yet, nothing is too hard for God. Just when we needed them, four big houses became available to rent. Locals told us the vacancies were truly amazing. We told them we have an amazing God. The staff housing problem was solved when a nearby apartment building with ten units was completed just days before staff began arriving to move in. Wow! What a mighty God we have!

By October 18th, just days before Ken and my arrival, the evacuated students from ICA began their second quarter of school at their new location. Some were happy to be there; others were not. One cannot experience the trauma of war and evacuation and loss as these kids did and not be affected to some degree. Most of the students made a good academic transfer. International Christian Academy had a strong academic program, so blending into Dakar Academy's program was not difficult. Socially and emotionally the adjustment was not as smooth for everyone.

With the influx of ICA's staff and students, we'd turned Dakar Academy upside down. Students from both schools had difficulty at first, just getting used to each other. The ICA kids were grieving

First arrivals.

211

multiple losses: the death of Dave Golding, the loss of their school and home, many of their friends, and their cherished possessions. Many of us were also experiencing post-traumatic stress syndrome, some to a greater extent than others. Former straight-A students began doing C-level work or worse; normally well-behaved boys started lashing out in anger for minor reasons; kids had difficulty sleeping. Some students developed eating disorders during this period. Everyone jumped at loud noises. Our hearts beat faster just seeing men in uniform, even though we knew Senegal was at peace.

When some Senegalese children set off firecrackers in the street outside of the girls' dorm the teenagers freaked out. Kalashnikovs! Lock-down! But, there were no curtains on the windows to close, no locks on the bedroom doors, no beds to crawl under—just mattresses on the floor.

"We're going to get killed!" The girls started crying. JP and Judy Schultz, the dorm parents, quickly assessed the situation. Discovering the illusion was not reality, they ran to calm the girls.

Numerous ICA parents sought us out and thanked us for coming to Dakar. They were grateful that we'd continue to teach their children, but even more important they expressed relief that their kids would have people who already knew and loved them but who also understood what they had recently gone through because we'd gone through it ourselves. The Dakar teachers tried to be sympathetic but just could not offer the same understanding and mentoring. These parents, along with their children, helped affirm what we'd seen as God's leading us to Dakar. God walked alongside us during those difficult days.

An additional point of tension was also building, one which was outside our power to control. The rumble was that the USA and coalition forces were going to enter Iraq to bring down Saddam Hussein. BBC Africa news spoke daily of the likelihood; Al Jazeera news claimed the true reason was that Americans wanted an excuse to kill Muslims. Our US Embassy advised us to keep a low profile, not frequent places known as American favorites, avoid being seen on the street, and to stay inside and off the roads on Friday afternoons after prayers at the mosques. Although Senegal was a friendly nation to the USA no one knew how the people would react once hostilities began in Iraq.

Our ICA kids half-joking said, "So we escape the flying bullets in

Bouaké where we weren't the target, and evacuate to Dakar where we ARE." I know that it was the prayers of Jesus believers who enabled us to make it through that year. I was constantly reminded that "in our weakness, He is made strong." Amen!

I wrote in a prayer letter to supporters: "We've all had a hard time adjusting here—the complexities and noises of big city life (though still in a 3rd world country), insane demolition derby-style traffic, regular and loud calls to prayer day and night, getting lost frequently, poor communication (no telephone, no international newspapers, faulty

email service, no grass anywhere, not having various practical items that were left behind in Bouaké,

Begger boy walking along busy street;

Prayer beads;

Street shop

and SAND EVERYWHERE!!! It's impossible to walk to school or anywhere without going through deep, dry sand which gets between your toes and scratches your feet inside your sandals and gets into your apartment and even your sheets and into every nook and cranny. Ugh! It's enough to drive you crazy!

But wait! Isn't Dakar where we know God wants us to be this year? And, isn't He here with us to help us each moment, just as He's done in the past? And, aren't people praying for us and helping us through this hard time too? Of course, the answer is a resounding YES! But some days it's just easy to forget.

So, please pray with us that God will use the SAND—these irritations and problems—to create PEARLS of great worth in us, that we would effectively and joyfully minister here and bring glory and honor to Him."

Neighbor kids

The transition did have a good side too. Because the Academy was located in the capital city there were many advantages. The international airport was only thirty minutes away. Medical care was available. There were shops—some even with ready-to-wear clothes; and a mall with a large grocery store and four shops. The many restaurants in Dakar offered a variety of cuisine, including French and Vietnamese, as well as delicious and fresh seafood. Our house had tile on all of the floors and the ceilings were finished with plaster. We didn't even have any resident geckos. No longer was it necessary to watch your step to avoid treading on venomous snakes. While malaria was present it was not as much of a problem. We almost felt guilty for living so *high on the hog*!

Ken and I invested in a small radio/CD player we'd found downtown to keep us abreast of the news. The intense, overt violence in Côte d'Ivoire had settled down but stories of horrific torture and persecution on both sides of the divided country were reported. The international community had been trying to broker a peace agreement. I was an optimist: the parties would reach an agreement and the country would come back together.

Our small cluster of ICA staff at DA awaited our opportunity to return to Bouaké to salvage some of our things. In January we heard that there was a week-long ceasefire for peace talks in Paris. Ken and I and six of our colleagues threw a few things into our bags and caught a flight into Abidjan, Côte d'Ivoire, not knowing what awaited us on the other end.

Abidjan had changed little. Government soldiers were everywhere, strutting with their guns slung over their shoulders. But we expected that. People seemed to be going about their business as usual. Good sign! We jump started our little red jeep, parked at a colleague's home, filled the tank, and joined the convoy driving north into rebel territory.

Official-looking papers written in French and ink-stamped by missionary friends helped get us through the myriad of checkpoints along the highway, as did the signs we plastered on our windshields declaring that we were missionaries. The papers were scrutinized as were our passports, driver's licenses, car papers, and any other documents we could think would be helpful. The soldiers were gruff and suspicious and seemed to revel in intimidating us. No, we were not carrying any weapons. No, we were not bringing supplies or money

to the rebels. We were neutral missionaries. We wanted only to bring good to the beautiful country of Côte d'Ivoire. Check point after check point we tried to explain our mission in respectful voices.

As we wended our way north rebel check points began popping up. I wondered how many of these stops were simply opportunities by civilians to gain money. We were expected to give monetary *gifts* to soften the heart of the soldier we were dealing with. Often, giving out tracts written in French or a bottle of water or a chunk of bread would be enough to have the soldier pass us along to the next official. They were a rag-tag group with more enthusiasm than organization or training. Driving toward the demarcation line, we had yet to reach the first *official* rebel checkpoint.

This checkpoint was the most imposing we would come across. Barricades had been erected blocking traffic on both sides of the highway; vehicles had to weave back and forth, with vicious-looking metal toothed strips stretching across the road. Before we even reached the makeshift obstacle course, we saw ahead of us a giant barricade upon which were placed numerous objects. Forced to stop some distance away, we asked a rebel soldier if we could get out of the car.

Sitting atop the giant barricade were dozens of frightening looking

idols, fetishes, and objects meant to protect the rebels from harm. The largest of these was a wooden chimpanzee, with garish colors slashed across his body, and eyes painted to frighten. It was all pretty creepy. And dark. Very dark. I thought of how deceived these people were, who trusted in spirits and idols of wood and metal rather than the living God. Unfortunately, these rebels were not ready to listen to us tell them the Good News. It was not God's power they were seeking. Nearly an hour after we arrived we were finally allowed to pass through—into rebel territory. Driving through small villages, children would laugh and point at us and shout greetings of welcome. Very few civilian vehicles traveled these roads. I felt myself being drawn back into this land that I loved.

Many checkpoints later, we arrived at the gates of our beloved school, International Christian Academy, or ICA. The French army unit, named l'Operation Licorne (Operation Unicorn) had control of the guard station and security was tight. I gazed at the barriers that had been erected in the road in front of our school: sandbags, hurdles, barbed wire, and a makeshift guard station. Our little convoy had to pass through a rebel checkpoint just a few dozen yards down the road before we reach the French checkpoint. The dividing line for official rebel territory was just a stone's throw away. ICA was in the small DMZ, or the zone between the two sides. The French were entrenched as peace-keepers. The UN had yet to become involved.

It was surreal to see our school taken over by French soldiers. The French Special Forces had moved on; these were regular French army soldiers. Lookout stations had been erected along each of the perimeter walls. Military vehicles were scattered everywhere. Tents had been set up near the entrance for soldiers resting from guard duty. Soldiers were going about their business or were relaxing under the flamboyante and mango trees. The men stopped and stared at us, curious about these crazy Americans. There were many weapons in evidence, including tanks and some heavy-duty armed vehicles. I felt safe once again.

A French lieutenant met us at the door of our house. He wanted to warn us that our home was in bad shape, and well he did. Our home looked like a tornado had torn through it and left filth and destruction in its path. The staircase was so filled with dirt and dried mud we would

have to use a shovel to start cleaning it. Everything was covered with a deep layer of dirt with bits of food and garbage thrown in for good measure; the floor was not even visible The furniture was broken and torn; books were carelessly tossed any which way. Scattered in every direction were articles from the kitchen, bathroom, bedroom, and living room, all mixed together and in various states of destruction. My art room study was perhaps in the worst shape. Every treasured book from all three bookshelves had been opened and thrown onto the dirty floor, taking its place among bits of old food, medicine wrappers, broken kitchen utensils, dirt, dead insects, and art materials. My art supplies were decimated. My art work had been scribbled over with markers; my tins of expensive pastels and paints that donors had given me all destroyed. The heaps of garbage intermingled with our ruined possessions rose knee high, with only a narrow path crossing the room to the balcony with its snipers nest still at the ready. The filth and senseless vandalism was overwhelming. Did I weep? Sure. I couldn't help it. I thought I'd prepared myself for this but the magnitude of destruction and loss was just too personal.

As we surveyed the damage with mouths open in disbelief, the Lieutenant returned with a sheepish look on his face. He'd expected our reaction and felt badly, even though he was not responsible for the state of our home.

When I entered the ransacked kitchen I saw an amazing sight on the counter-top. There, in a clean spot, amidst all the filth and decimation, was my collection of antique tea cups and Bettie's tea pot sitting in the dish drainer. Clean as a whistle. Not a chip or crack. How could this be? I was flabbergasted!

The Lieutenant saw the expression on my face and thought I was upset that the cups had been used. No! I was simply amazed that they had survived! He explained that when he recently arrived he found the house even worse than it was now. After clearing a space, he set up his tented cot in the dining room. When he got up the first morning he planned on making some tea but nary a mug was to be found.

However, on the top shelf he saw, untouched, my tea cups and pot. Realizing they were special, he had been carefully using them each day.

When I asked him why he took such delicate care of them he replied in English. "But of course, Madame! My father is French but my mother is English. She raised me well! I could see that someone had cherished these lovely cups." And then he dashed off.

I asked God "why". Why did He save my tea cups and pot? There was no logical reason why they weren't destroyed along with nearly everything else. But I knew why. In His great grace he was confirming to me that He knew, He understood, and He was in control. God is so good. Great is His faithfulness.

For the next six days Ken and I worked from dawn until dark cleaning and trying to sort through our mangled goods. We filled two suitcases each, including some business records we'd left behind as well as my God-is-amazing-tea cups and pot coddled in my carry-on. Most of our favorite things had disappeared, for which I couldn't help but mourn. Not really for the items themselves but for the memories they represented or the people who had given them, often sacrificially. We remembered the most important fact: no one had been killed or even injured, despite the fighting all around us. It was a great comfort.

Once back in Abidjan we ladies decided to window shop along the Rue des Jardins. We felt relieved as we walked along the Rue des Jardins. The war and our troubles seemed far away.

That evening as I was taking my shower I heard a roar of loud voices outside, raised in strong emotion. The Marcoussis Agreement had been signed that day so I thought that the crowd was celebrating the forthcoming peace. How wrong I was! But I went to bed in ignorance, thinking happy thoughts.

David Belle Isle greeted us the next morning with the news that instead of celebrating, the crowds were rioting. The mobs had ranted down Rue des Jardins, where we'd walked just hours previously, breaking windows, looting, burning cars, and beating up people. The rioting had continued most of the night and mobs were still roaming the city, destroying what they could in protest. President Gbagbo's supporters declared that he would never have signed the agreement unless he was pressured into it, especially by the French. Everyone else

was staying in their homes out of fear.

We listened to the news on the radio and searched the internet for updates and information. What we learned was not good. We'd flown on Air France into Abidjan and their offices had been destroyed by the rioters, as had many businesses down town. The airport was closed. The borders were closed. Crowds of angry rioters, led by the Young Patriots, continued to wreak havoc in the city. All flights were canceled indefinitely.

Day two passed. We ate some of the food we'd bought earlier, rationing it as we didn't know how long it would have to last. We prayed.

Day three we heard that the airport was re-opened. Was it a rumor? Yes, it's open. No, it's not. Whether it was or not, we were running out of food and decided to take a chance. Another rumor was that the Young Patriots and their followers were planning on taking their grievances to the US Embassy, hoping to garner support for the government.

The crowd was angry against the French, not the USA; they wanted help from the US. Dave had a color printer and had the brilliant idea of printing off copies of the US flag, which he'd found on the internet. We would tape the old red, white, and blues in the windows to announce that we were Americans; we would hold our passports in our laps and hold them up if needed, to prove our citizenship.

Emerging into public was still a risky undertaking. The roving bands had been halting the few vehicles that ventured out, dragging out and then beating the occupants, setting fire to the vehicles. The mobs were not stopping first to ask questions.

Our group finalized our plan, such as it was. The Belle Isles would stay in Abidjan, assuming it would settle down at some point. Dave would drive us in the new school van. I remember the worried look on his face as we made our preparations. When I asked him if he wanted to talk about it he responded, "If we get stopped, which I pray we don't, I don't mind getting beat up. I just don't want to lose this new van. A lot of people in the states sacrificed so it could be bought and used to spread the Gospel." Wow.

The Belle Isles shared a last kiss before Dave climbed into the driver's seat; after scanning the street for potential danger, Laura

opened the gate for us. We crept slowly onto the street as Laura closed the gate behind us. There were no other vehicles on the road within our sight. We pulled onto Rue des Jardins. Broken glass was scattered everywhere, stores emptied of their inventory.

My heart was beating fast. This step of faith was no easier than the others I'd been taking, but again, God's faithfulness in the past reminded me of His presence. How many times had I reflected on and paraphrased the words of Daniel's friends: "Our God will save us; but even if He does not we will still serve Him." It was time to put our faith to the test once again.

As we drove across the Cocody neighborhood and closer to the downtown Plateau area towards the Houghouët-Boigny Bridge crossing the lagoon, we began seeing more pedestrians. A very few were furtively hurrying to accomplish their errand. Soon, we came upon groups of young men gathered in intense conversation or marching to an un-identified destination. Eyes lifted toward our van, the only one on the litter-strewn road. Brows furrowed in curiosity at the toubabous crazy enough to venture out.

I grasped my passport ever tighter. Glancing out the window, I saw a large group of angry men, marching in the middle of the road right in our path. Slowing down even more as the mob split and surrounded us, we all madly lifted our passports to the wisely closed windows and shouted "Americains! 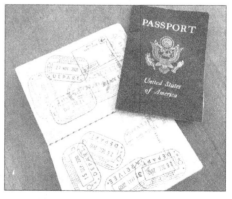 Americains!" To our amazement and relief the angry faces broke into smiles and clenched fists turned into friendly gestures as they shouted "USA! Number one! USA! Number one!" with index fingers jabbing upwards. Whew! As we'd hoped, the group continued on their way towards the US Embassy to entreat President Bush to assist them. I silently thanked George W. for having an international reputation for being a man of action and compassion, but reserved my greatest thanks to God for continuing to preserve us.

221

In Dakar, settling back into a peaceful routine with lesson plans and teachers meetings seemed almost surreal for a while, but with the impending Iraq war hanging over our heads it was still far from tranquil. Not long after our return Ken began experiencing some unusual chest symptoms. My heart lurched in response. With no 9-1-1 emergency system what would I do if Ken needed urgent care? Where would I go? Who could I turn to?

Our field leader's wife, Esther, an RN, made several doctors' appointments for Ken, followed by tests. The doctor explained that his results were atypical but he did not have the resources to explore Ken's problems any deeper. He recommended we fly to France or the USA for Ken to undergo more extensive testing not available in West Africa.

Just hearing the term atypical brought back to me the nightmare of Ken's preliminary biopsy results when he had lymphoma. Ken's medical evacuation plan was quickly put into action. We entered the cardiologist's office in Los Gatos, California with fear and trepidation.

Ken was carefully examined, poked, prodded, tread-milled with enzymes coursing his system, and sent for an MRI. The diagnosis? The cardiologist could find no organic reason for Ken's symptoms--no congenital abnormalities, no blockages, no malfunctions! But, what was causing his problems? The doctor finally asked, "Have you been under any unusual stress in the last few months?" Ken and I turned to each other and smiled broadly.

We flew back to Dakar with much lighter hearts and spirits. Thank you, God.

Yet, no one who had experienced what we did at ICA was untouched. Art class gave students opportunity to debrief while working on their projects. I believe it was Kofi, a twelfth-grade student from Ghana, who shared this story.

"On that Monday night when the gunfire broke out all around us, my friends and I dove under a table in the dining hall with the coffee cups we'd been sipping from. As the battle raged my mind went back to the day before at Uncle Dave Golding's memorial service. During the service Uncle Evan told us that one minute as Uncle Dave was running, he put one step on the track and the next step took him into the presence of Jesus Christ. So, as I was sitting there with the bullets

flying I looked into the faces of each of my friends and wondered if the next face I would see would be Jesus."

These students didn't just survive their experiences; they didn't continue to grow DESPITE their experiences, they grew BECAUSE of their trials. No more *playing games* with people or with God. This was real. This was what was important.

We ended our time in Dakar with a final surge of effort as I facilitated a juried Fine Arts Festival. The Junior-Senior Banquet followed hard on the heels of the Festival and Ken and I were called into service to help with that production as well. Graduation a few days later was an extremely emotional affair with students happy to graduate but anguishing over the separation from friends who were closer than a brother. They were bonded as few people ever are. Theirs was to be the very last class to graduate from ICA. So ended ICA's sojourn at Dakar Academy.

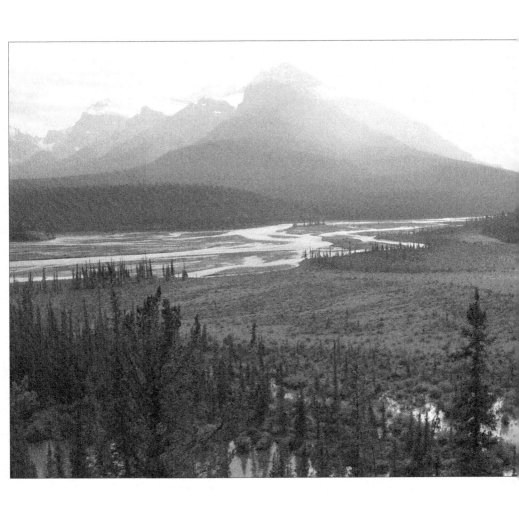

H *e restores my soul.*
Psalm 23:3

Chapter 18

Our closure in Senegal that June of 2003 was definitely one of mixed emotions. I missed being able to hug and say goodbye to all of the people who did not come to Dakar after the evacuation. And, it was bittersweet to bid farewell to those students and staff who did come to Senegal. But we were ready to literally shake off the dust of our feet from this edge-of-the-Sahara country and move on, with Cote d'Ivoire in our cross-hairs. Somehow, someday, we were going back to Bouaké. Ken and I both were ready to say goodbye to Dakar for forever, no looking back.

Our stateside families were delighted to see us and we them. The brief time we'd spent with them in October had reassured them to a point. They confessed that due to our PTS (post-traumatic stress) they had been concerned about our returning. We were delighted to just kick back and play with little Peter, watch movies, shop, and eat western cuisine. It was just what we needed.

Colleagues and fellow evacuees Dave and Connie Johnson and their girls had invited us to come visit them in Fairbanks, Alaska. Wouldn't that be wonderful?

"Yes! Perhaps someday we can come."

They persevered. "So, usually when someone says *someday* that day never comes. Would the reason you say *someday* instead of *yes* be because of the expense for the tickets?"

"Umm. Well, yes, actually."

"We can take care of that! We have lots of extra free miles in our airline account so it won't cost you anything!"

Wow! Now that's an offer Ken and I couldn't refuse! So, in August

we hopped into yet another airplane and headed north.

"Amir!!!" I shrieked.

Our former student, the Israeli boy who'd figured so prominently in our lives back at ICA, was just finishing up his visit with the Johnsons. He wanted to surprise us so no one told us that he'd be accompanying Stephanie to pick us up. What a wonderful surprise! It was so good to see him again! We heard about his life since leaving ICA, including his stint in the Israeli army. Now, he was at another crossroads in his life, looking for God's direction in finding a university to attend. All too soon he flew out, back to Canada where he was temporarily staying.

Fairbanks was far more beautiful than I had imagined and the weather was absolutely gorgeous. The Johnsons were gracious hosts and treated us like royalty. Touring historic sites, exploring helicopters on a military base, touring Denali National Park, and exulting in the amazing scenery and wildlife, and berry picking in the wilderness were all terrific fun. Well, except for a moment when Connie, Katie and I were deposited alongside the road in search of berries (at 11 o'clock at night but full light). The guys went off to drive 4-wheelers in another section of this beautiful wilderness.

I was enjoying the raw beauty of the countryside, no evidence of

humans anywhere in sight, when I had a thought.

What if a grizzly bear came along? What would we do? What could we do? So, I who had lived among cobras, scorpions, and mambas had more than a bit of concern about being attacked by a huge mammal with giant teeth and claws. Connie explained that there were two philosophies of attack prevention. One was to stand upright as tall as you could and remain motionless and hope the bear would think you were a tree or other inanimate object. The other school of thought recommends finding a low area or natural trench in the ground, then curling into a fetal position, remaining absolutely still, hoping the bear overlooks you and passes along his way. Neither choice sounded great to me but we did scope out the area and found some hollows in the meadow which Connie said should do, should we need them. Although I loved picking the berries with the spiffy scooper thing designed just for blueberries, I admit to keeping a wary eye out for large furry animals at the same time.

Ken and I spent the rest of the summer and fall in northern California. Dave and Barb Baldwin hosted an ICA reunion at their home in Palo Cedro so we had the joy of seeing people we'd not seen in many years. Visits with our supporting churches and individual supporters were also encouraging. They had been praying for us all along, walking the road with us. Now they listened as we shared our stories and prayed over us for our healing and for direction for our next steps. My sister Bettie and brother-in-law David graciously opened their San Jose home to us, despite the close quarters and changes it meant in their lives. I loved being back with my sister. We spent many hours sharing, as I poured out my heart. She helped me process our recent experiences in Cote d'Ivoire and Senegal. Dan Grudda had invited us to join the Restoration Team returning to ICA. We wanted to be ready in every way when that time came.

Meanwhile, Ken and I waited for the key political players in Côte d'Ivoire to settle their differences and for peace and calm to return to this divided country. For, divided it had become, with the government of Laurent Gbagbo controlling the southern part and Les Forces Nouvelles (the New Forces, formerly called rebels) controlling the upper part of the country with Bouaké as their headquarters.

After the intense battles and occupying of territory in September

of 2002, the fighting had subsided but still included ambushes and occasional smaller battles as well as inter-tribal retributions. Both sides had thrown up countless checkpoints along the roads. The atmosphere was often tense—with violence simmering just below the surface. Neither side was budging, nor would the President sign various peace agreements, saying they favored the rebels. The conflict was at an impasse.

We knew Côte d'Ivoire was historically a peaceful country with a growing economy. Surely the two sides would arrive at a compromise soon.

As the autumn passed with no peace in sight, Ken and I decided to move to Flagstaff. There we could spend time with Laura, Aimee, Christian and Peter. They found us a little place to stay while we bided our time, shooting for March 1 as a departure date.

But March 2004 came and went. We were advised not to return yet. We reset our goal for May 1. We knew that we'd need to re-outfit our Bouaké house to an extent due to the looting and damage it had sustained. We certainly could not replace everything we'd lost, so I tried to prioritize what we really needed to survive. I tried to imagine what we could purchase in the capital of Abidjan. The one large grocery store in Bouaké was closed. Now there was only the open-air market and tiny *boutiques* about the size of a walk-in closet. I corresponded with several families who'd evacuated, leaving nearly all their things. I arranged to buy a few of their items that we needed, if I could find them.

Our friend, Maria Groza, insisted on buying us a set of new sheets and bedspread. Ken and I were appalled to learn that our house had been used not only as a snipers nest but also as a brothel for a few months after our evacuation. Yes, ick. And double ick. Rather than dwell on how our bed had been used, we chose to think of the bed as being crafted by our woodworker friend from Benin, Pascal. Made from local irokro wood to my design, I'd then found a woodcarver working by the side of the road, to carve a floral bas-relief on our headboard and foot board, making our bed one-of-a-kind. Despite its recent notorious use I was loathe to discard it. I preferred to think of it as another victim of war which needed caring for, not rejection. I was hoping to find it not too badly damaged.

As April drew to a close all of our baggage was packed. Our apartment was cleaned out. Peter's second birthday was celebrated. We said our goodbyes once again. I hate goodbyes! Despite my resolution not to cry, I always do. This farewell was no different. How we'd miss our first grandchild! Aimee was expecting again and wanted me by her when she delivered the baby. But, I did not see how I could fly back for the baby's arrival in just six months. My feelings of loss were not just for momentary goodbyes but also for the anticipated loss of not being a part of Peter's young life, of not being there to help Aimee with the arrival of the baby. Laura and Andy were doing great, but Aimee and her little family tugged at my heart.

Yet, Africa drew me. Was it easy to leave our loved ones since we knew we were doing what God had called us to do? No! A thousand times no! But God was continuing to teach me that doing something good does not always mean the task will be easy. I was learning that the hard things can be the best things. I certainly do not realize that truth while I am going through those hard times, but I've seen the faithfulness of God countless times to ever doubt his trustworthiness.

Was separation from loved ones painful? Yes. Was serving in Africa the right thing to do? Yes. I was thankful that God had kept that love of Africa in my heart. It would serve to sustain me in the coming difficult months. It was not with dragging feet, kicking and screaming, that I headed out to the Phoenix airport; it was with eagerness and hope and excited anticipation that propelled me back to the land which I loved.

What could I expect with this next term? What would the campus look like? How long would the French army be staying? Would the relative calm solidify into a lasting peace? Would any parents send their children back to ICA? I anticipated hard times but good times; lots of work but lots of fun too. Ken and I couldn't wait to get back and be part of that Restoration Team helping to bring ICA back to life.

This was going to be another great adventure!

L *et all who take refuge in You be glad;*
Let them ever sing for joy!
Psalm 5:11

Chapter 19

May 2004

More than one person had told Ken and me to our faces that we were idiots or just plain crazy to return to Africa. Maybe they were right—at least from their point of view. We were just crazy enough to jump at the chance to return to the continent we loved despite all the logical reasons for not going back into a country still in crisis, a land of a fragile peace.

We stepped off the KLM plane, hit by the familiar heat and humidity, gulping in the ripe tropical aromas. We felt we'd returned home. Almost. We had arrived on the Ivorian coast; now to drive into the interior, into rebel territory, back to Bouaké and ICA, our true home. Two other vehicles, filled with missionary colleagues, would be accompanying us. We were more than happy to be part of a convoy rather than traveling alone.

Once again our little red Suzuki crawled through checkpoint after checkpoint: first, the Ivorian military followed by the UN checkpoints (the 'Blue Helmets'), the rebel or New Forces checkpoints, and the French army checkpoints. We passed through a total of perhaps twenty official checkpoints plus numerous unofficial ones.

Every one of the men clustered around the checkpoints was heavily armed, with bandoliers of extra ammunition slung crosswise over their chests, along with a handgun and often a baton or nightstick. We'd been warned that traveling from Abidjan to Bouaké would be frowned upon and we would be seen as suspect. Why would someone want to leave the commercial capital, head of the government military,

231

and travel north to the 'rebel capital'? Were we carrying weapons or money or information to help support the rebels?

The soldiers manning the checkpoints were all serious, some outright menacing. We quickly got back into the routine of fervently praying each time we were flagged down. Our reactions were of critical importance. Respect their authority. Exercise patience. Speak with wisdom and kindness. Do not be arrogant or culturally insensitive. Do not ask questions. Do not get out of the vehicle. Make sure all of your papers are in order. Make sure you get all your papers back after each careful examination by the soldiers. Have a small gift to give--we had a supply of tracts and other literature, which were gladly accepted, and perhaps a bottle of fresh water.

As we neared the final checkpoint before entering rebel territory, north of Tiebiessou, we slowed to a crawl. Armed men, some in uniform some in tattered civilian clothes, stared openly at us—some with curiosity, others with defiance in their eyes. We knew we were at the defining line between government controlled land and rebel-held land. We could be refused entry. We waited and waited, remaining in our cars while soldiers called ahead to higher authorities to discuss our fate. The atmosphere was tense.

The road before us looked nearly unchanged from when we last saw it in 2003. It was blockaded with spiked boards, logs, sandbags, overturned tables, making a formidable barricade and leaving only a

narrow opening. A long spiked board filled the opening. If we were to enter, the men would pull back the spiked plank.

Many new items had been added to the top of the barricade since we'd seen it last. All of the objects were arranged facing us, toward the enemy's path. The most eye-catching item was a near-life-sized carved chimpanzee, sitting and peering towards us with large, unnaturally painted eyes, its body adorned with bits of metal objects, beads, and other "gris-gris" or amulets. This display was constructed to not only physically bar the enemy from entering their territory but to spiritually prevent them from invading. Each statue had been consecrated by a fetish priest who had offered a blood sacrifice over it to ensure that the spirit would inhabit the statue and exert its power in their favor.

Confronted by this frightening display, I prayed for these people in their spiritual darkness. I asked that one day they would find the One who gave His own blood to save them, the One who is stronger than any army or spiritual forces of darkness: the God of love and the Prince of Peace.

The board of spikes was eventually dragged out of the way. Our small group cautiously proceeded past the forbidding-looking barricade. We'd made it! We were now in rebel territory.

As we wended our way north on the curvy pot-holed roads we passed village after village, seen through occasional openings in the fifteen-foot high elephant grass bordering the road. Vehicle traffic was still a rare sight, so when villagers saw us approaching they would run out into the open, children waving their arms and smiling and calling greetings to us. I wondered if they were the same children who greeted us as we passed through a year and a half earlier. I felt very welcomed and madly waved back.

Many checkpoints later our convoy reached Bouaké. I eagerly peered out the car's windows to see how our city had fared in our absence. There was some damage to buildings from the fighting. To

non-African eyes it would have been difficult to discern what damage was due to natural deterioration and what was caused by mortars or grenades. Nothing seemed to have been done to repair anything.

There were certainly lots of armed soldiers, some mere boys. The United Nations forces had taken over the mairie, which once contained the mayor's office and city hall. UN funds had provided mobile housing for the peace-keepers from various countries. They had created their own little village on the outskirts of town.

We kept driving six kilometers east, arriving at ICA in the late afternoon after passing through yet more checkpoints. The French Military held the last outpost, positioned on the road outside ICA's gate. ICA now served as the demarcation between the rebel-held territory and the government-held land further to our east, along the road to M'Biakro. The French military occupied the school as peace-keepers. We were going to live alongside them.

My stomach was doing flip-flops as we were checked by soldiers at the gate before being allowed entry into the compound. I couldn't wait to get out and see everything! How were the dear people who had stayed behind when we'd left?

In the following days we discovered that no one we were close to had been killed or even wounded in the fighting. Amazing! A wife of one of the pastors had been shot in the leg by a stray bullet, causing much pain and damage but she was the only person we heard about. Relatively few civilians had been hurt, though they had suffered deprivation and hardship.

With few goods being transported from the south there were major shortages of many staple items. Government officials had fled at the onset of the fighting so there was no government or law except that provided by the New Forces. Banks were closed. Money was tighter than ever. Most hospitals were closed or operated without doctors and technicians. Doctors Without Borders (MSF—Medicins Sans Frontiers) and the UN supplied what care they could.

Our mission hospital up in Ferkessedougou became a vital source for medical care for the entire north region. They posted a sign at their entrance: Leave your guns at the gate—no weapons allowed! A primitive painting of a Kalashnikov with a crossed red circle through it communicated the message to those who could not read. There were

no grocery stores operating. The school's land line for the phone had been damaged in the fighting so we had no outside line. Living at ICA was going to be even more challenging! We couldn't wait to start!

Before we could accomplish much of anything we had to do major cleaning. Eighteen months had passed since we'd been there during the ceasefire. The hot tropical weather with strong winds carrying dust and dirt wreaked havoc on the contents of all the buildings. None of our windows or doors closed tightly, allowing dirt, rain, and insects to invade everywhere. We had our work cut out for us!

Our first two weeks were spent dawn to dark cleaning our one-bedroom townhouse. Every single cupboard or drawer or closet had to be scrubbed with every single item inside washed as well. We had to sort through all the accumulated debris before we could start cleaning. What was damaged beyond repair? What needed items were missing? As we went over our house I was hit again by a sense of loss. So many things had been looted. So many things that people had sacrificed in order to give us. Many of the gifts had fondly brought to my mind those who had given them. While I mourned the losses I knew that their absence could not eradicate my treasured memories.

My beautiful garden was in sad shape. My porch swing in the little hut outside our front door was still intact and had been put to frequent use by the French soldiers. I began pulling out dead plants, careful to watch out for snakes. To my delight Silas showed up one day. He was a gardener from Burkina Faso who had worked for several families before we evacuated. I was so happy to see his friendly face and hear that his family was intact and doing well. He needed more work. I hired him on the spot and together we started bringing our garden back to its former beauty.

When Ken and I drove into town to buy supplies I just had to stop at a couple of my favorite places: little roadside nurseries. There I chatted with the *patron* or boss, catching up. One man, with tears in his eyes, thanked me for coming back. He said that with our return he now had hope for peace and a re-unified country.

This stoop-shouldered, craggy faced little man then proudly led me over to a corner where he was guarding the yellow rose he had found for me. I was stunned! Two years had passed since I had told him that I was searching for a yellow rose bush! He'd remembered and

had kept looking until he'd found a beautiful plant, hoping I'd one day come back and claim it. This rose would take a place of honor in my reclaimed garden. I would think of this man each time I looked at it.

From the moment we arrived we looked for our beloved dog, Cobie. Dan Grudda had written us that the French soldiers had adopted all of the dogs left on campus, finding comfort and amusement in their company. Cobie was their favorite. She was a sweet-faced mutt with limitless energy and a good nature. Her skill at catching Frisbees and playing with balls added to her appeal, making her an ideal pet. Africans had frequently asked if they could have one of her puppies. Cobie had been the consolation for Aimee as she awaited our return after Ken's chemotherapy. Cobie was part of our family. So, where was she now?

While we were still in the States, Dan had written us that the French soldiers had requested permission from Rod Ragsdale, who was care-taking the campus, to take Cobie with them to their next post down the road near a village. They promised to return her to ICA before they returned to France after their four-month tour ended. That was the last Rod had heard from them and their tour had ended some time previously. Rod was now out of the country. My heart sank.

One day I heard a familiar "Ko Ko Ko" greeting at the door. Antoine, one of our faithful guards, had come to tell me that the mystery of Cobie's whereabouts had been solved. While in the village, she had

stepped on live electrical cables and had been electrocuted. The soldiers had been so upset and sad they could not bring themselves to return to ICA with the bad news.

At the end of the story, Antoine raised his eyes to meet mine. He said with great emotion in his voice, "I am so very sorry, Madame." I exploded into unexpected tears. Not the silent, gentle tears coursing down my cheeks but the gasping, shoulder-shaking sobs wracking my entire body. Through my tears I saw that Antoine was also crying. Tears for a beloved dog. Tears for so much that had been lost.

Shopping was always such an adventure—even more than it had been before. I loved it! Each outing was like a treasure hunt!

Several small *boutiques* carried some food and other items but supply was undependable. In one shop you might find one can of green beans next to a box of nails, but you'd need to go next door to find a can of corn. We rubbed elbows with rebels who moved their weapons so you could squeeze past them to get to a tucked-away shelf of goods. Fresh local produce was readily available so I would always stock up on juicy pineapples, tomatoes, lettuce and whatever else was in season. Potatoes and onions were trucked down from Mali and Burkina Faso. Fulani tribesmen still brought cattle into town to be butchered. I carried my woven basket into the meat market early in the day before the heat and flies got bad, picking my way around all the eager vendors and looking where I stepped. I breathed through my mouth to avoid the malodorous air. Carcasses hung from hooks on dusty rafters: beef, mutton, goat.

My friend Lois Gillespie put in her meat order. I avoided looking at the *personal* parts while I waited for the other butcher to whack off the bits I'd requested. Just then I noticed the row of freaky-looking skinned goat heads lined up on the rough wooden counter across from us. I caught Lois' eye just as she'd seen them as well. Yikes! Would we scream? Would we puke? Instead we burst into uncontrollable giggles, making heads turn to see what was causing all the fuss--just another find on our treasure hunt.

Our duplex-mates were still the communications unit for the French Operation Unicorn. Due to security we could not visit upstairs where they worked with all their equipment. They rotated shifts four

hours on, four hours off, round the clock. When off-duty, they slept downstairs on six cots enclosed with mosquito nets. Despite their efforts to be quiet, with their erratic schedule we'd often be awakened by their outdoor conversations and cigarette smoke wafting up to our bedroom. The odd hours were routine for them. However, they had trouble sleeping through what was normal for us: fruit bats dinging, roosters crowing, fire crickets chirping, frogs croaking, insects buzzing. Slap!

Sebastien, Ben, and Rudy were the three soldiers we got to know best of the six staying next door. They were friendly and curious and probably lonely, so far from France. They loved talking with us about America and our families, the school, and the Ivorian culture.

Ken and I liked to listen to *oldies* music like the Beach Boys, Simon and Garfunkel, and the Carpenters. One day as I approached the house the strains of American music filtered out. Puzzled, I knew our neighbors had not borrowed our music. When I rapped on their door, I discovered that they were playing music popular among young people in France: American oldies! It was a good bridge between us.

The guys also often invited us to their frequent soireés or dinner parties. Beginning outside their apartment for drinks, soda for us, whisky or beer for them, we'd continue on to join other soldiers in an outdoor feast. The carnivorous fare consisted of mainly roasted meats and more whiskey, accompanied by lots of cigarette smoking, talking and laughing. We had a lot of fun even as the conversation was a real stretch for our French-speaking skills. I suspected that some new expressions I heard I should never repeat.

The men never tired of discussions. Inevitably someone would eventually ask us the question: You're from America, the greatest nation on earth. You're from California, the most beautiful state in America. You've left your beautiful country and your family to come to THIS? This war-torn third-world country? Life is hard here, and dangerous. Why? (expletives removed) It doesn't make sense.

Ken and I would turn to each other and smile. "We're glad you asked. Let us tell you why we are here."

We'd then take turns or complete each other's sentences sharing how it was indeed illogical that we'd choose to live and work in Côte d'Ivoire, especially at this moment. We would point out what they

themselves had observed: people steeped in their traditional beliefs, doing the best they could, following in the steps of their forefathers, but remaining in complete spiritual darkness. Although few men were practicing any type of religion, they agreed that this was true.

"Don't you think that people should have a choice in what they believe?" we asked them. "How are these people to learn there is another Way unless someone tells them? How are they to discover that there is a loving God who provided His son as a sacrifice for their sins so they no longer had to sacrifice animals and seek to pacify the spirits through fetish priests?

"As Jesus-followers we want to share our faith. We want to share the Good News of God's love and a rich, abundant life."

We explained that like the parents of our students, we had come to West Africa to live alongside the African believers, to partner with them in sharing this Truth so others could choose to believe also. Life on earth is so brief, like a vapor. But eternity is forever. Where we spend eternity depends on the choices we make here on earth— whether to accept God's free gift, or to reject it. That's why we were in Africa.

"Thanks for asking!"

One Saturday I began feeling crummy—kind of achy all over, with a killer headache, soon followed by a high fever. Oh great! I thought. Now what?

No other symptoms appeared to help diagnose the illness, so I just gritted my teeth and decided to let the illness take its course. Was it malaria? After three days of unrelenting high fever, Cathy Bliss, our school nurse, decided I should be seen by a French army doctor. At the nearby French school was another military post, with a makeshift clinic.

Ken helped me down our stairs as I was too weak to navigate them alone. Brian and Cathy drove me the short distance to the school where our students had played sports with their students in happier days. Following their security procedures, we left the car at the guard post at the entrance and walked onto the property. Never has such a short distance seemed so long! We finally made it to the library where we'd been directed to go.

As we passed through the door into the library we arrived to a

surreal scene. Bulletin boards were still displaying children's artwork, school announcements, and cute little decorations. The bookshelves still held their normal load of novels, biographies, reference books. Shuffling up and down the aisles were French soldiers holding onto their IV stands, clad in t-shirts and camouflage pants, each with their own ailment or wrapped wounds. In the center of the children's reading area an examining table had been installed, with various gadgets and supplies on a rolling cart next to it.

I was instructed to climb up onto the high table. Not thinking when I dressed for the visit, I had thrown on my knee-length denim skirt. I now rued the choice. There was no privacy curtain or even a blanket or disposable wrap. I lay down as my head swam, feeling very exposed as soldiers curiously eyed me.

Oh well, I thought, there was nothing I could do about it now. A masked man in a uniform drew blood and wrote down my answers to his questions. Then we waited. After an hour another similarly garbed man approached and asked me if I was okay.

How do you say "hanging in there" in French? Oh yeah, "ça va".

Nearly another hour passed before the doctor arrived. He poked and prodded me, took my temperature and blood pressure again, asked more questions. The blood tests had come back negative for four strains of malaria. Regardless, he decided to treat me for malaria, along with an antibiotic. We Americans referred to this method as a *shot-gun* treatment and hope for the best.

As I slipped off the examining table, the floor rose up to meet me. The doctor caught me before I fell and helped me back onto the table. Brian and Cathy and the doctor discussed what to do with me. There were no separate facilities for women and I had no desire to stay there. So, the doctor broke security regulations and ordered an army jeep to the front door. The young driver hopped out and nearly carried me to the side of the high jeep, transporting me to the front gate and the Bliss' vehicle.

I don't remember much else. The doctor had supplied me with all the necessary medications, refusing any payment. I must have taken the medicine. I must have eaten and drunken fluids, but the following days were fuzzy. I didn't feel as absolutely awful as when I had typhoid fever, but I sure felt sick. Like so many times my family had been sick,

we never knew the cause but again, I was awash with thanksgiving for good friends, a wonderful husband, a kind French army doctor, and the many friends and family who regularly prayed for us. Jehovah-rapha: God our Healer. He is always good!

As soon as I began feeling better I resumed my now-daily routine: up in the dark at 5:30, the time between the fruit bats dinging and the birds' morning chorus. Rolling out of bed, onto the floor to do my core exercises, grabbing my clothes and shoes, I'd quietly change before slipping out into the pre-dawn mist, an almost magical time. Stretching, then trotting up to the nearby track, I'd pick up eight or ten small stones, slipping them into my pocket to mark my laps. As dawn began breaking over the hills, Nancy McComb and I would run our two miles, chatting along the way as our faces turned up to welcome the fresh morning dew. It was pure bliss; an island of calm before our busy days started. By 6:30 after completing our run, followed by a few minutes of prayer, we hugged each other's sweaty, dew-soaked bodies and went our separate ways. My day had begun.

I'd treat myself to a homemade mocha Frappuccino using ice cubes and my old Oster blender. Grabbing a hunk of fresh bagette I'd head to my porch swing where I'd munch and sip while looking out over my now beautiful garden, taking the time to cool down and have a quiet time with God. Such a beginning to the day gave me tremendous joy and peace and renewed strength. It was a gift.

By the time June had passed, we now numbered twenty returnees, including children. We five ladies decided that we couldn't pass up the opportunity to host a 4th of July celebration for the French soldiers. We'd barbecue hamburgers and hot dogs, make salads and desserts, and have a baseball game. The Commandant gladly accepted our invitation for his seventy-five troops.

July 4 dawned with beautiful fluffy clouds against the intense blue sky with no rain in sight. A good start! We set up tables with the food and for dining and the men began to trickle in. They were quiet and shy. As we reached out to them we learned that few of them had ever met an American and they were feeling overwhelmed. And to think we Americans were feeling intimidated by them!

The soldiers we now considered *our guys* helped bridge the gap and soon the men began to relax. Cathy had brought paper napkins which had the American flag on them as a special touch-- any paper napkin was a treat! We were merrily wiping our mouths and hands with them when Ken noticed that the soldiers at our table were not using theirs, but carefully folding and placing them in their shirt pockets. Ken explained that they were napkins and encouraged the men to use them.

The men replied, "Oh, no. We would never desecrate your flag by soiling it!"

The softball game was a big hit as few of the soldiers had ever

Teachers Tyler & Jessica Mallett at French Soirée.

Baoulé chiefs >

Story-telling soldier.

played and had to be taught the rules of the game. It was hilarious to watch them strike and miss the ball but still run as fast as they could to first base, continuing in a straight line far into right field and beyond! Or, with a man on base the batter would get a hit and while rounding the bases pass up his teammate. The experience created much laughter and bonding that day!

The military also used the field as a parade ground for recognizing units ending their tours, or for other important events. On such occasions all the local officials and people of prominence were invited. The Baoulé chiefs arrived; complete with fan-waving multiple wives in attendance. The top-ranking rebels came, all decked out in their uniforms and gris-gris, along with any visiting dignitaries. The French nuns from across the road made a gracious appearance. Canopies were erected; much pomp was displayed, complete with a military band. A reception usually followed in the school's dining hall, provided by the army cooks, giving us a chance to visit with these interesting people. What an opportunity of a lifetime! We were certainly out of our comfort zone but loving the experience anyway.

When the field wasn't being used for softball games or ceremonies it was used as the helicopter landing pad. The huge blades swirled gusts of wind, forcing dried leaves through the screens in our open jalousie windows. The choppers made a tremendous racket as well so we could hear them approaching from far away. We'd guess what kind of helicopter it would be and who it was carrying. The French Foreign Minister landed on our soccer field as did various UN officials on special assignment from Kofi Annan, the Director General. Eventually, the operation was moved across the road since it was deemed unsafe with the coming of the students.

While we were celebrating with the French, building relationships, we were also preparing the campus for the school year to begin in August. Unused for so long, the classrooms were as dirty as the houses, so we got to work. We had foreseen that this would be a huge task, so when Laura volunteered to use her vacation helping us clean, we gladly accepted her offer. Ken and I drove the gauntlet to Abidjan again to pick her up; she was accompanied by a good friend, Carmen Miller. Laura was happy as a clam to be back home and Carmen was such a trooper, fitting right in despite never having been in Africa before.

Before they arrived I paid a visit to *our guys* next door. I told them about the two pretty girls' upcoming visit. I explained that I knew that the soldiers had not seen many *Western* girls in a long time but that I was relying on them to be their protectors. I asked them to make sure all the other soldiers treated them with respect.

"But of course!" they replied. "It would be our honor!"

When the girls arrived on campus, one dark-haired with ivory skin, the other with long, fair hair, and both quite fetching, they created quite a stir on campus. The girls must have felt every eye on them as they walked to and from the classrooms each day. But never once did a soldier make an improper comment, gesture, or even a whistle. They were such gentlemen! The young men even asked permission to chat with the girls! Supposedly they wanted to practice their English but I just smiled, knowing better.

We did take a couple of breaks from the hard labor. I drove them to one of my favorite places: Tanou-Sakassou, the potters' village just three kilometers down the road. The village was having a hard time with few clients for their beautiful wares, so Julian Gada, the director, was especially glad to see us. I hadn't seen him since we'd returned so it was a sweet reunion. He gave the girls the grand tour, showing them the entire process from raw clay to finished product. We ended in the large room where half a dozen ladies sat making amazing coil pots, using small turntables for their hand-built pieces. Kiln-fired wares lined the walls, a corner for each artisan. All the metal-shuttered windows

were wide open, with the sills filled with little brown heads popping through to see the interesting-looking visitors.

The girls' visit was over all too soon and we saw them off safely. They had accomplished a great deal. During our cleaning frenzy, we made an interesting discovery. The walls of each building are constructed of cement bricks. The roofs are relatively thin corrugated metal over wooden joists. Simple 3/8-inch plywood sheets comprise the ceiling. There is no insulation between the thin metal roof and the thin plywood ceiling.

As the men worked to mend a leaky roof, they were amazed to see daylight! Multiple bullet holes had pierced the metal roof! More bullet holes were found in the roofs of other buildings. Yet, no bullets had ever reached the rooms below! The angles of entry indicated that they should have continued on their downward paths. The only time this could have happened was while the 200+ student body was diving under tables and taking cover during the battle for Bouaké. Why was no one hurt? I believe we were supernaturally protected. Prayers on our behalf resulted in an angelic *force field*. One of my favorite Psalms is chapter 91 and verses 9-11, and 14-16 certainly seem to apply here.

"For He will command his angels concerning you
To guard you in all your ways;
"Because he loves me," says the Lord, "I will rescue him;
"I will protect him, for he acknowledges my name.
"He will call upon me and I will answer him;
"I will be with him in trouble,
"I will deliver him and honor him."
"With long life I will satisfy him
"And show him my salvation."

While we are weak and prone to sin—far, far from perfect--we are still His children. Despite everything, He loves us! And He did indeed rescue us! He is so good! What a privilege to be a part of seeing God's hand at work! If there had not been bullets flying we would not have seen the power of God to save us from those bullets! He did not have to rescue us, but this time He did. If we never had problems in our lives we would never experience the grace of God in walking with us

through those problems, regardless of the outcome.

As July drew to a close we were able to switch gears from cleaning and repairing to preparing for the new school year to begin mid-August. It was no surprise that few students had enrolled. The school board had calculated that we could operate two to three school years with low enrollment; years of building confidence as well as the number of students. Our hopes remained high that the two sides in the civil war would resolve their differences and peace would return to this wonderful country.

Dan Grudda was our director again, with Mike Cousineau as our Business Manager and Deleen our Counselor, Eliz Carden our Principal, and Brian Bliss, the Dorm Director. The rest of us gladly took our places in the classrooms, dorms, dining hall, shop, or office. I had the joy of teaching Art to the entire student body except one student who had a schedule conflict. Ken returned to his favorite group of students: middle schoolers. We were all happy as clams.

Being a small student body had its advantages. Dan arranged with the French army for special field trips—first, across the road to the helicopter pad. What fun the students had climbing in the cockpits, donning the headphones, and pretending they were flying! The pilots explained the use of each type of helicopter while the kids thoroughly

Field Day with the French at ICA. Checking out the equipment!

enjoyed themselves. A few weeks later the soldiers opened up their tanks and armored personnel carriers and other heavy equipment so the students could crawl all over and inside them, goggle at all the instrumentation, and inhale the aromas of confined combat vehicles.

The student body then visited a cocoa farm and learned how to harvest cocoa pods. By the end of the visit students were giving a helping hand to the workers, eliciting many smiles and words of encouragement and appreciation.

As August and September were slipping away I made preparations to fly stateside to be with Aimee when their next baby was to be born. A generous gift from a friend had made this seemingly impossible trip possible. There were rumors of an escalation of fighting but nothing much had come of them.

After the usual exhausting flight I arrived in California to spend a few days with my parents who had begun to develop some serious health issues. My time quickly flew by and I soon found myself in Flagstaff where Aimee had delivered Anne Katriel earlier than expected. Anne developed jaundice and had to spend most of her time in a clear, suitcase-like contraption fitted with bilirubin lights. I was glad to be there, helping Aimee during this difficult time, as well as spending

time with little Peter. By the time my visit ended, Anne was out of her contraption and Aimee was regaining her strength.

While in Flagstaff, I had read in the news about some new skirmishes in Côte d'Ivoire so I was anxious to get back to Bouaké and my husband. Things were sounding ominous. There had been a lockdown on campus when fighting erupted in town. Ken sounded nervous on the phone.

The night before Ken drove to pick me up from the airport he had a dream. In the dream he was driving south, as he would be doing in a few hours. As he waited at one of the many rebel checkpoints on the outskirts of Bouaké, a uniformed rebel soldier approached his window and asked if he could hitch a ride with him down to the next main checkpoint. Normally reluctant to accept weapon-wielding passengers, Ken felt that God wanted him to take this soldier with him and so they drove off together. Ken woke up scratching his head, thinking, "Now that was kind of crazy!"

After throwing in his few items for the trip, Ken climbed into the Suzuki, not looking forward to making the five-plus-hour trip alone. Anything could happen and who would know?

As he finally passed through all but one of the nasty checkpoints, his dream started coming to life. A uniformed rebel soldier came to his window and asked for a ride to the next checkpoint. Ken remembered his dream. Was God trying to tell him something? The soldier turned out to be a friendly fellow and the trip passed uneventfully. As they arrived at the famous Tabou checkpoint where we usually had to endure an hour or more of interrogation, he was waved through as the officer had opened his window and the men at the barricade recognized him. No hassles or even checking of papers!

"Wow! That's really nice!" thought Ken. "Thanks, God!"

On the return trip leaving Abidjan, the government soldiers at the checkpoints seemed unusually testy. The rebel soldiers at their checkpoints seemed to mirror the same anxiety. Only the UN soldiers retained their equanimity. We wondered what was causing this extra tension. We approached the Tabou checkpoint with fear and trepidation. If the minor checkpoints were so bad, how much worse would this one be? Our fears were unfounded as the soldiers remembered Ken and our thirteen-year-old red Suzuki from the day before. Hurrah!

Thanks again, God!

But, our relief was short-lived. When we came to the long line of some eight rebel checkpoints, one right after the other, at the entrance to Bouaké, our hearts sank. The first station's soldier was as aggressive as they come. He wasn't content to check our papers or our rebel-issued Laissez-Passez. He wanted a *gift*, a bribe. No tract or bottled water for him! Drunk? High on drugs? Who knows, but he was acting crazy. He leaned against the driver's side of the car, patting his holster ominously and asked if we wanted to become acquainted with his *friend*. Other soldiers watched anxiously from under a tarp canopy to see how

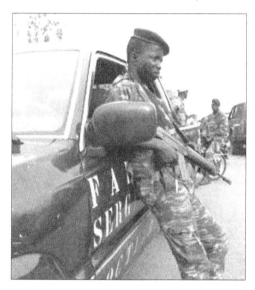

this was going to develop. Then, Ken had the bold idea of sticking his bent arm out the window, as if to get some fresh air. The crazy rebel knocked his arm as he was wildly gesticulating. This gave Ken the opportunity he needed.

"Help! This man hit me! Help! Help!" Rebel soldiers came running and dragged away the protesting soldier, waving us onward. Whew! Thank you, God!

But the trial was not yet over. Only a few dozen yards away at the second checkpoint, more rebels waited for us. Ken was stressed, wondering how he was going to manage yet another encounter, when who should show up but the soldier he'd given a ride! After a brief greeting he waved us through that checkpoint, then walked alongside our car as we effortlessly passed through all of the checkpoints to follow. He was indeed our guardian angel, just when we were at the end of our rope. God is so good!

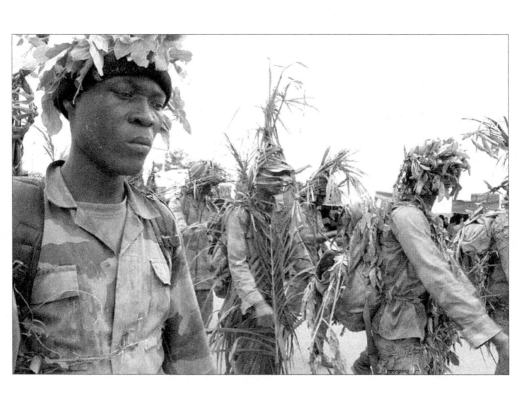

When I am afraid I will trust in you
In God whose word I praised
In God I trust;
I will not be afraid
What can mortal man do to me?
Psalms 56:3-4

Chapter 20

November 2004

Roar! Ka-boom! Ka-boom! What on earth was that? I peeped out the bathroom window as I quickly stepped out of my post-jog morning shower. In the sky above I glimpsed an airplane passing overhead. It was not French and it was not United Nations. Could it be.........?

Quickly dressing, I grabbed a bite and dashed up-campus. Despite the signed treaty and agreed-upon ceasefire, the President had sent his government troops north to re-take Bouaké. Now we knew why the men had been especially tense at the checkpoints. Through the French we learned that government ground troops and heavy artillery had crossed the demilitarized zone, past the UN peace-keepers, and were nearing Bouaké. Classes were moved to the dining hall and dorm homes; the classrooms were too near the main road and in the expected direction of attack. Intermittent sounds of war thundered in the distance.

For days we had been hearing mortar fire and machine gun blasts as the two sides clashed east of the school. The national army was drawing an ever-tightening circle around the city. Although we did go into lock-downs several times, the assurance that we were surrounded by well-armed French troops did much to allay our fears. God's words to Joshua lingered on the edge of my mind: "Be strong and courageous. Do not be afraid; do not be discouraged, for the Lord your God will be with you wherever you go."

Cyril, one of the French general's aides, stopped me as I was walking home. "How's it going out there?" I asked him. Much of the information he was privy to was top secret but I could tell he was upset and needed to talk.

"You know that one of my jobs is to document events here, both in writing and with photographs." He continued, "Remember all that gunfire you heard yesterday?"

"Well, the government troops had men from the Young Patriots fighting alongside them. As they were fighting their way toward town, they were screaming, "Death to every white face!"

I gasped.

"They were only three kilometers from here. A camp of French aid workers stood in their way, between the village and ICA."

"So, what happened?"

"By the time I arrived many villagers had been shot or hacked to death with machetes. I had to take their pictures." His voice cracked with emotion.

"What about the aid workers? Did the troops reach them?"

"No, the Ivorian troops never reached them. They were saved."

"So, who stopped them?"

Silence.

"They were stopped. That's all I can say."

He squeezed my arm and with eyes brimming with unshed tears, turned away.

The French soldiers at ICA had brought in more heavy weapons, including monster-sized guns that looked like modern cannons. These were installed on the soccer field and pointed toward the hills across from our townhouse. In fact, they looked like they were pointing at our house, though I'm sure that wasn't the case. Watch towers had been erected at regular intervals around the perimeter wall and were manned by well-armed soldiers.

I was granted permission to still run around the track in the mornings. I waved at the watch-tower soldiers as I trotted by. Although the exercise served as a good stress-reliever, gone was the sense of elation and utter abandon, replaced by a sense of God's presence and a peace in His sovereignty, despite the atmosphere of uncertainty. None of this was a surprise to Him. He knew what was happening and how it would turn out. I ran alone. Nancy was busy with her boys.

Thursday morning the planes began dropping their bombs on Bouaké. The French said the army was *softening the target* prior to their final ground assault. We waited tensely, trying to maintain a semblance of normality.

Friday did not bring renewed bombing to Bouaké. We wondered if that was a good sign or bad? News was that Korhogo to the north and Vavoua to the west were being bombed.

While running Saturday morning I saw the bombers emerge from the clouds, heading toward us. Ken and I quickly gathered up necessities and raced to Beth Eden dorm where the rest of the school was gathered.

Together, we watched as Sukoi bombers manned by Ukrainian pilots flew overhead. Yes, Ukrainians who were given Ivorian citizenship so as not to qualify as mercenaries. The planes flew so close we could see the pilots. Bombs were being dropped in town and we speculated as to which section was being hit. We prayed for those people being injured or killed, our hearts going out to them even while we were helpless to help them physically.

Then the bombs started falling even closer. Our windows rattled and we could see plumes of smoke arising from where the bombs had found their targets. The scenario was fascinating and horrifying at the same time—almost like being in the middle of making a movie. But this was not make-believe. This was real.

255

Watching the air-borne bombers.

As one plane made an especially close run we knew the hit was very close to us. Almost instantaneously the French commander yelled: "We've been hit! They've bombed the French school!" Immediately, news was relayed of deaths and injuries at the school where I'd been helped by the army doctor, only a kilometer away. The communications unit had listened helplessly as they overhead the Ukrainian pilot confirm his target: the French school. This was no accidental bombing. The peace-keepers were their target, destroyed by a guided missile.

Nine men had been killed—eight French soldiers and an American aid worker, who had just arrived in Bouaké as the city came under attack. Thinking the safest place to be would be with the French peace-keepers, he'd taken refuge with the troops. Many other soldiers were wounded.

At ICA, officers shouted orders. Soldiers ran in all directions. We Americans turned to each other and went into action as well. Casualties would surely be brought here to our campus. We ran to gather clean rags, make the neglected dispensary ready, find blankets and sheets-- bring whatever we could to help out. My heart raced as sirens screamed, guns pounded, soldiers dashed to stations.

The Commander listened intently to his radio, then barked, "The planes will be coming back. Their target was a school used by French

soldiers. They sent a guided missile into the barracks. We're going to take them out before they can return and bomb THIS school!"

It seemed only moments passed before we got word that the French military had disabled the bombers' headquarters while the planes were on the ground awaiting refueling in Yamossoukro. The deadly helicopter gunships were also rendered incapable of flying. We collectively let out the breath that we hadn't realized we'd been holding.

But the battle was not over. Some of the Ivorian ground troops had moved in, although their previous plans had been disrupted. Loud fighting and skirmishes occurred throughout the city.

Wounded soldiers began arriving from the French school. Within hours French troops took armor personnel carriers into the hardest hit areas of town, loading up ex-pat survivors and bringing them out to safety at ICA. The large gym was transformed into a gigantic dormitory as army cots were set up wall to wall. Dormitories were made ready for families—people who arrived with nothing but the clothes on their backs. Dirty, hungry, shocked, these people needed some care.

We quickly assem-
bled baskets of toilet-
ries, clothes, and combs
and brushes from our
personal stocks and
delivered them to the
people as they arrived
("Bless you, dear girl!").
We promised to try to
find whatever else they
needed. Some with tears

of thanks responded by blessing our efforts. Now, how were we going to feed all these people?

No dining hall staff had come to work due to the fighting. So, we all pitched in and threw together a meal, serving each other. The French volunteered ready-to-eat meals for the refugees. We heated these and served them with whatever else we found. The people were so very gracious, thanking us again and again. Some insisted on helping serve the food; others assisted in washing the dishes.

I thought of the words from Proverbs: "He who refreshes others will himself be blessed."

While scouring out some big pots I looked up and there was a young dark-haired man who looked vaguely familiar. He had come to help out. I handed him a towel and began chatting. He was the son of Catharine, a bookstore owner in town. He had come up from Abidjan to visit his mom. He'd grown up barely a stone's throw away and had ridden horses with the Baldwin children and attended many events at ICA. He said he always felt welcomed here and had many fond memories of our school. He said it was so very fitting that in their time of need, ICA would also become a place of refuge for him and his mother.

Many of the other refugees had been shop keepers we'd done business with; others were health care workers, international journalists, relief workers. Each had their own harrowing story to tell. Each expressed profound thanks to us, as well as to the French soldiers who had driven their armored vehicle within inches of their doors, reached out and pulled them inside before zooming away to safety. Some had been trapped in their houses for days without food or electricity, too frightened to move, as battles swirled around them. Those who were injured received treatment.

The post-attack frenzy was followed by relative calm within a few days. We set up a system of helping the displaced visitors and they were settling in well. The wounded soldiers from the French lyceé sat outside

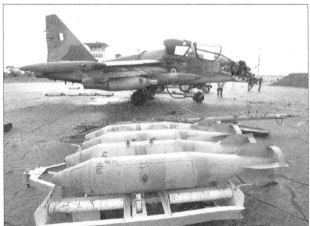

Plane destroyed by the French;

in the shade, enjoying the peaceful atmosphere while recuperating.

I wondered how long the calm would last. What would happen next? Word arrived from Abidjan that the Young Patriots were inciting an already tense population. Sporadic street-fights and gunfights had erupted.

Hate-filled speeches were broadcast over the radio and television: "The French have arrogantly destroyed the sovereign national air force! The French are trying to take over Côte d'Ivoire! We must retaliate! War is declared on all non-Ivorians, especially the French!"

Mobs of angry young men rampaged door to door, looting and searching for white people to harm. Hundreds of people were beat up; women raped; stores and homes stripped of their goods; schools decimated. In just three days nearly 9,000 people fled for their lives, flying out on any available plane. Abidjan was in chaos!

The parents of all of our Korean students lived in Abidjan. Communication was near impossible: not only were the land lines down, but the government had disabled all cell towers as well. Were their parents safe? Were they in hiding in Abidjan or had they fled?

The leader of the rebel New Forces in Bouaké publicly expressed his outrage at the UN for allowing the government troops to cross the de-militarized zone. How dare the President break the ceasefire, break the treaty he had signed! Without giving specifics he declared that his troops would retaliate within eight days.

Rebel Commander Cherif

This promise of retaliation put us in an even more frightening situation, isolated as we were. We knew we must evacuate. But how?

We had been surrounded by the government army. Were they still out there waiting? If we were to try to drive out, would they attack us or take us hostage? With the violence, fleeing to Abidjan and the airport was not an option. We could not escape to the south; there was no direct route east to Ghana--we would have to zig-zag our way through hostile government-controlled territory. To the west we could eventual-

*Crisis Manage-
ment Team*

ly reach Guinea or Liberia, but some of the heaviest fighting had taken place in that region.

Should the rebels choose to retaliate, they would try to head south across the demilitarized zone as the government troops had. We knew that neither the UN nor the French peace-keepers would allow that to happen. It could get ugly. Should that occur, the previously *friendly* rebels could easily turn against us as well. Dan insisted we must evacuate the children as soon as we could, however we could. We certainly had no idea what the future held. We just knew that we could not stay.

Dan and Mike contacted Missionary Aviation Fellowship (MAF) in Bamako, Mali. They would send down a plane so that at least the Korean children could be evacuated. Ken and I had been designated their guardians. We would fly out with them. Could they land on the soccer field?

While arrangements were being made for rebel escorts to accompany a seven-vehicle convoy overland, we began packing up. This time we would be able to bring two suitcases—a big improvement over the single carry-on of the previous evacuation. We selected items carefully, making sure that each object was of practical or memorable importance. Then we started giving away as much as we wisely could, to dear people like Silas, Abi, Josephine, and Antoine. Some cherished things we packed away, hoping to return some day to reclaim them.

The day was set, only three days after the bombing. We would evacuate on November 13th, Ken's birthday. It would be a memorable birthday.

260

Sunday found us clustered in the little white chapel, where we had enjoyed church services, plays, graduations, funerals, and weddings—where we'd honored the lives of Julianne Grudda, Doris Betty,

The final chapel service at International Christian Academy.

and Dave Golding. This service would be a marker occasion: the last service of the International Christian Academy.

No formal decision had been made yet but we knew in our hearts that the bombing of the city sounded the death knell for our school. Our beloved school would close, never to open again. After forty years of faithful service to the mission and international community, ICA would be closing its doors. The French would stay for a while, but our time had drawn to a close. Our hearts were broken.

For the last time, I cut flowers for a bouquet. My tears were lost among the roses, ferns, lilies, and bougainvillea. Chairs were dusted off. Soldiers and refugees were invited to join us.

Our time of singing was especially poignant. Evan Evans and Brad Trosen had written most of the unique songs sung at ICA, some which we sang that morning. My heart beats a little faster when I hear "You Give the Victory". Tears still fill my eyes when I sing "Shepherd's Lullaby":

261

"..I rest content, untouched by trouble."

I thought I was alone in my tears until I lifted my eyes to those around me—many cheeks were wet, not only those of the ICA community but those of visiting soldiers and refugees as well: we shared in our loss. We found comfort in our faith. Our God was still good.

Our hearts echoed the words of Job, "The Lord gives and the Lord takes away. Blessed be the Name of the Lord."

Why did God bring us back, only to take us away so soon? Ken and I had only been back six months, most of our colleagues an even shorter time. Dan asked us if we still felt that it was God who had led us to return. To a person the answer was in the affirmative. There was no doubt in anyone's mind that God had called us back.

Re-opening the school was only part of what we'd accomplished here. We'd also built relationships with French soldiers, planting seeds of faith. We had encouraged our African brothers and sisters. We had shared with refugees. Would any of these actions ever bear fruit? This was our prayer but not our responsibility. Our role was to be faithful and obedient—the results lay in God's hands. When asked if any of us had regrets that we'd come, the universal answer was "No! No regrets!" We'd do it again in a heartbeat.

My spirit plummeted when word came down from Bamako. MAF would not be sending down a plane for us after all. They had heard a rumor that the President had bought more bombers. The planes were waiting over the border, ready to be put into action. The people at MAF apologized. They could not allow their plane to serve as target practice. They sent their prayers but not their plane. What now?

Thankfully, room was found on the school bus for all the children as well as Ken and I. Our convoy lined up in front of the school offices, not far from the front gate. Before we climbed aboard, we tearfully hugged those staying behind—my last-time hugs for Silas, Josephine, Abi and Antoine, who were all weeping too. Darl Powell and Mike Cousineau had volunteered to stay behind and make final closures at the school. French soldiers watched from distance, wondering why these people who were escaping a dangerous situation were crying about leaving. They had no idea how wrenching it was for us to leave.

The rebel escorts were anxious to leave, climbing into the first and last vehicles. Each vehicle was adorned with small American flags, an important distinction as we traveled through potentially anti-French territory. We waved goodbye as our vehicles passed through the gate and swung onto the road, this time turning towards town instead of away from it. Although this was a familiar route we had no idea what lay ahead.

I thought again of the verses "A man choses his path but the Lord orders his steps." Then the comforting verse, "Trust in the Lord with all your heart, lean not on your own understanding; in all your ways acknowledge Him and He will direct your path."

Our path took us through the town of Bouaké where people were going about their daily business, buying bread, going to market, as if bullets and bombs had not been exploding around them in recent days.

We could stay, I thought. Life could go on as it had! But then I brought myself back to reality. Bombs dropping from the sky changed all the rules. Living with the French army no longer provided the protection we needed. Children could no longer remain in such an unstable and dangerous place. Since our ministry was with those children we had to leave as well.

Our feelings of sadness were soon replaced by the sense of urgency to get out of the country as soon as possible. The tension began to mount again. Would we run into government troops? What would happen if we did? I had advised the teenage girls to wear loose clothes, long skirts and no makeup. I didn't want these pretty girls to look any more attractive than possible, not knowing what encounters we might face.

As our convoy snaked its way north just past Katiola, we pulled over to the side of the road. Eliz and Timothy Carden's car had a flat tire, the first of many unscheduled stops we would make. We stayed on the bus. I crossed the aisle to check on Esther, one of our Korean charges. She had come down with malaria and was burning with fever. I mopped her brow and gave her water, encouraging her to sleep.

Before long we were moving again, lulled by the motion of the bus into a light sleep, only to be jerked wide awake again with yet another breakdown. Before the long day was over our convoy was to

collectively experience nine breakdowns.

Between the breakdowns and checkpoints our progress was slow, not that we could really speed along the broken, potholed road. The heat and dust combined with the all the starts and stops left us wondering if we would ever reach the northern border.

Thankfully, we did not encounter any hostile government soldiers. The multitudes of checkpoints were still time-consuming. Our rebel escorts and *gifts* we had to pay made the process far less trying than it would have been. Few private vehicles had ventured onto the roads. Our American flags and white faces made our convoy easy to identify. People pointed, some waved, and some just stood in wonder at our passing. We wondered ourselves. Armed soldiers abounded.

As we were nearing the town of Korhogo there was a loud clank from the bottom of the bus. Driver Chris Marine expertly maneuvered the unwieldy vehicle to safety. Other drivers in the convoy popped out of their cars. They all congregated around a back wheel, discussing various courses of action. The bus was jerry-rigged just enough to crawl down the road and onto the mission station.

Before the dust had settled, Ivorian workers ran forward to greet us as we stiffly got out of our vehicles. The Powell's under-construction house provided us with the first bathrooms we had seen since ICA—what luxury rather than our usual bush stops! As I wandered through the unfinished house, appreciating the design of Jill and Darl, I wondered if they would ever be able to return and finish the building and resume their ministry. Their container of goods was

still unopened in the back of the property, having been delivered right before the civil war broke out.

The mechanically minded men figured out what the problem was with the bus and created an African-style solution, hoping the repair would hold. Although it seemed we had been on the road for forever, we still had many hours and many kilometers to go. Would we make it in time? Dan reminded us that it was of the utmost importance that we get out of the country that day.

As we passed through the town of Korhogo, Chris tried to avoid the many potholes. The task was impossible. Clank! The bus came to a sudden stop. The men clambered out to investigate only to discover that with the constant jostling and bumping a part of the wheel had either broke or worked itself off. The bus was undriveable.

Dan announced that if they could not fix the bus, all of the baggage would be left on the bus and the bus passengers squeezed into the other vehicles. We would forge on, leaving no one behind, but without our prized possessions. A couple of men set off for the nearby open-air marché in search of the rather obscure part. The odds of finding the right part were grim. Even if the part was available, to find it amidst the hundreds of jumbled piles of dusty parts from dozens of makes, models and years of other vehicles was a seemingly hopeless task. To make the Herculean effort even more challenging, many vendors were off celebrating a local holiday.

Meanwhile, back at the bus several of us women decided that an intense prayer meeting was in order. Not only did we need to escape to the border, but we also wanted to take those cherished items in our bags with us. Doggone it! With the last evacuation we'd only been able to take a small, very inadequately packed carry-on bag; this time we'd carefully packed two suitcases with memorable treasures and important documents. We didn't want to lose them after coming this far.

As friends, we circled our arms around each other, tightly closing our eyes as we entreated our Father: "Please, please, God, let them find the part so we can continue. And God, please let us keep our baggage - it's all we have left. Whatever happens, though, we know you will do what is best for us. We give you the glory."

As we opened our eyes we blinked in wonder. There above the roof of the bus had appeared a beautiful rainbow. What a reminder to

us--God is a Promise Keeper! He had promised to never leave us or forsake us. He was still with us. We knew at that moment that everything was going to be all right. Somehow, He was going to finish the job he had begun with us. The issue of our baggage faded in importance.

When the men returned, weary but triumphant, they carried the *impossible to find* part we needed. God is so good—He just keeps amazing me!

With the bus repaired and reloaded, we crept through the town once again. As we neared the outskirts we slowly passed the main rebel headquarters, a formidable sight. The convoy continued on through the unending and ubiquitous checkpoints. With the increase of heavily armed soldiers near the headquarters we were especially quiet, subdued by the stress we were feeling.

At the last major checkpoint the soldiers stopped us for a long time. Dan got out and walked up to the little hut servicing as a shelter for the men manning the checkpoint. Before long we could see Dan leaning into each vehicle, one by one, saying something to the occupants. The soldiers wore angry expressions as they watched expectantly from the side of the dusty road. When Dan arrived at our bus we learned that as our convoy had passed by the rebel headquarters one of us had taken a photograph. The incident had been noted and word had preceded us. Who had done such a foolish thing? And, more importantly, what would the rebels do about it?

The teenage culprit admitted his action. He explained that he was only taking pictures of interest and never thought about it being a dangerous thing to do. Only days after being bombed, the rebels were hyper-vigilant about spies or government sympathizers gathering key information. Were we enemy sympathizers? Why were we taking photographs? Should these people be detained?

We waited nervously in our vehicles, praying for Dan who was interceding for us.

"Who knows but that you have been placed in your position for such a time as this?" I thought.

Undoubtedly, Dan was speaking excellent street Cebarra with the ranking officer, using his knowledge of the Senefou culture and language to smooth the rough road the boy had unwittingly created.

Dan was an excellent negotiator and communicator. I knew that if anyone could get us through this critical point he would be the man God would use.

Eventually our motley crew was waved through the barricade, out of that dangerously volatile situation. The rebel officer had watched while Dan digitally dumped the offending photographs, and even allowed him to keep the camera—a truly amazing action! Not surprisingly, Dan confiscated the offending apparatus for the remainder of the trip.

The black, star-studded night had now fallen. We had been on the bumpy road for seemingly endless hours. After passing through several more checkpoints, only the final checkpoint at Pogo remained before reaching the final frontier. This was an infamously nasty checkpoint with rebel soldiers reveling in their power over people wanting to cross the border. With just a word they could grant permission or they could deny the request. Either way, we knew we were in for a long drawn-out wait with Dan negotiating our passage, accompanied by our rebel escorts. People were camped out alongside the road. We wondered if these were people who had been denied crossing? Would we be camping out too? Would God bring us this far only to allow us to be turned away? My weary heart hoped not, but I knew that His ways are not our ways.

Our drinking water had run out. Our food was gone. We draped ourselves over the sweat-sticky uncomfortable bus seats, wilting in the heat and fatigue. Esther mercifully slept, curled into a ball. We had been on the tortuous road for 16 long hours.

Suddenly, vehicles began creeping forward; our bus followed. We were being allowed through into Mali! Our convoy slowly and carefully crossed the border from danger into safety, from war into peace. Praise God, we had made it! Praise God we had made it! Praise God! My bloodshot, weary eyes filled with tears, this time with thankfulness.

God is good—all the time. All the time—God is good.

As Ken wrapped his loving arms around me I whispered into his ear, "Happy birthday, Sweetheart."

No regrets.

267

African Child
~ Julia Vaughan

He who began a good work in you
will carry it on to completion
until the day of Christ Jesus.
Philippians 1:6

Epilogue

Nearly blinded by the bright lights beaming from the Mali border guard station, we stumbled out of our vehicles and into the arms of our colleagues who had been waiting many hours for our arrival. Refreshing bottles of water, bread, and hugs were all gladly welcomed through our haze of fatigue. Many tears were shed. Often, it is when we are past a crisis that the reality finally hits us and then emotions overtake us. Our tears were a blessed release. Our adventure was not over yet, but the danger point had been crossed and we were safe. We were safe! Malian soldiers requested by the US embassy in Bamako were to be our new escorts, replacing the rebels who stayed on the Ivorian side of the border.

Sikasso was our next destination; a refuge we pulled into at 1:30 in the morning. The lumpy hotel bed had clean sheets. The one small, thin towel Ken and I were given to share was a luxury and more than sufficient since the shower water came out only in drips. We slept soundly, grateful to be horizontal and out of harm's way.

After breakfast at the hotel we loaded back up and headed north to Bamako, Mali's capital city. Our entire group checked into a large modern hotel where crisis counselors would oversee our debriefing and help us through the post-trauma and closure process. Perhaps as helpful as the official sessions were the informal *normal* times we had together: we girls painting our toenails while watching a chick flick, deep sharing that went on long into the night, sealing unbreakable bonds.

The sound of the bombs which had fallen on Bouaké also

269

sounded the death knell for ICA. Our losses were many: our homes, our jobs, our community, our possessions, our friends with whom we'd so closely bonded. We grieved together. As the days passed we experienced even a loss of identity as we had to re-invent who we were. We'd be scattered once again, but this time without hope of reuniting. Some would return to the States, some to Niger, some to Cameroon, some to Senegal, some to Europe or Kenya, some would stay in Mali. Ken and I had absolutely no idea where our next steps would take us.

As we bid farewell to our dear colleagues Ken and I moved into a mission guest house to wait on God. The administration at Dakar Academy had told us that they did not need us for the current school year. We wrote to our supporting churches, family, and friends to ask them to pray for wisdom for us. Two MK schools in Europe were extremely interested in our joining their staff, phoning to interview us several times. Both were in beautiful locations, with access to famous museums and galleries as well; ideal for an art teacher. However, as we agonized over the two choices we had no peace. How could we leave the Africa we'd come to love? It was in our blood.

So, we offered our services to the small Missionary Aviation Fellowship school, later to become Bamako Christian Academy. Although they didn't really need us, they welcomed the supplemental assistance we could offer. In the Badalabougou neighborhood, Ken and I found a house to rent, although it was in dire need of work. The immense landlord, dressed in his regal white grand bou-bou with elaborate gold embroidery, made quite an impression on us as he accepted the required cash payment of six months' rent. Repairs and renovation costs would be borne by us.

Only forty-eight hours later we received an email from the director of Dakar Academy, "Please come immediately! Two of our teachers have been med-evaced and we desperately need you!"

Now Ken and I were faced with another difficult decision: was this God's leading, and, did we want to go? Our previous experience in Dakar had been very difficult. Desert sand, loud prayer calls, aggressive people speaking harshly, recurrent security warnings, big city noises, we had never felt quite at home. Should we move back, or, should we just wait for an easier ministry to open up? We'd been through a good deal and perhaps we deserved somewhere with less stress. But does such a

place exist anywhere this side of heaven? Whether it's political unrest, rebellious children, job disgruntlement, physical ailments, or church splits, a stress-free environment just doesn't exist wherever you live.

I wish I could say that God smoothed out all the wrinkles of our transition, changed the hearts of everyone we'd encounter, and made our move not only effortless but immediately gave us a deep and intense love of the people of Senegal. I wish. But I can say that God never left us or forsook us; he walked the path with us as we struggled to re-enter this painful place. Yes, it was painful—full of the memories of evacuation and loss and disappointment. Moving among strangers resistant to the Good News, I'd never felt such a foreigner.

Part of the process of working through change and grief involves making new memories to fill in those spaces of loss. I needed to open my heart - not compare one place with another, one experience with another. It was a challenging and continuing learning process for me. I am still going through it! But God has given me grace, accepted me as I am with all my questions and failings and brokenness. He reminds me that this world is not my home; I am a stranger wherever I live. My citizenship is in heaven.

One new memory bridge God gave me took place during a first day get-acquainted discussion in art class at Dakar Academy. We were sharing the various places we'd lived. It's always an interesting topic with such an international and mobile student body. When I mentioned that I'd lived in Bouaké a teen age boy spoke up.

"I've been to Bouaké," Nate volunteered. "We lived in Dabakala and came to Bouaké to get our supplies. The last time I was there I was actually kidnapped," he added.

"What! Were you four years old? Was your dad shot? Were you the child my heart went out to? Was yours the family we had prayed so earnestly for?"

I was reminded of a commentator who always included a segment in his program, called "And now, the rest of the story..." How gracious of God to show me the rest of the story for this family we'd prayed for more than ten years earlier. After their traumatic event they moved to Senegal, where they now have an effective role in advancing God's kingdom. Each member of their family was now in good health and was totally immersed in the Senegalese culture. Their lives are living

testimony to God's healing touch and His faithfulness.

Each time I teach my art students linear perspective, using a vanishing point, I repeat to them the truth that our perspective on life changes according to where we place the spiritual vanishing point. Our time on earth is so very brief—ethereal—but so very important, for what happens now will impact all of eternity.

So, while I teach my students to follow their Creator God I hope that I am instilling in them not just skills but values and concepts which will impact their lives for eternity. Whether I am heading up a mural team to paint in a rural village or school or center for street children, or teaching international students, I want my life to count. If God can use such a one as I, He can use you. The same God who helps me will help you. When life is hard you can run into His open arms and He will hold you. He is all we need, all we can hope for; He is worthy of our trust.

God has proved his faithfulness to us times without number. Each time I look at my wonderful husband I'm reminded of the grace God extended in healing him of his lymphoma. God did not have to do that, but I am profoundly thankful that He did.

"Why, God? Why my beloved husband? Why did You see fit to heal him? I have done nothing to deserve the rich blessings You have showered down on me throughout my life. Sometimes the blessings came disguised as troubles but You always made them into something You could use to knock off my rough edges to form me into Your image or to meld me tighter to Your loving side."

What has happened to ICA, that *garden of Eden* dedicated to the glory of God, to train young people to become mature and solid young adults? International Christian Academy is now called *Village Baptiste* and is still being used to God's glory. As I write this, the French military still maintain a small presence on campus, headquartered in our house by the creek, where we raised our kids. Pastors and their wives come for retreats. Bill and Dianne Grudda, now coordinators for short term teams coming to West Africa, often bring those teams to bivouac at Baraka dorm as they go out into villages to work. World Venture has begun an internship/training program for young single adults called Journey Corps. The main headquarters for this program is at Village Baptiste. The University of Bouaké has reopened and the medical

faculty is living on part of the campus as well. The Ivorian Association of believers would love to turn the school into the first Christian University in West Africa. What else is in the future for ICA? I don't know. But I know Who does.

Happy events have taken place in our family. Andy married his brother-in-law's sister, Grace Young, and Laura—who had vowed to never marry—is wedded to Caleb Lanting. Our three children have blessed us with eleven grandchildren, including a set of identical twins. What else is in the future for Ken and me? We have plans but we know that our trust-worthy God will order our steps according to His plans and according to His ever-gracious, never-failing love.

God is good all the time; all the time, God is good.

No regrets.

Laura & Caleb

Our growing family:
we have truly been blessed.

Andy & Grace

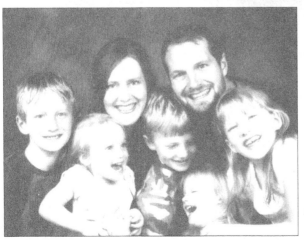

Aimee & Christian

Acknowledgements

It takes a village to raise a child and it takes a team to produce a book. I have attempted to be as factual as possible when writing my story, checking facts with actual documents and having readers make suggestions for correction or improvements. While so many people have contributed to my life and to the writing of this book, any errors are entirely my own.

With that said, I would like to thank Bruce Butler, graphic artist with World Venture for his inspiration and design on the cover of No Regrets. And Ruth Mortenson, my editor, who dogged me into writing my story and encouraged me every step along the way, spending countless hours putting the book into readable form and doing all the behind-the-scenes work I had no idea even existed. The readers of my first drafts are to be commended as well, and thanked for their time and positive feedback.

Stepping further back in time, I would like to thank my family for their inspiration and sacrifice in continuing to love and support us, mostly from thousands of miles away. Parents, children, siblings, extended family—I have felt your love! Countless faithful friends who wrote us, prayed for us, lifted us up in countless way and times—I thank you. We also had dozens of individual partners with the mission, who became our friends, and without whom we could not have served in Africa. You humbled me each time you told me you prayed for us daily, and your faithful financial support was often sacrificial but as steady as a rock.

Our supporting churches were also a mainstay and a lifeline through our twenty-eight years. Many of these churches upheld us for the entire time, others for a shorter time, but all were a blessing to us and I want to call them out by name:

Grace Baptist Church, Yuba City, California
Twin Lakes Church, Aptos, California
Church on the Hill, San Jose, California
Hillside Evangelical Free Church, San Jose, California
Sun River Church, Rancho Cordova, California

Sun Grove Church, Elk Grove, California
Calvary Church, Ukiah, California
Nice Community Church, Nice, California
Calvary Church, Los Gatos, California
Risen King Church, Sparks, Nevada
McCall Baptist Church, McCall, Idaho
Palmcroft Church, Phoenix, Arizona
Flagstaff Christian Fellowship, Flagstaff, Arizona

My love and thanks to Ken Vaughan, the love and light of my life!

And, of course, all thanks and glory to the only wise God, the Lord
Jesus Christ!

Photo Credits:

Author's collection
Nancy Grudda
Nancy McComb
Laura Belle Isle
Mike Evans-Maxon
Lois Gillespie
Dan Penney
ICA yearbook
Tucker Grose
Each has contributed to the photos in this book but my memory
fails to accurately identify each photo with each photographer.

CPSIA information can be obtained
at www.ICGtesting.com
Printed in the USA
BVOW06s1717021117
499350BV00023B/508/P

9 780999 110805